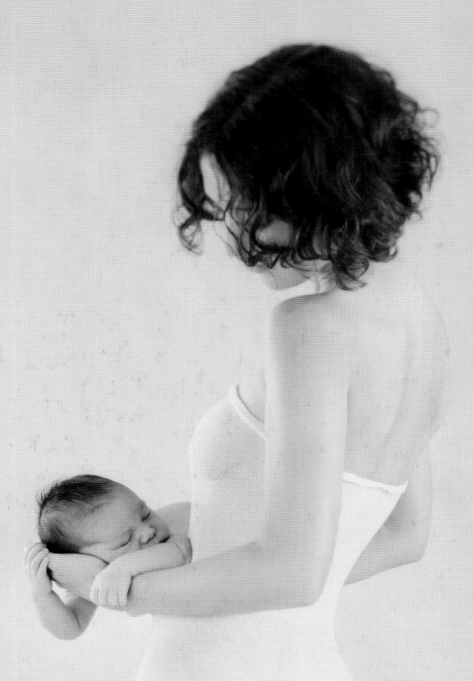

P                    U

R                                        E

UNIQUE

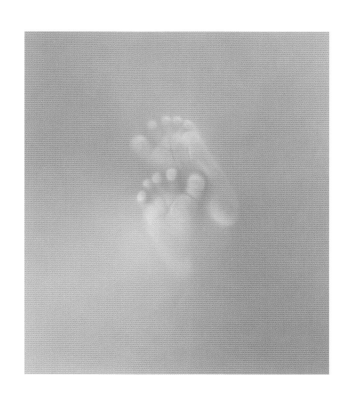

EXQUISITE

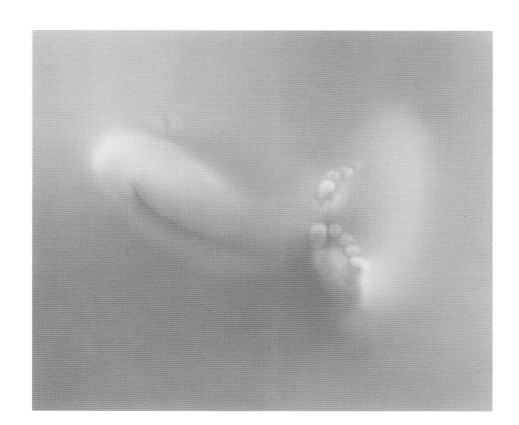

REMARKABLE

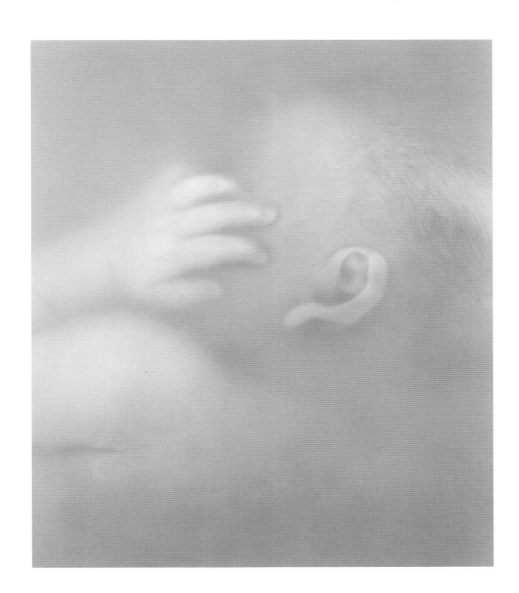

MIRACULOUS

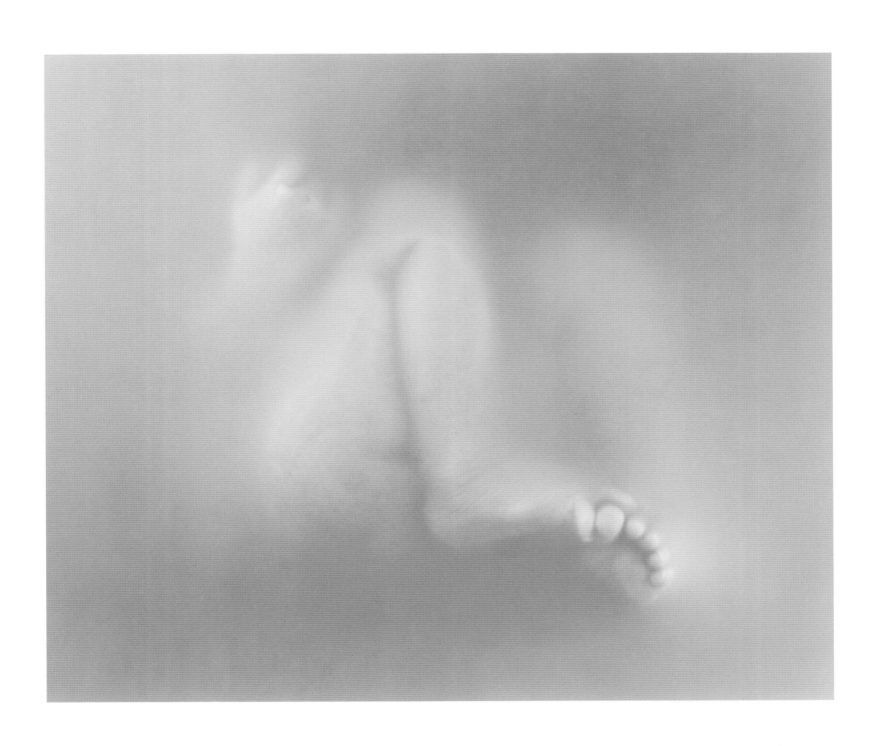

EXTRAORDINARY

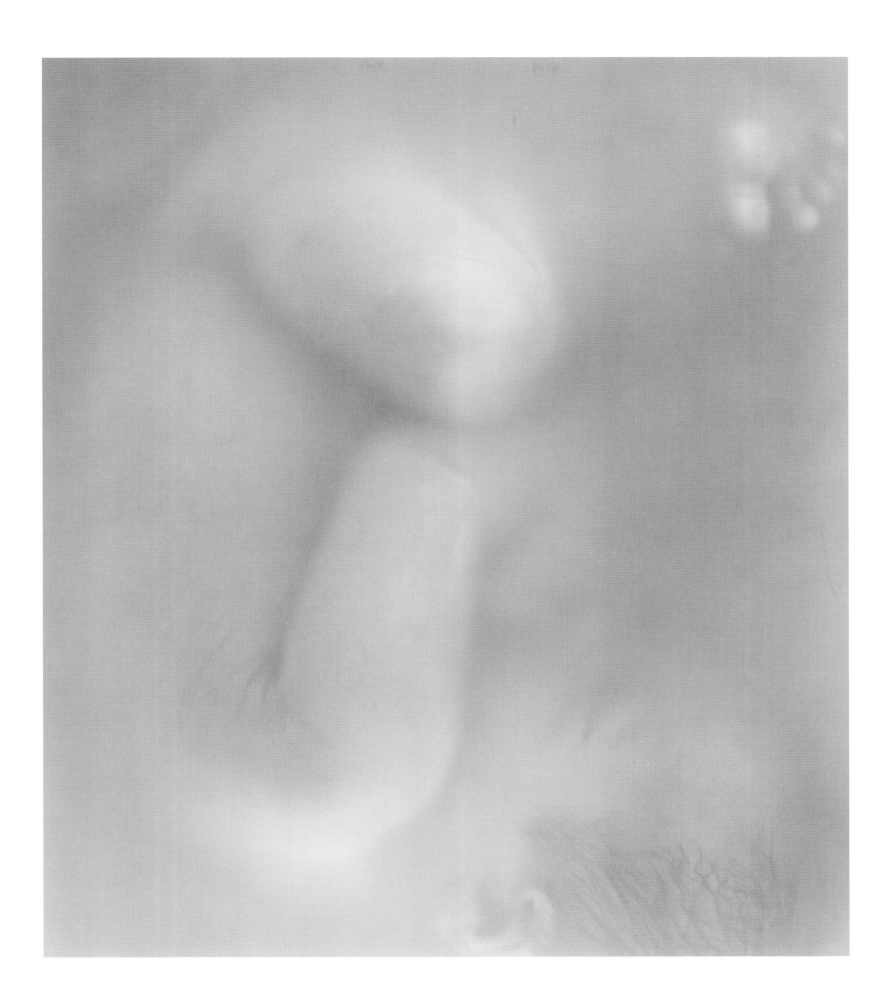

# ANNE GEDDES

### P U R E

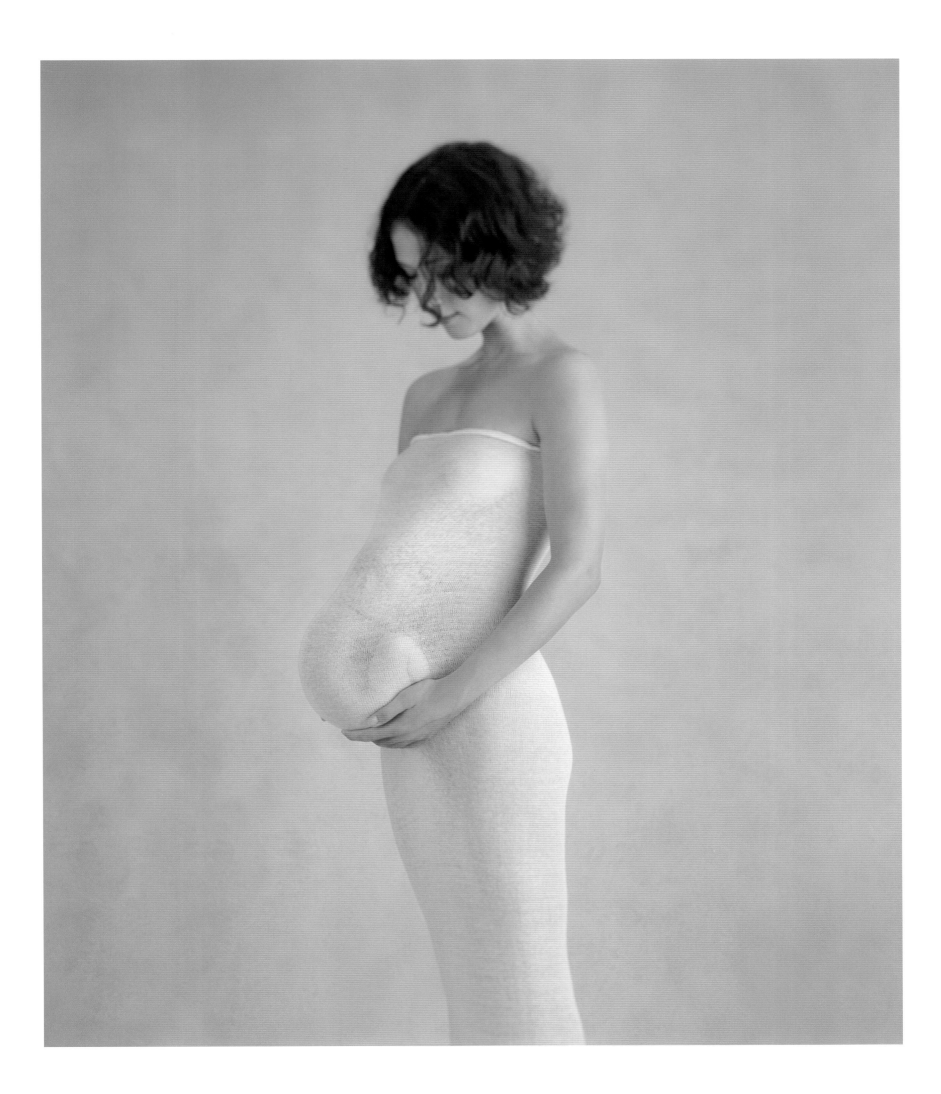

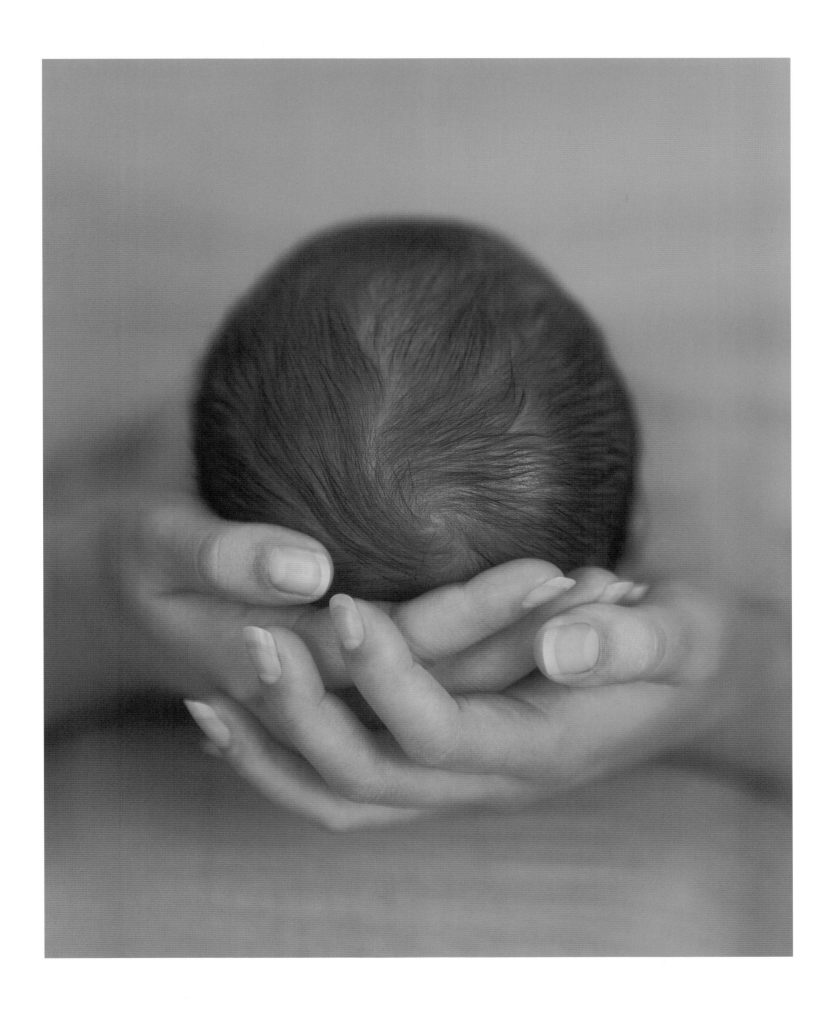

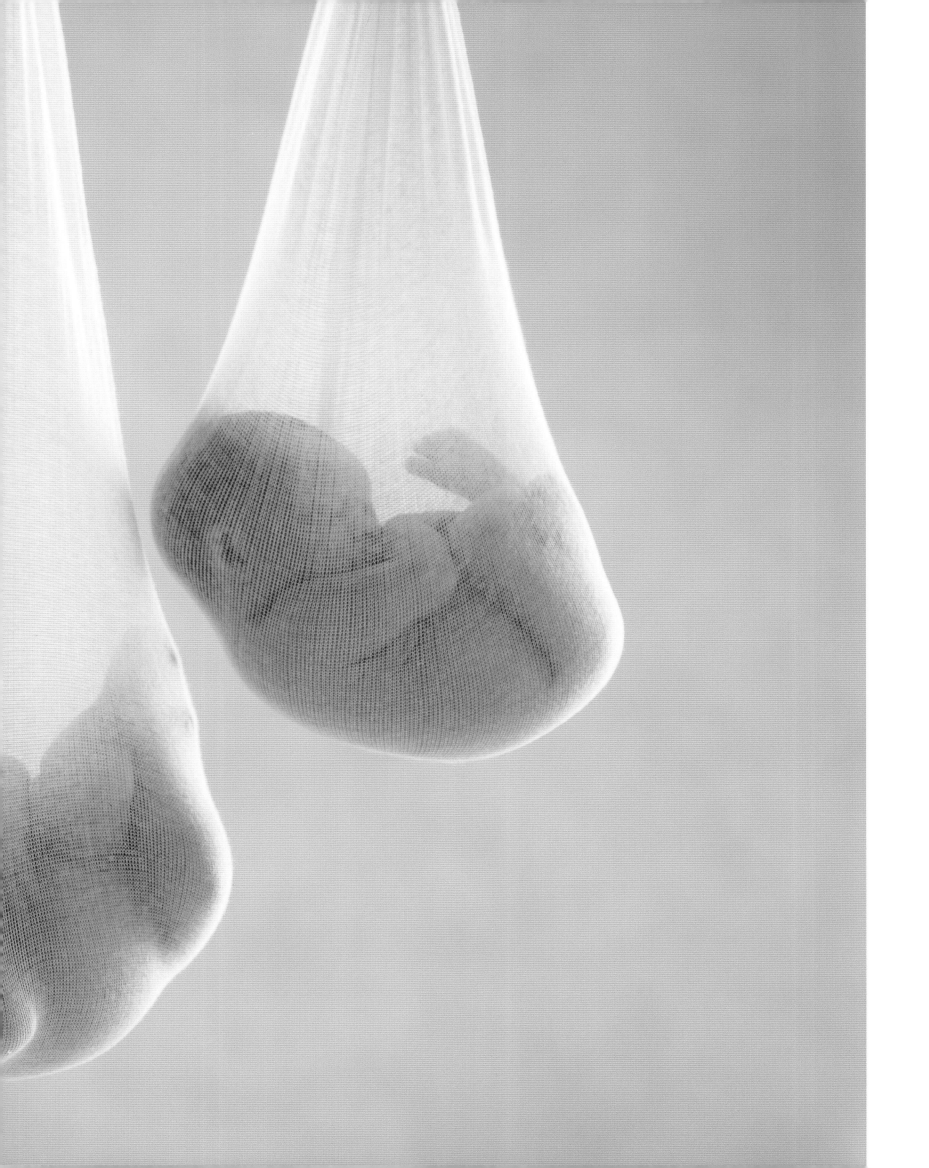

VULNERABLE

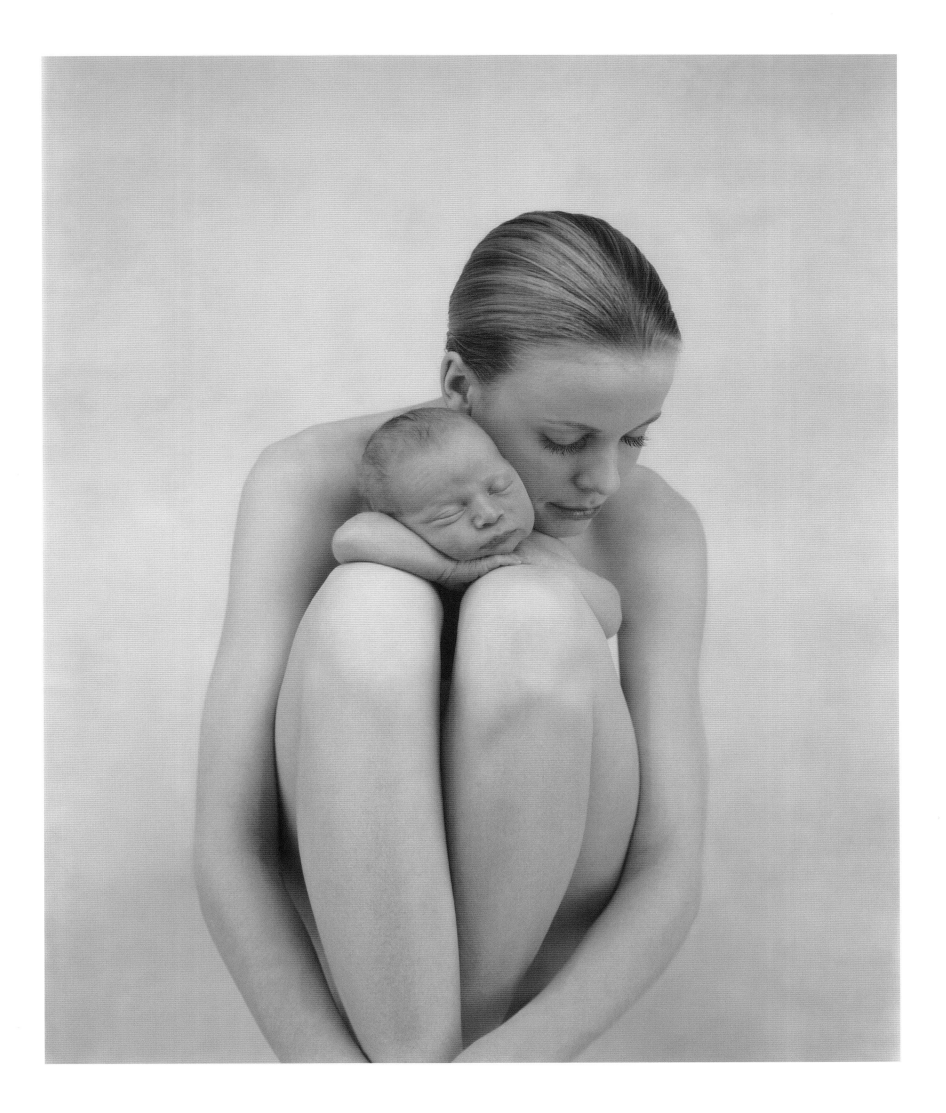

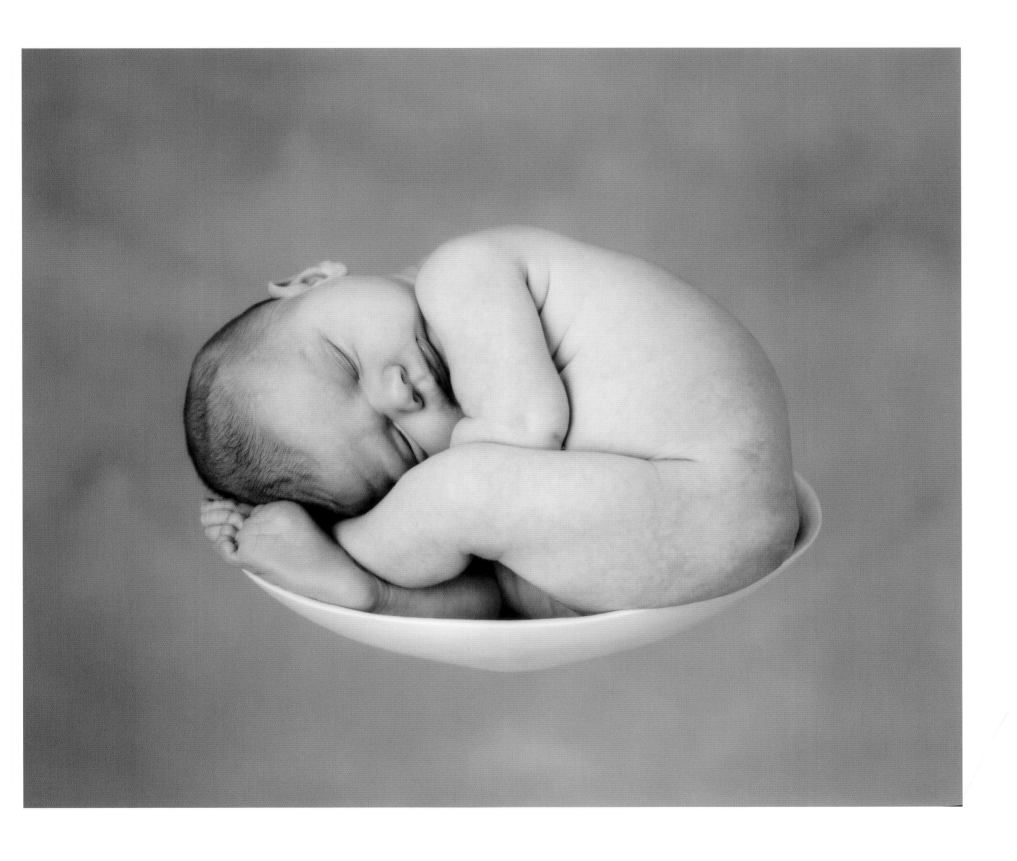

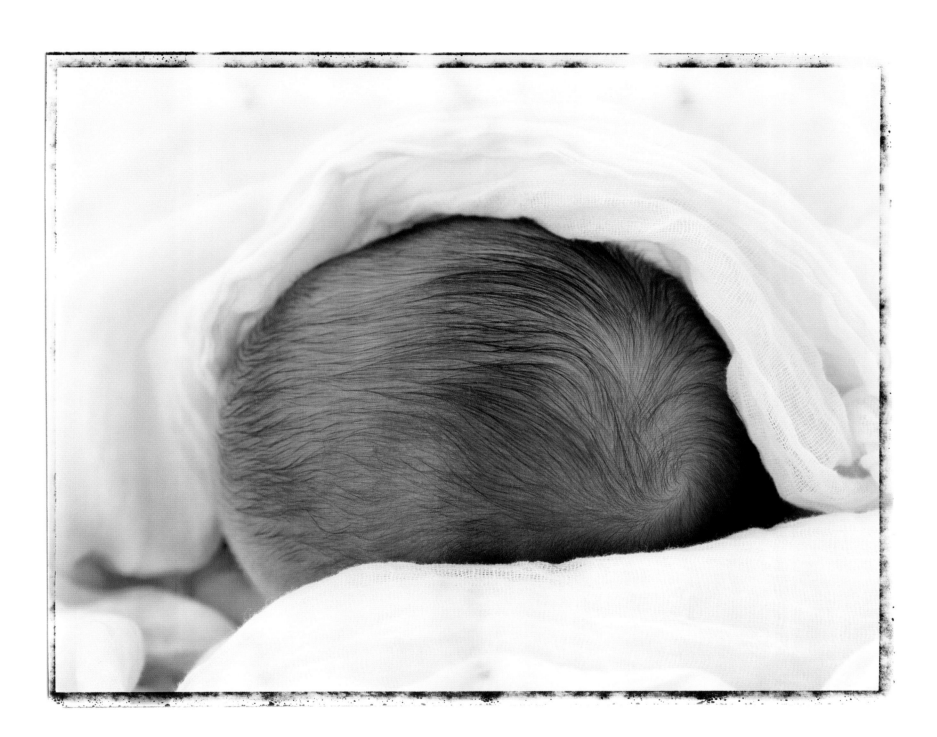

BEAUTIFUL

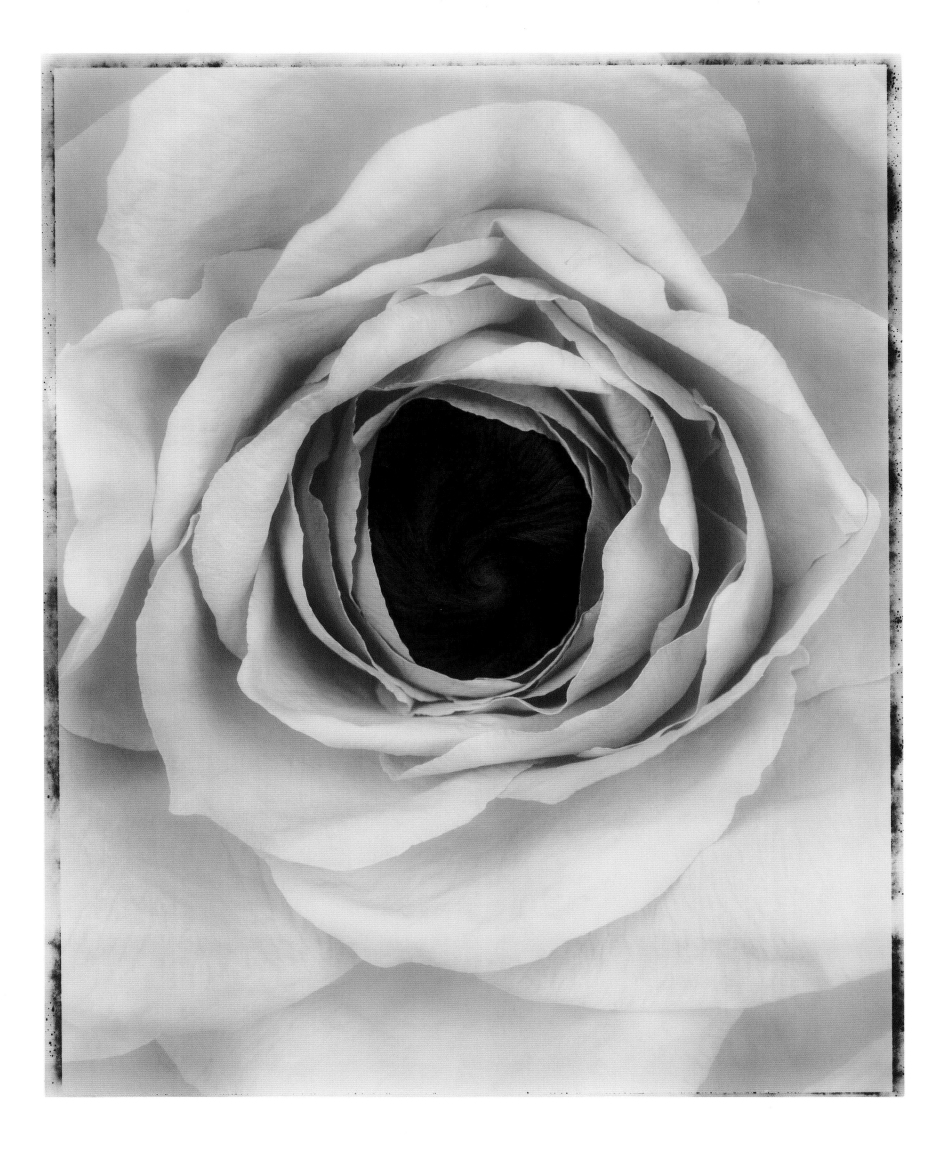

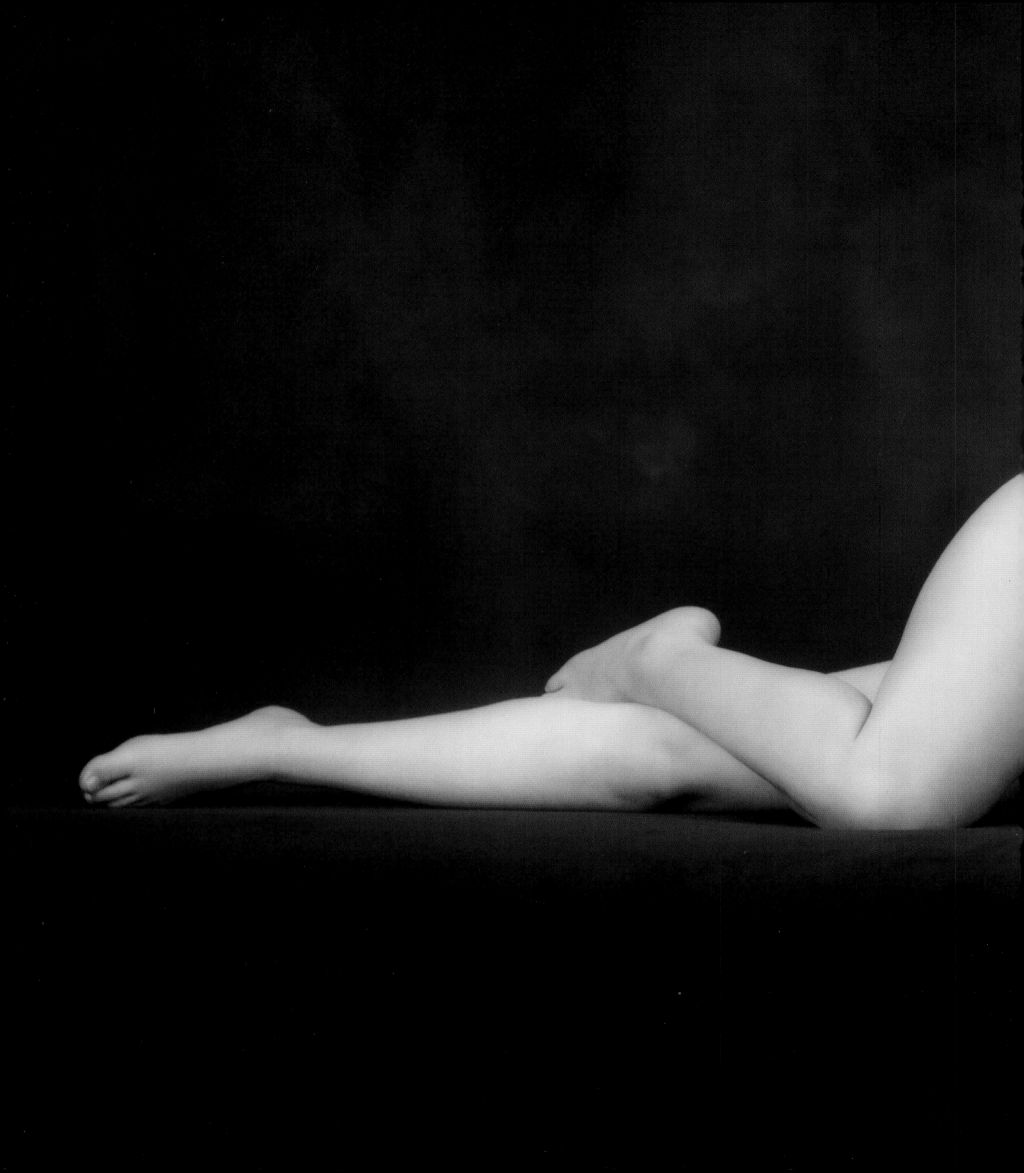

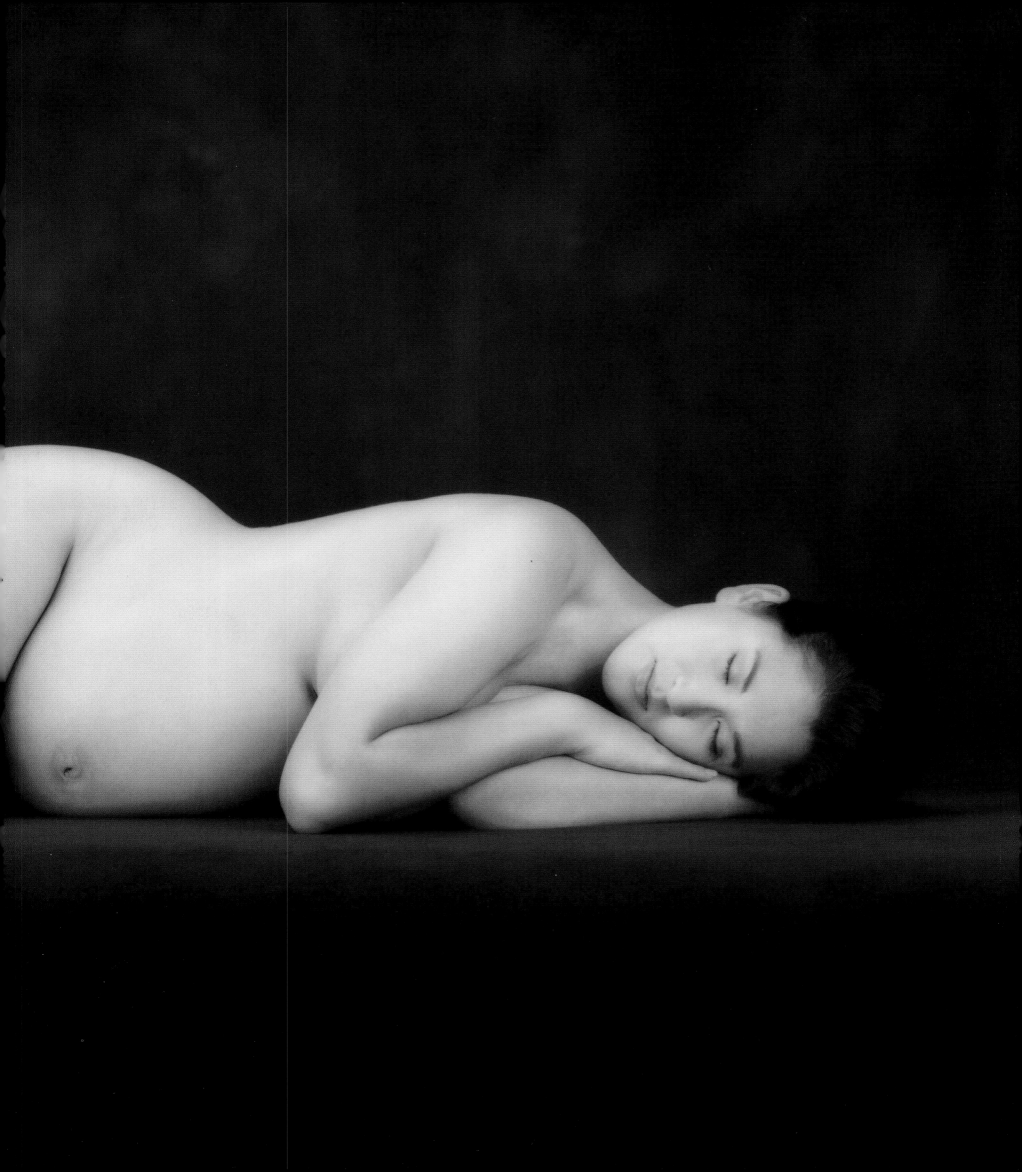

RIPE

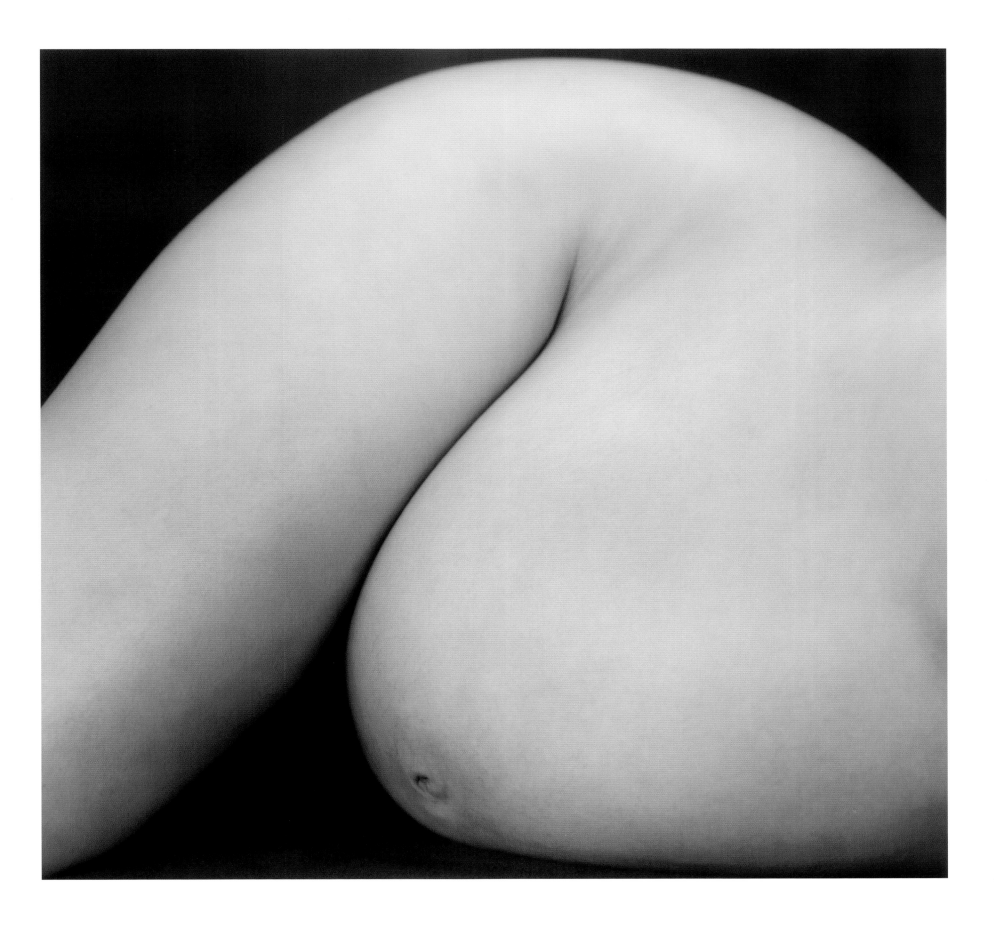

KYLE. 7 DAYS

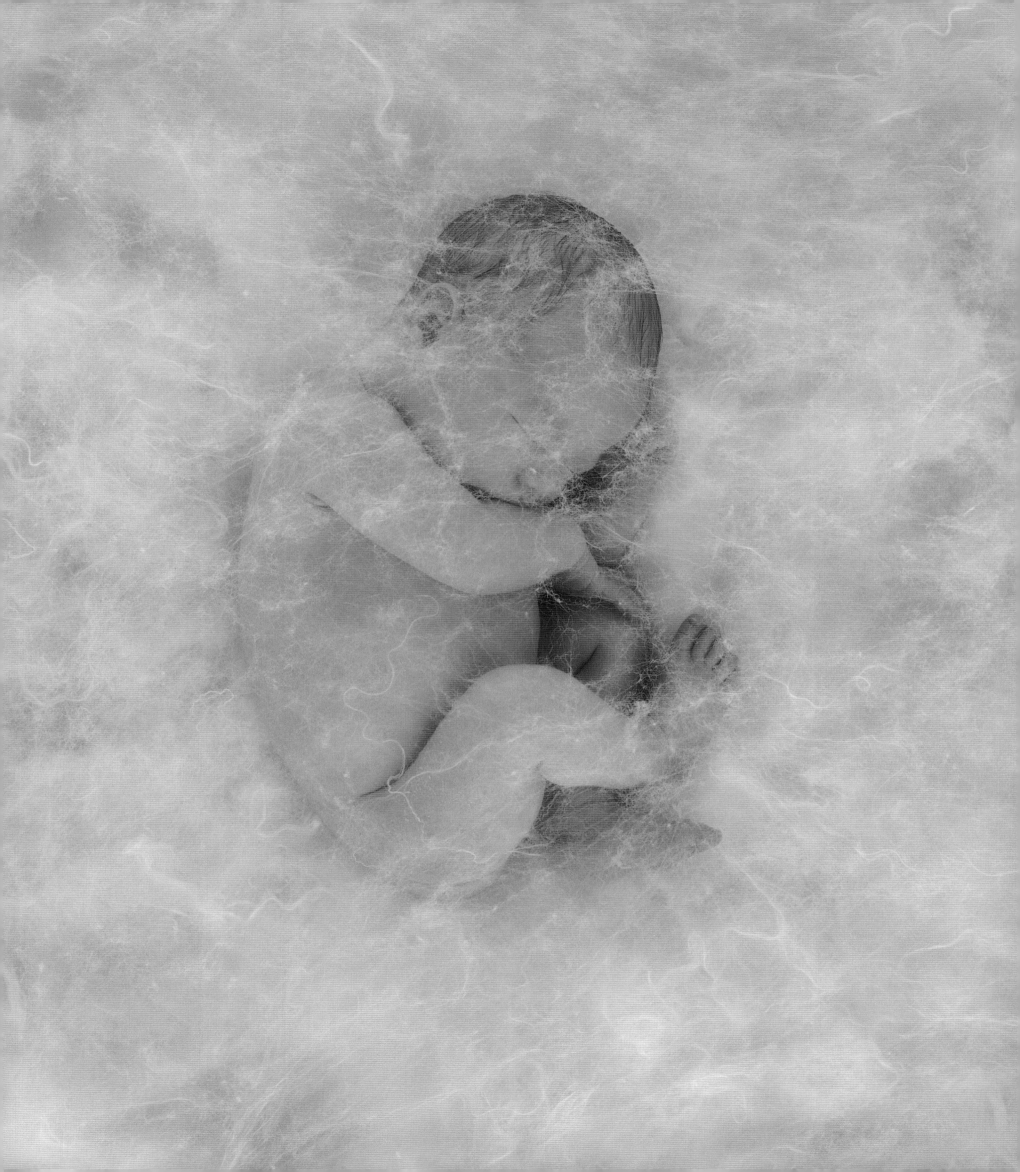

FRAGILE

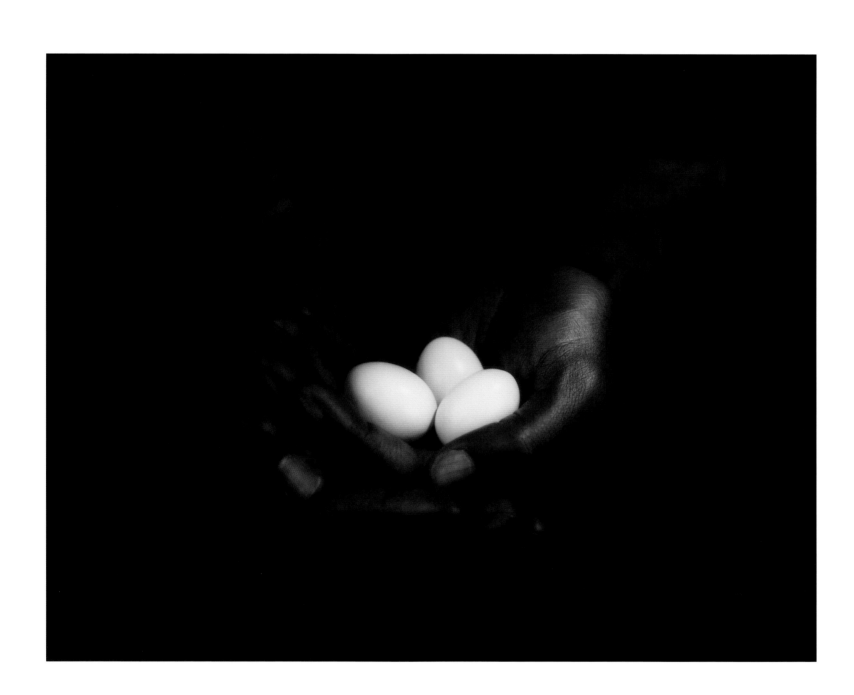

JACK HOLDING IDENTICAL TRIPLETS – CHARLEÉ B, SUSANNA & JACLYN, 9 WEEKS. (IMAGE IS LIFE-SIZE)

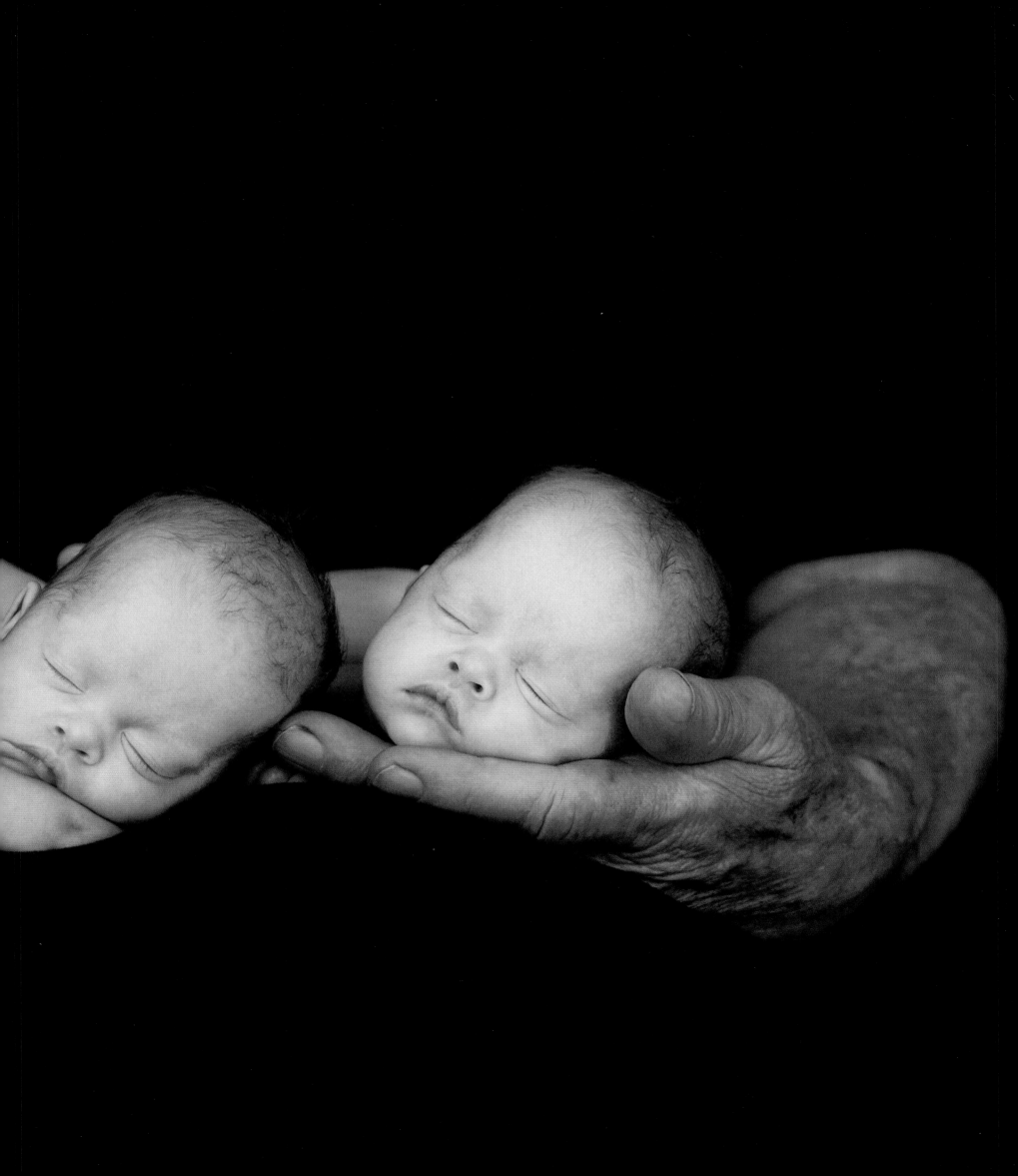

TENDER

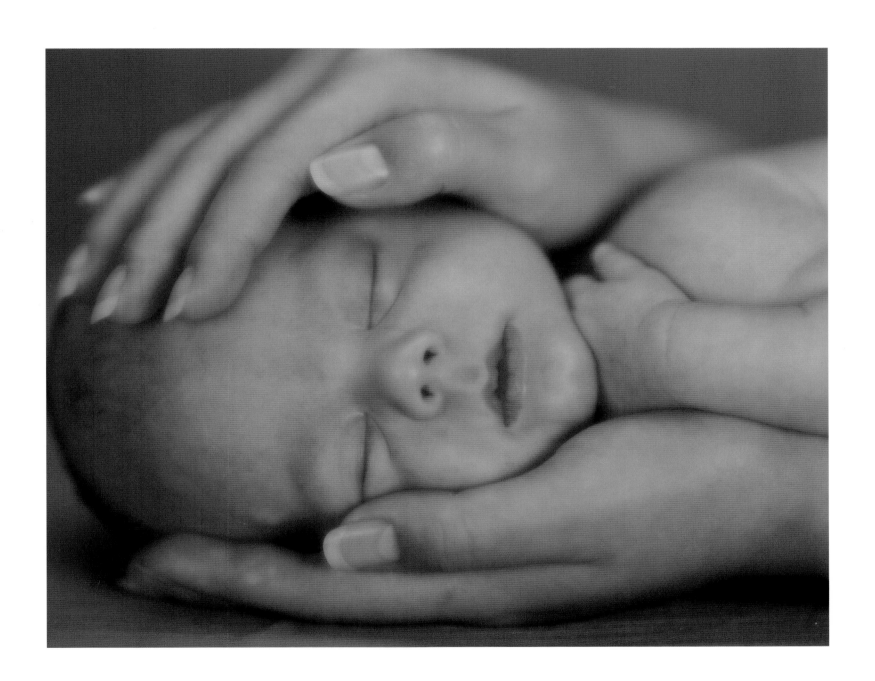

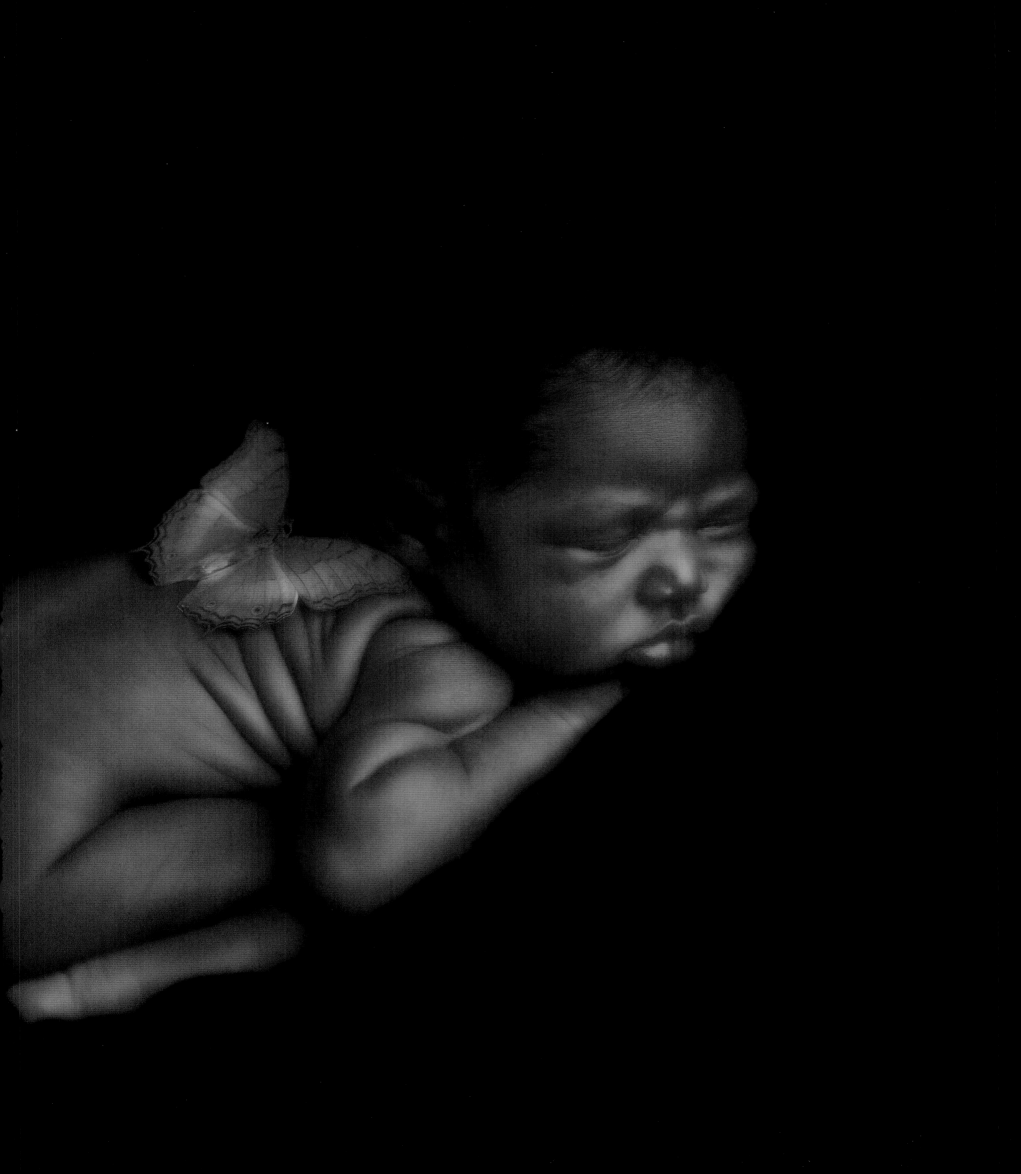

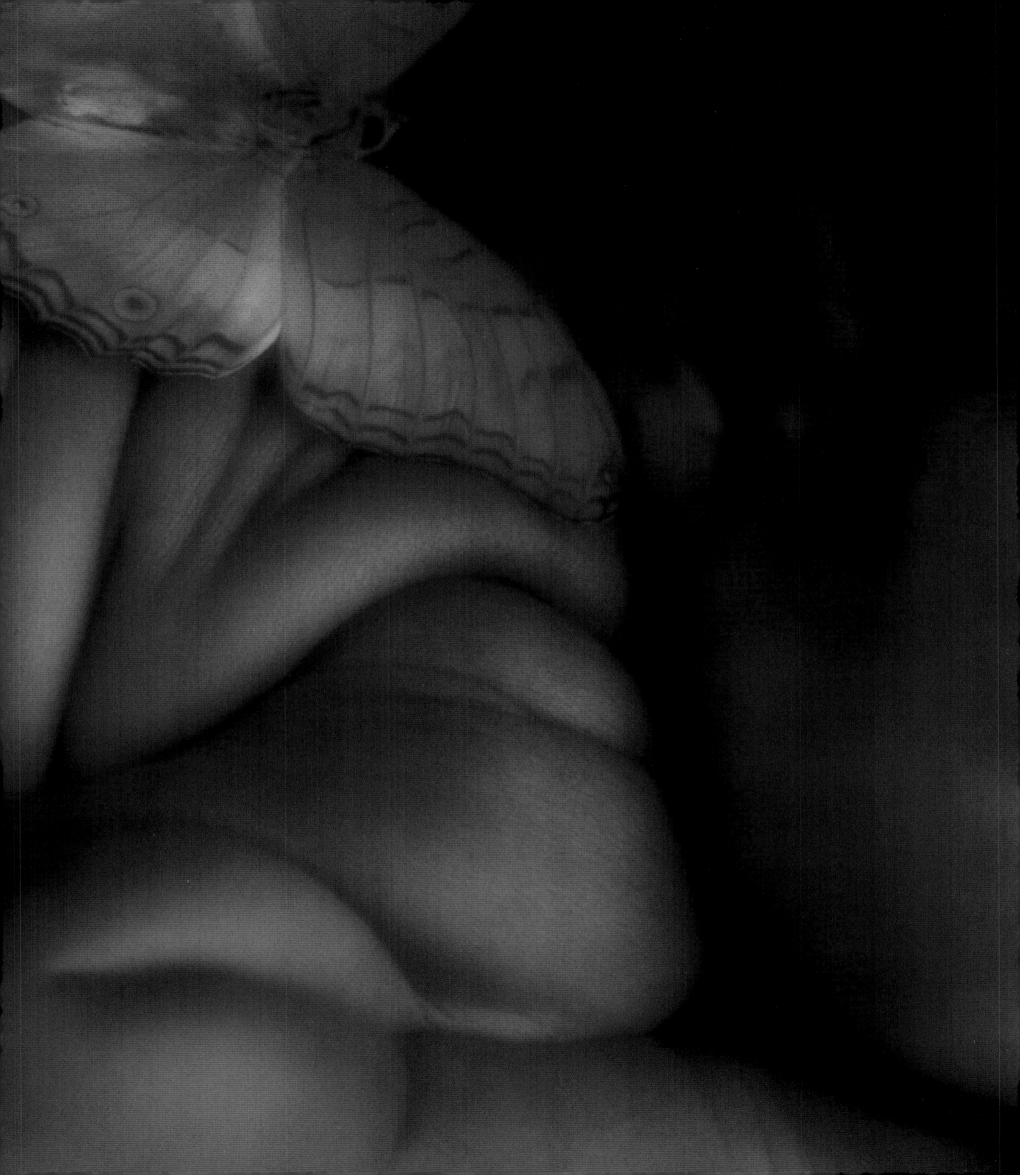

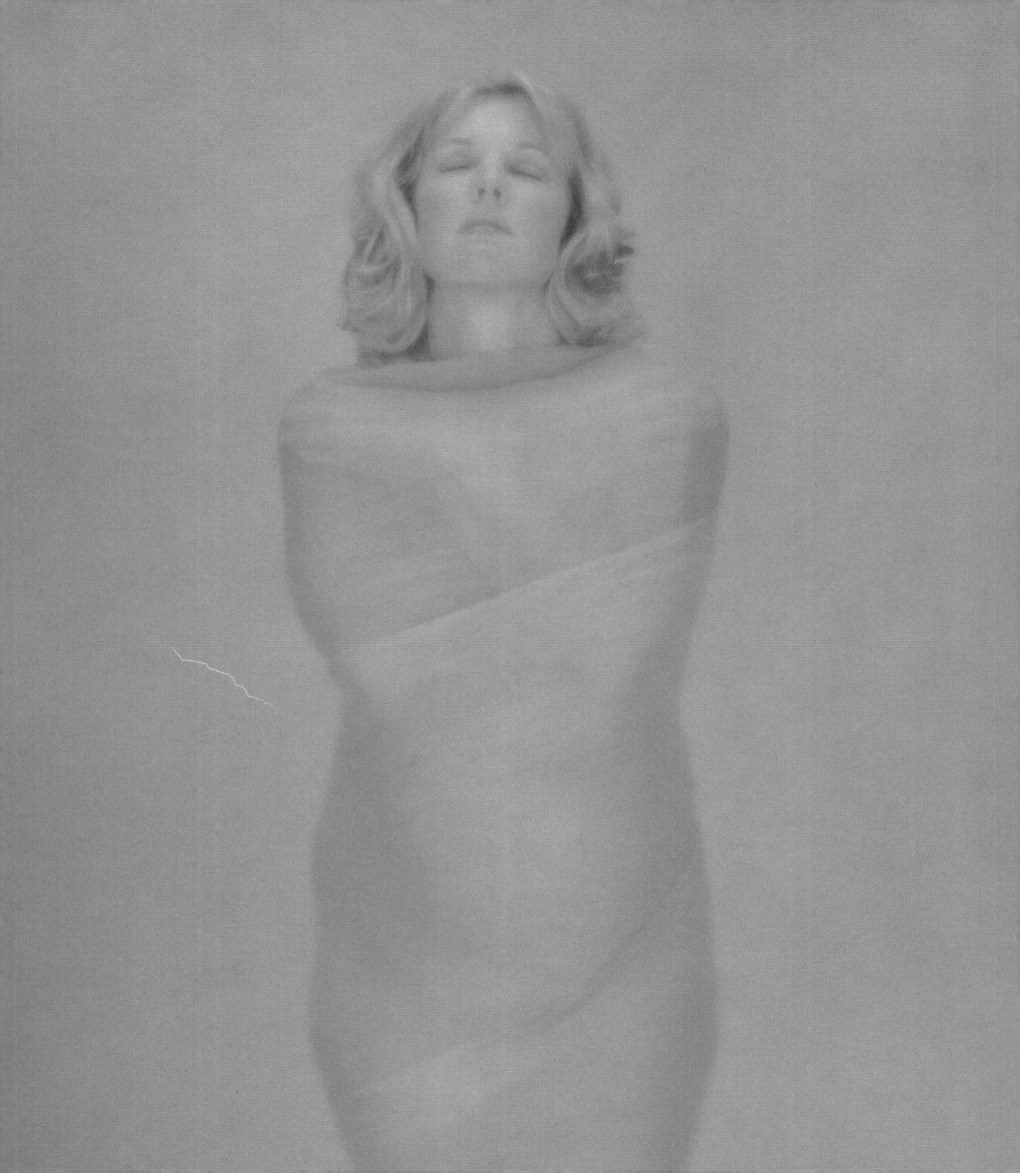

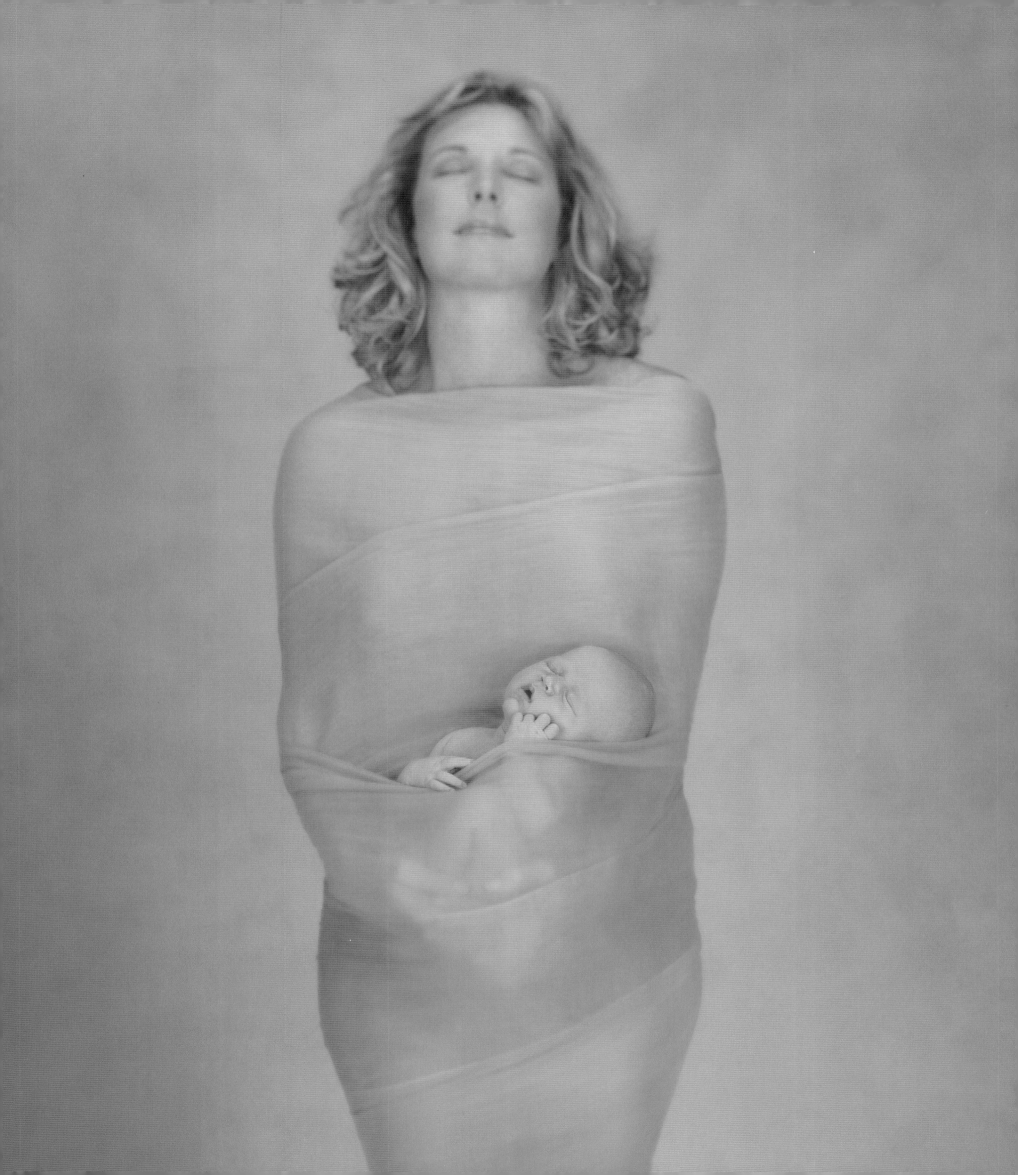

PERFECT

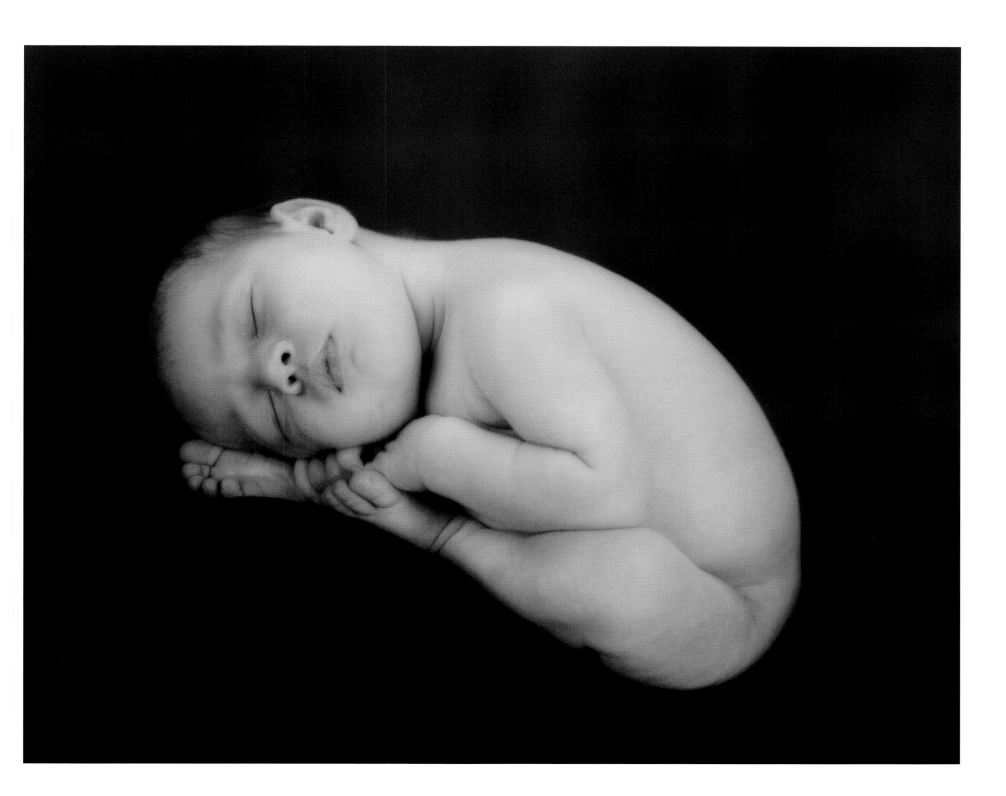

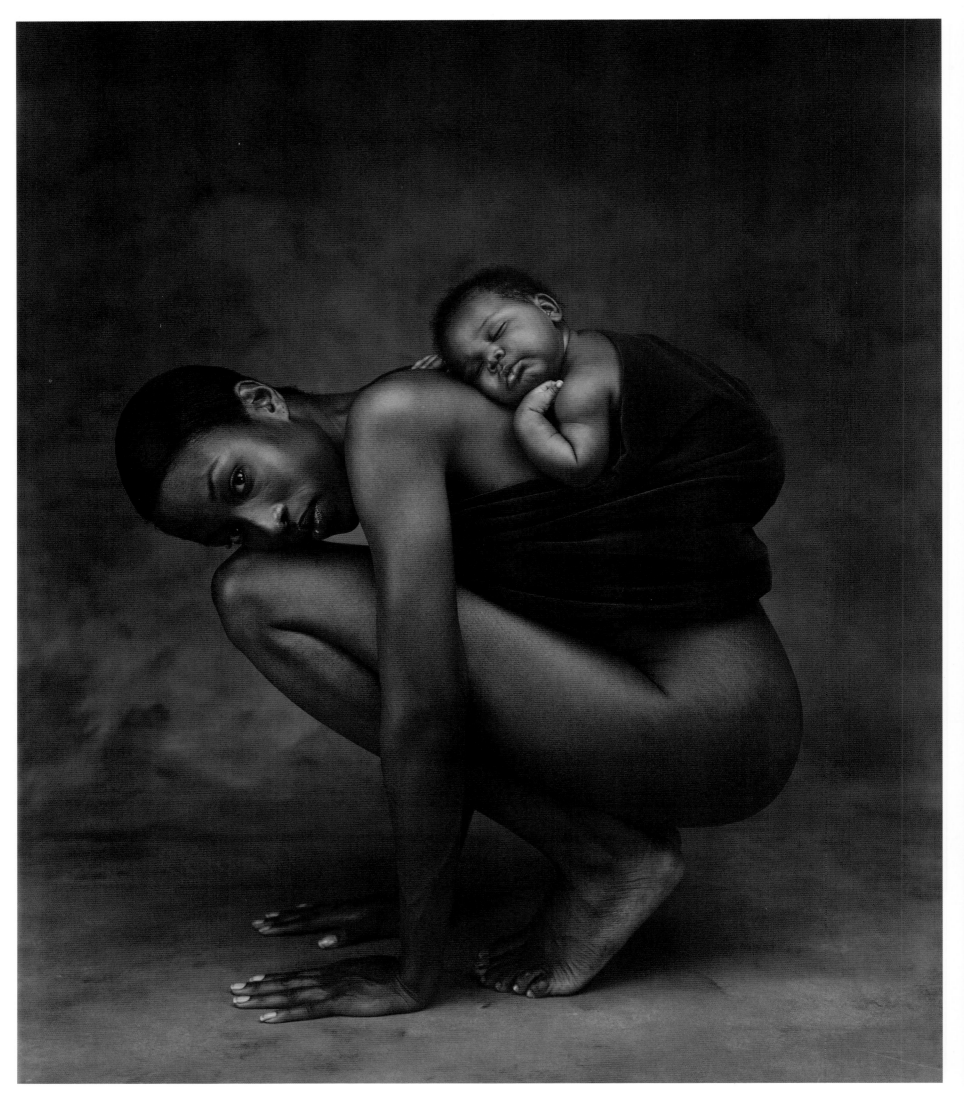

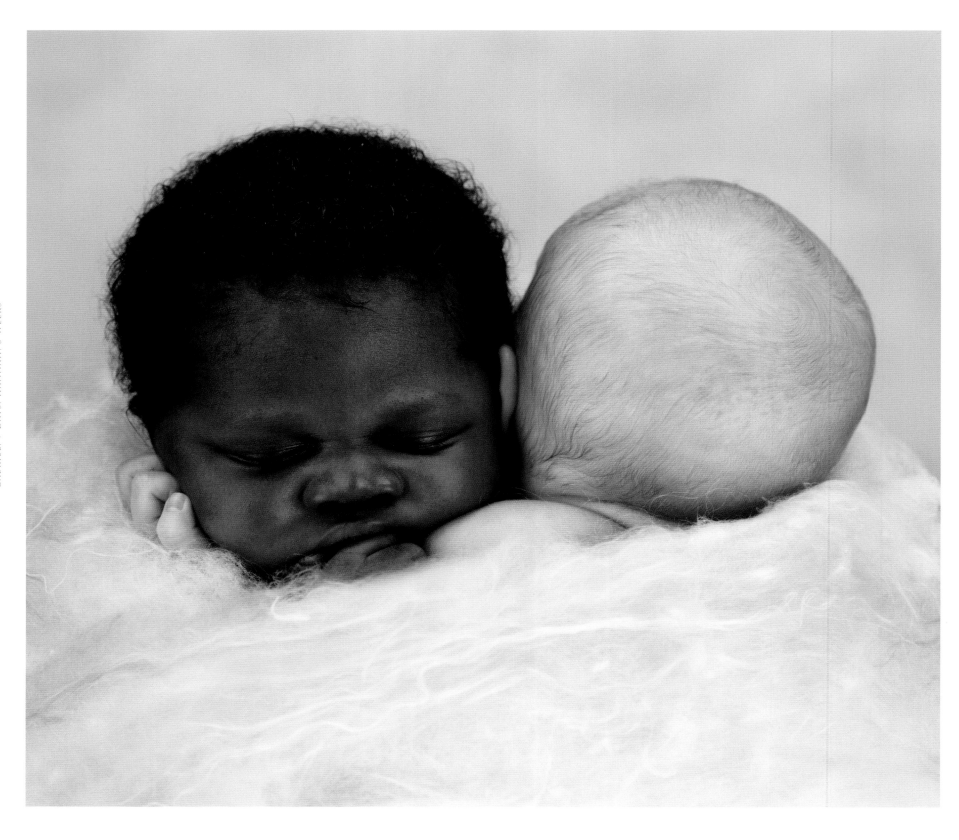

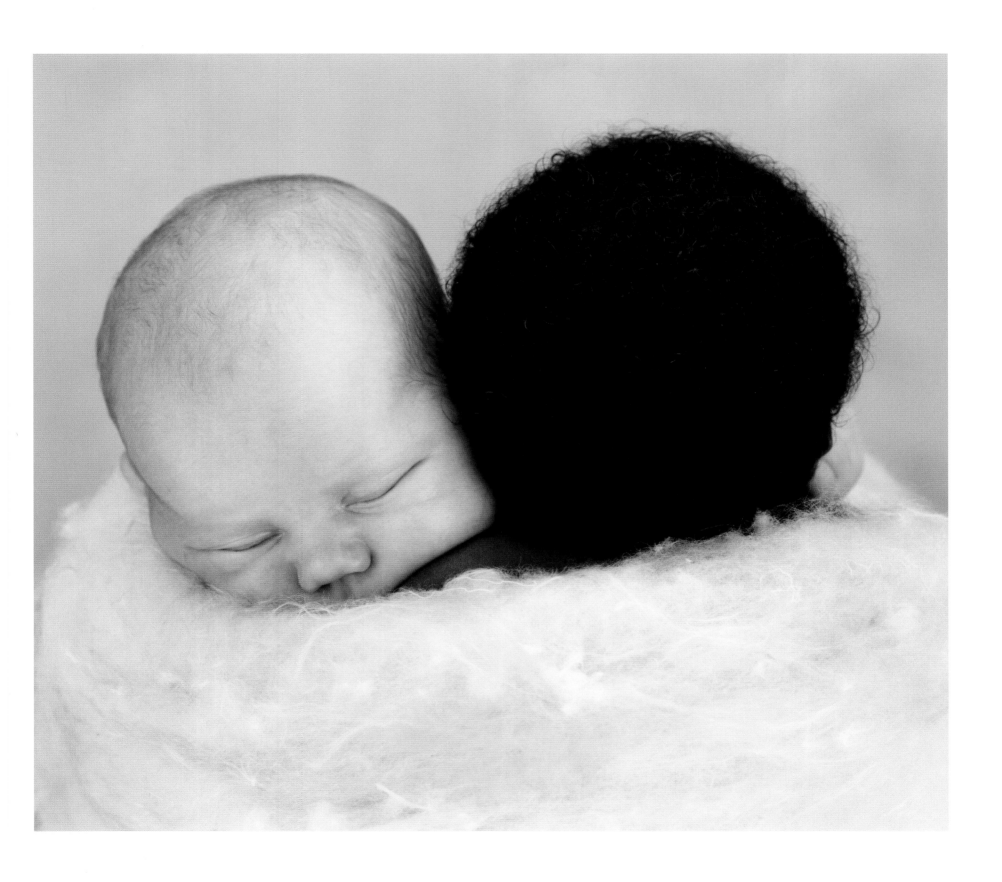

SOFT

BELOVED

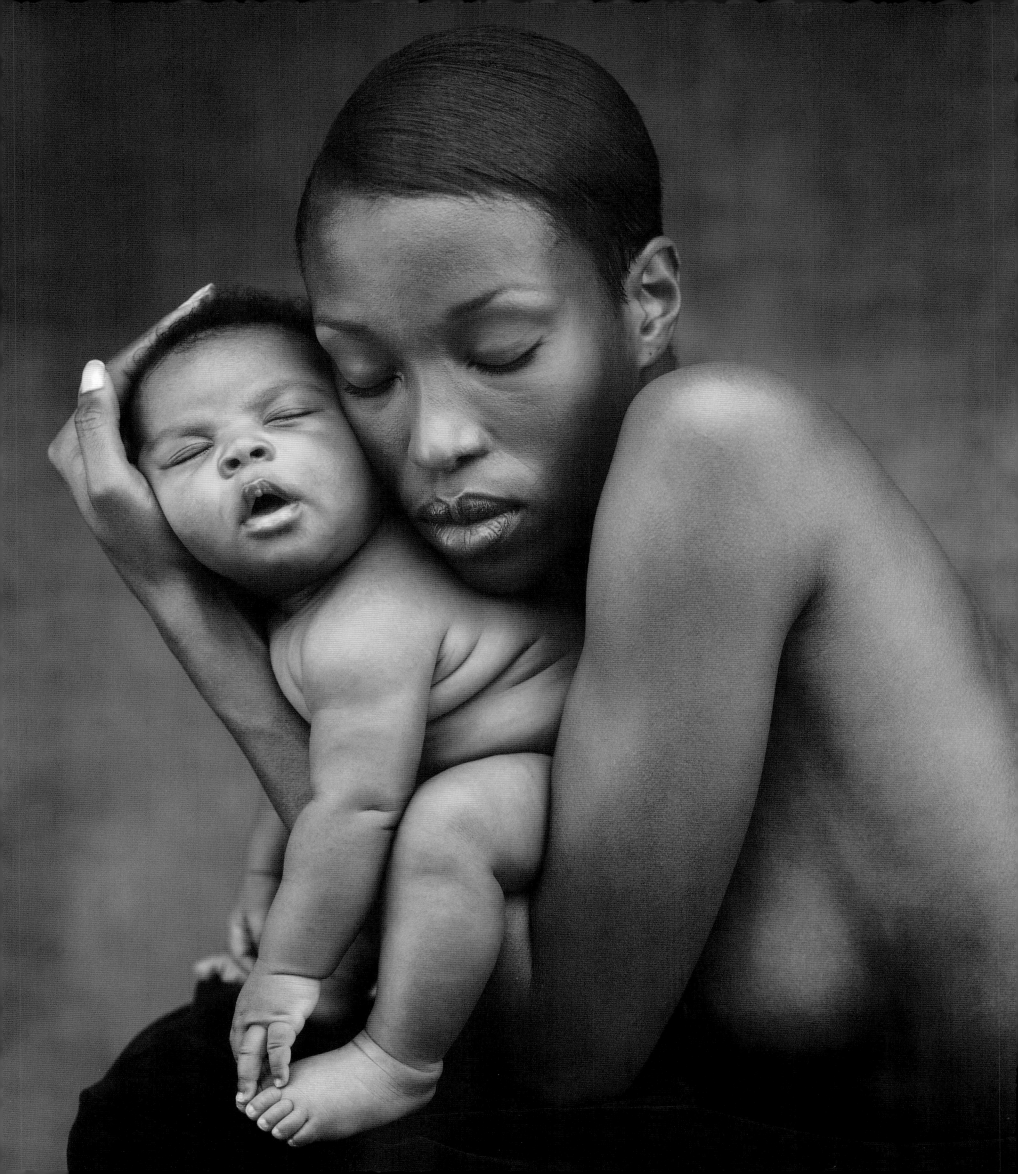

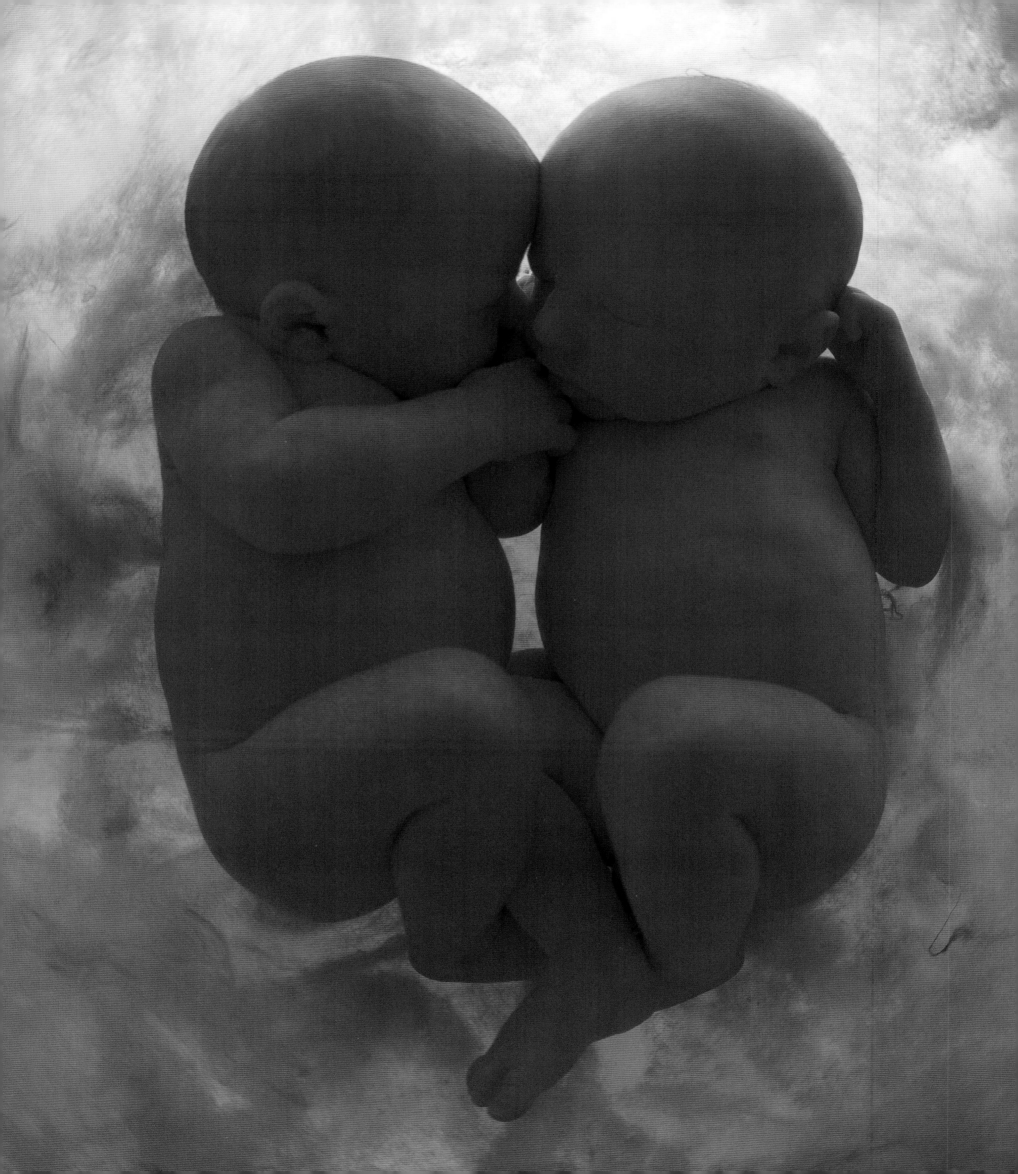

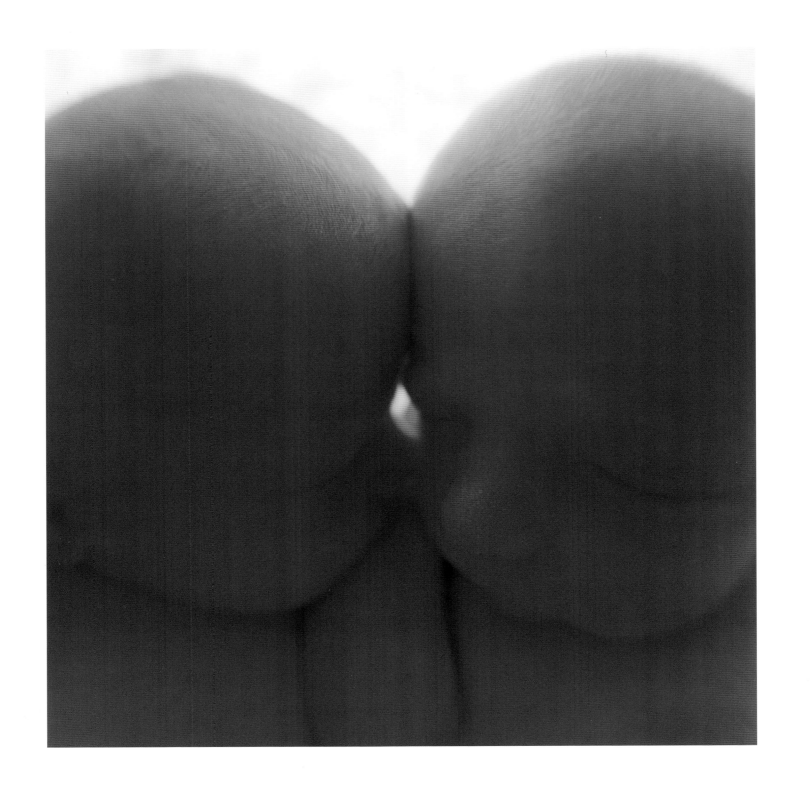

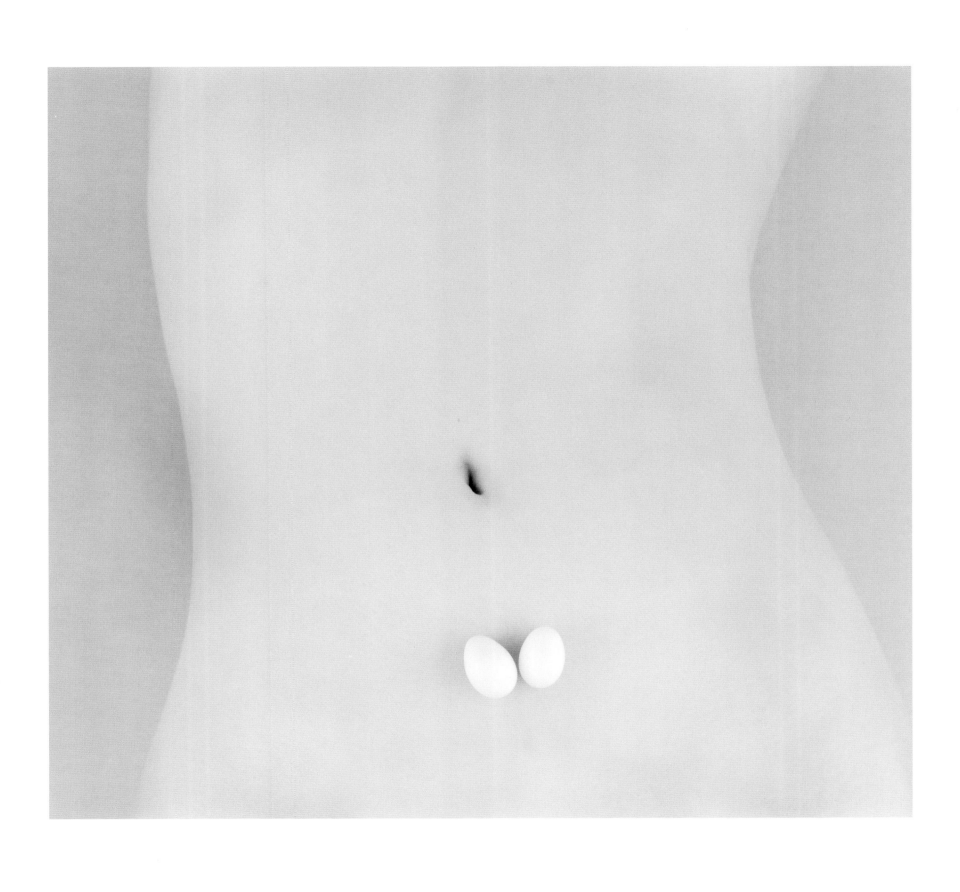

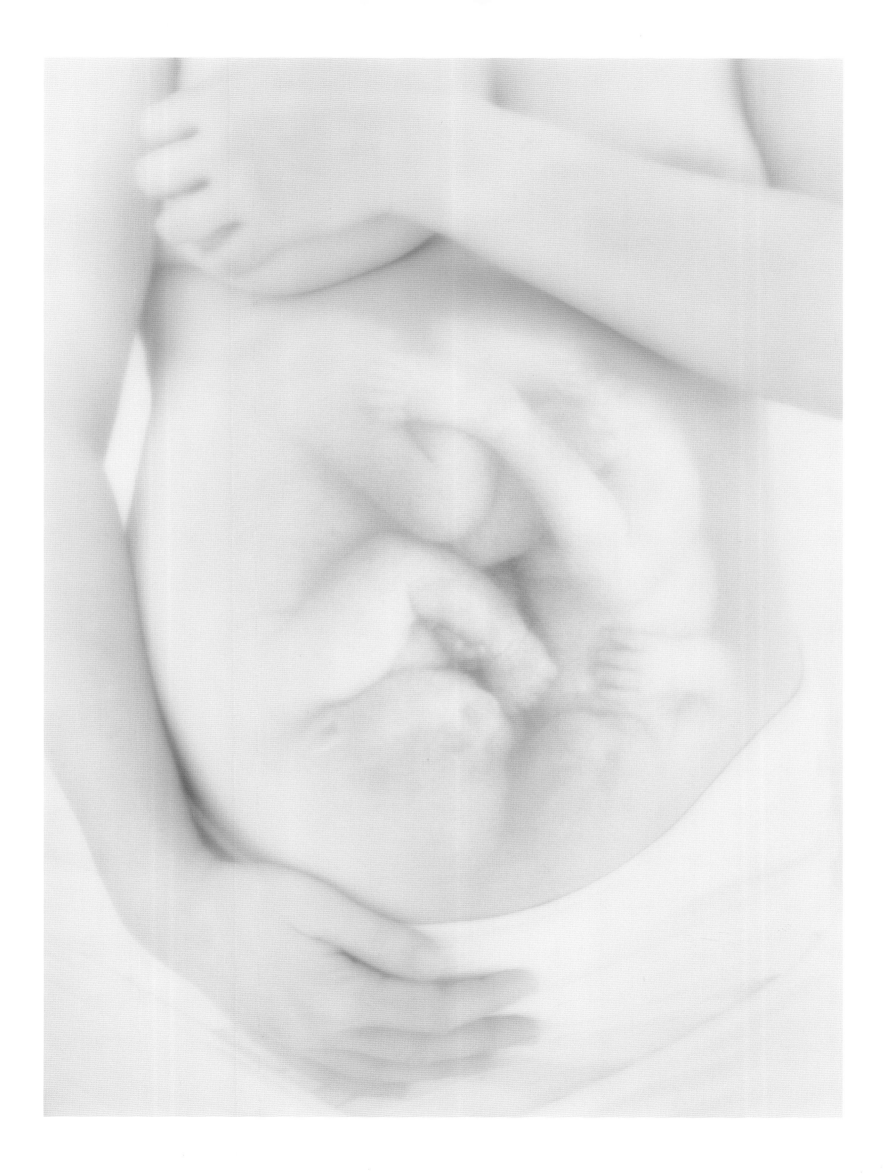

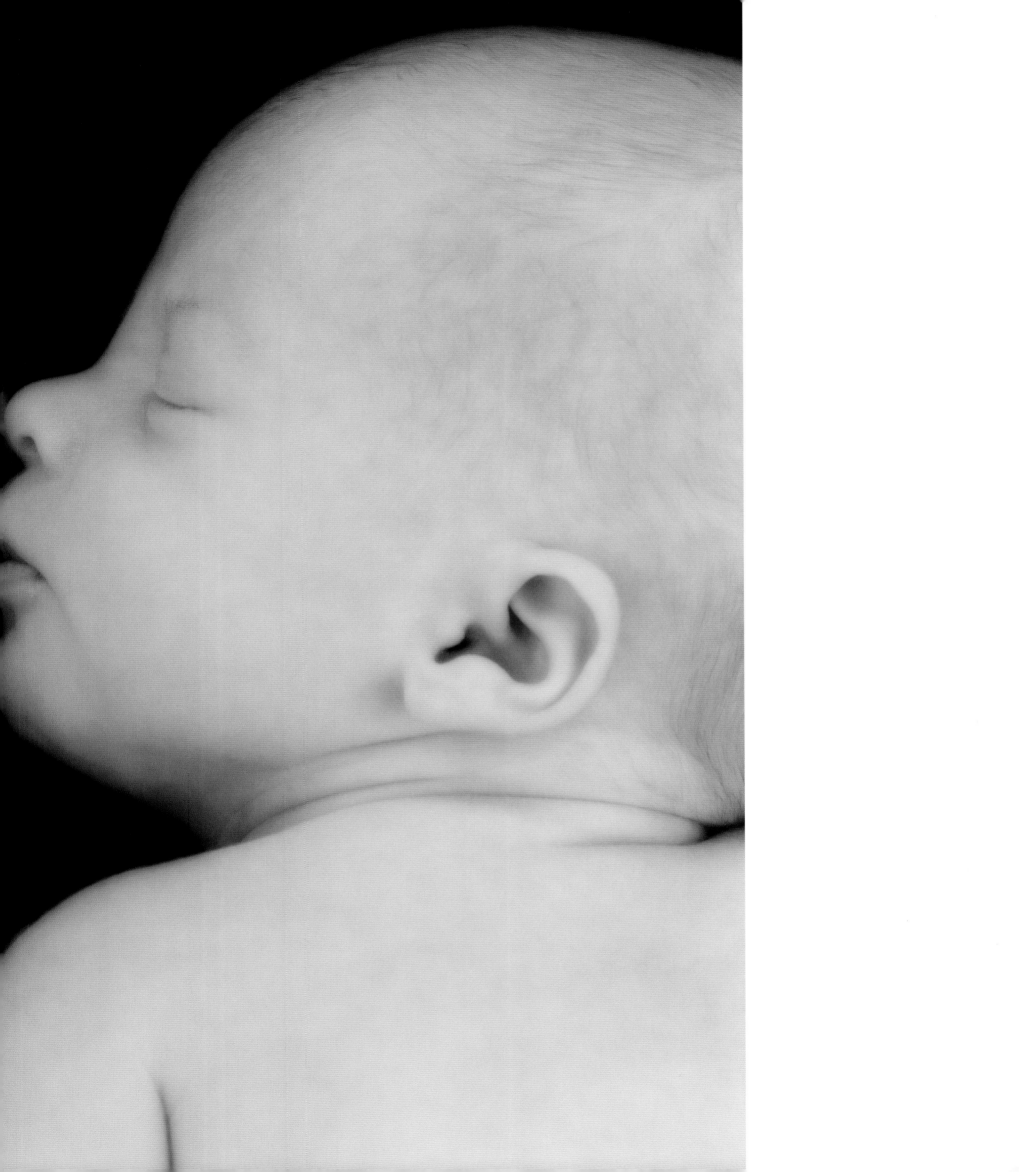

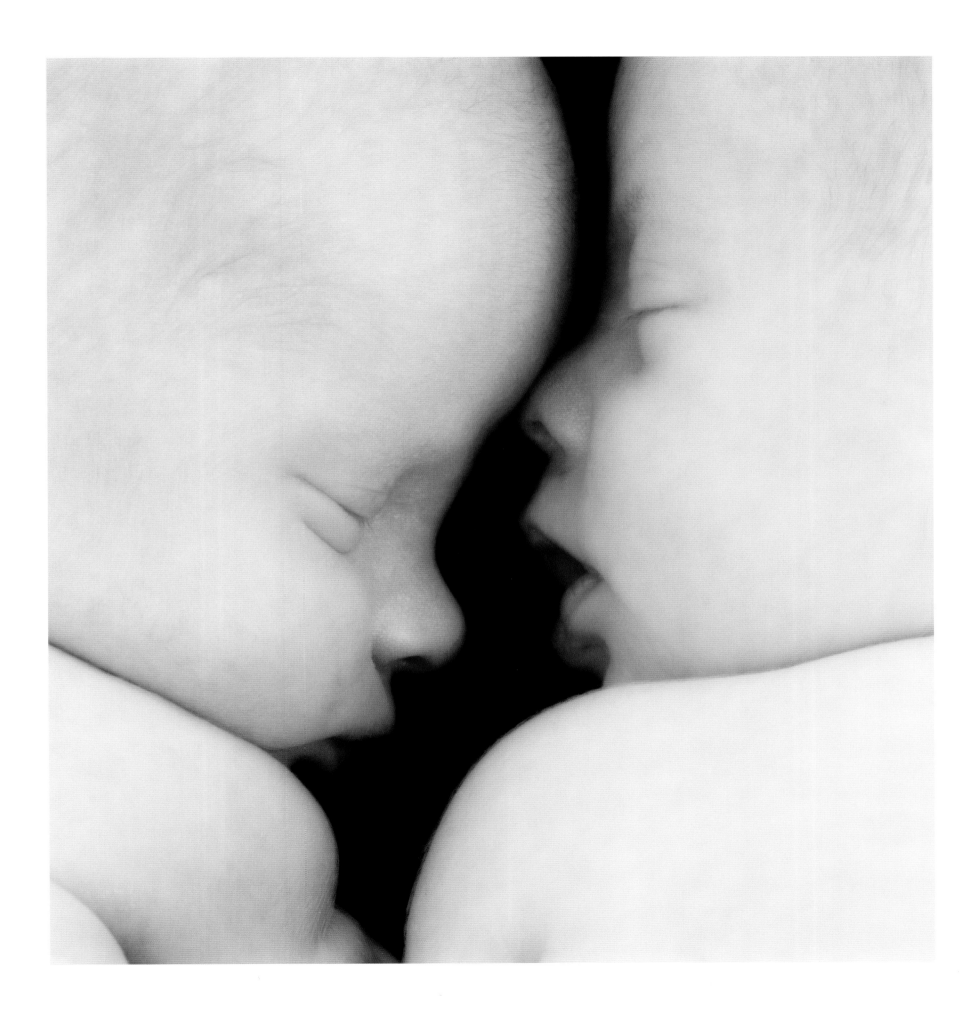

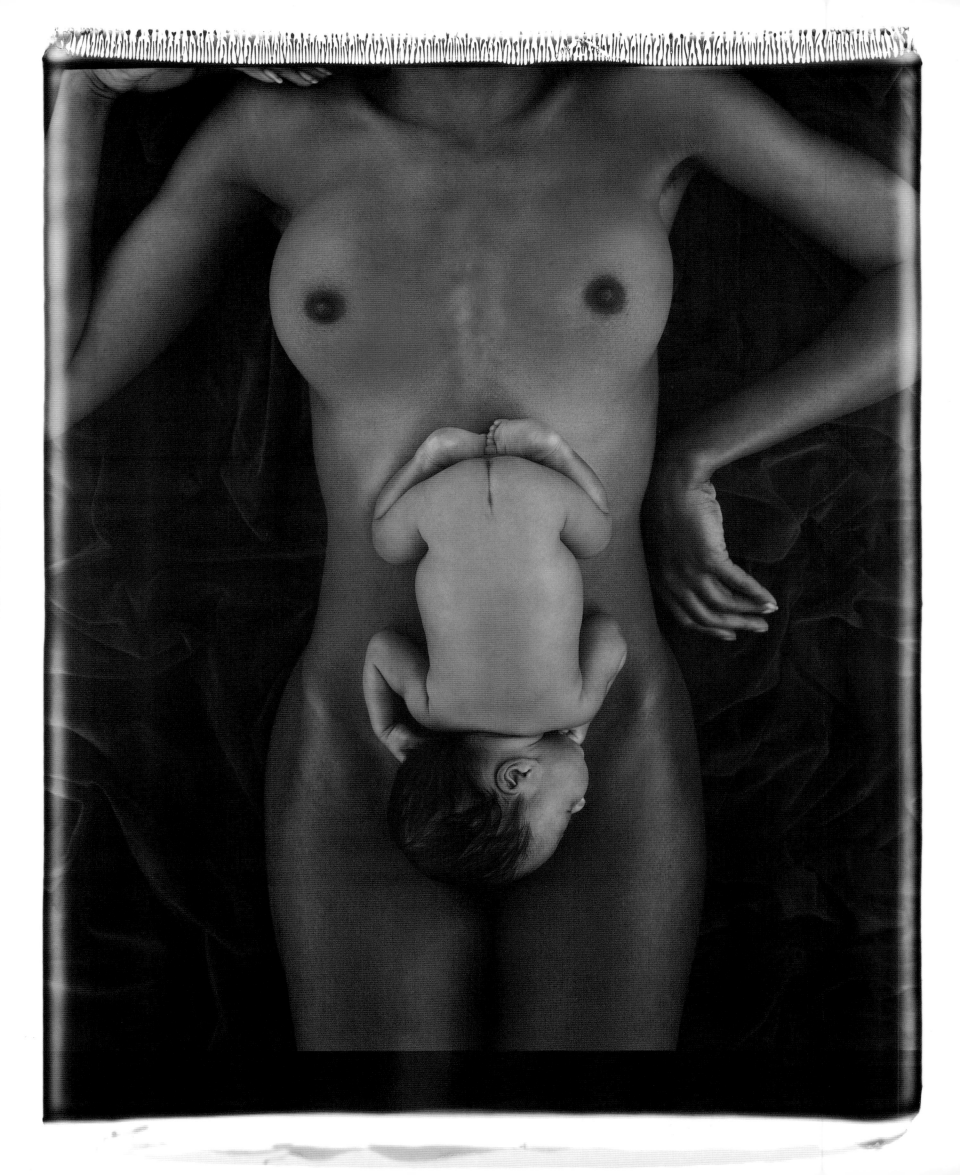

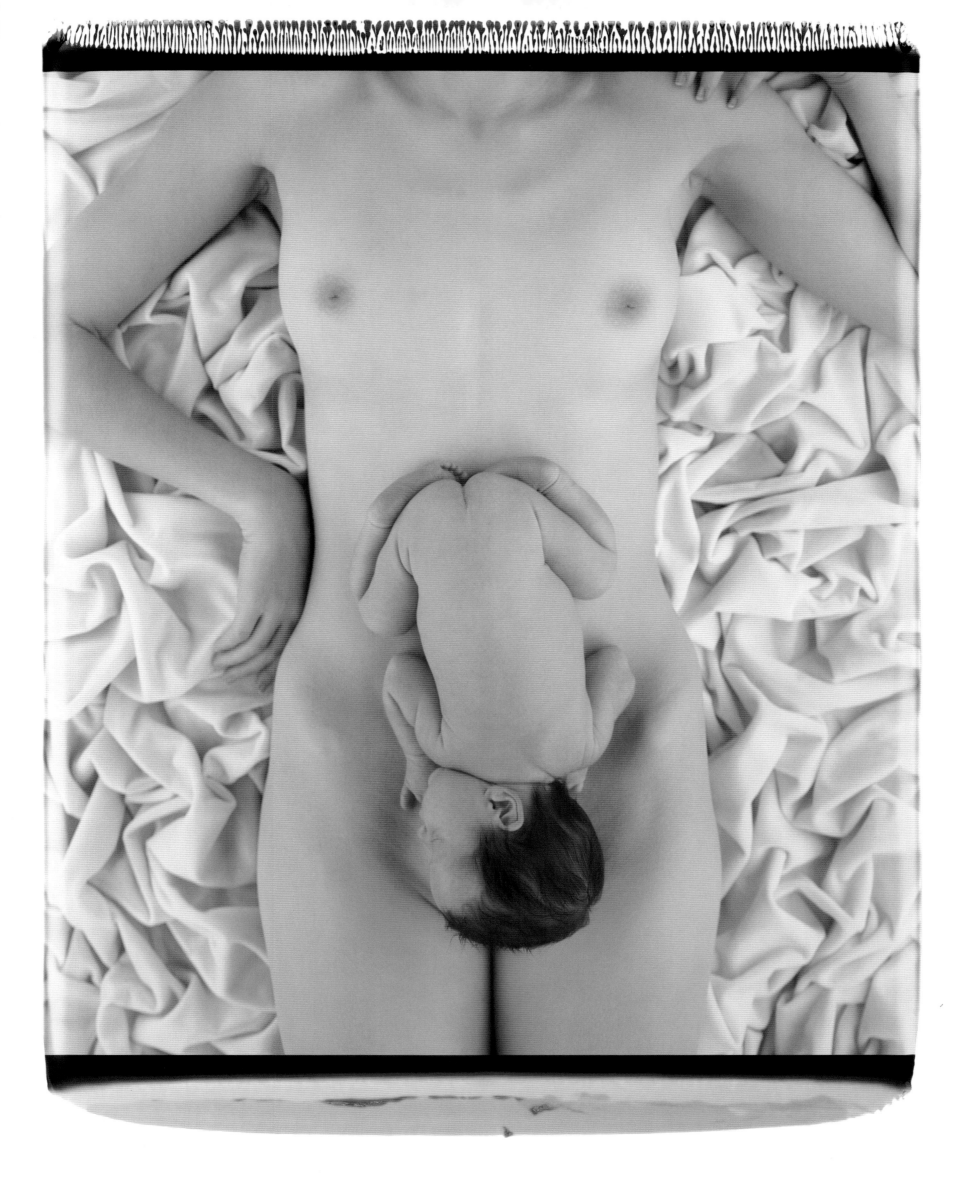

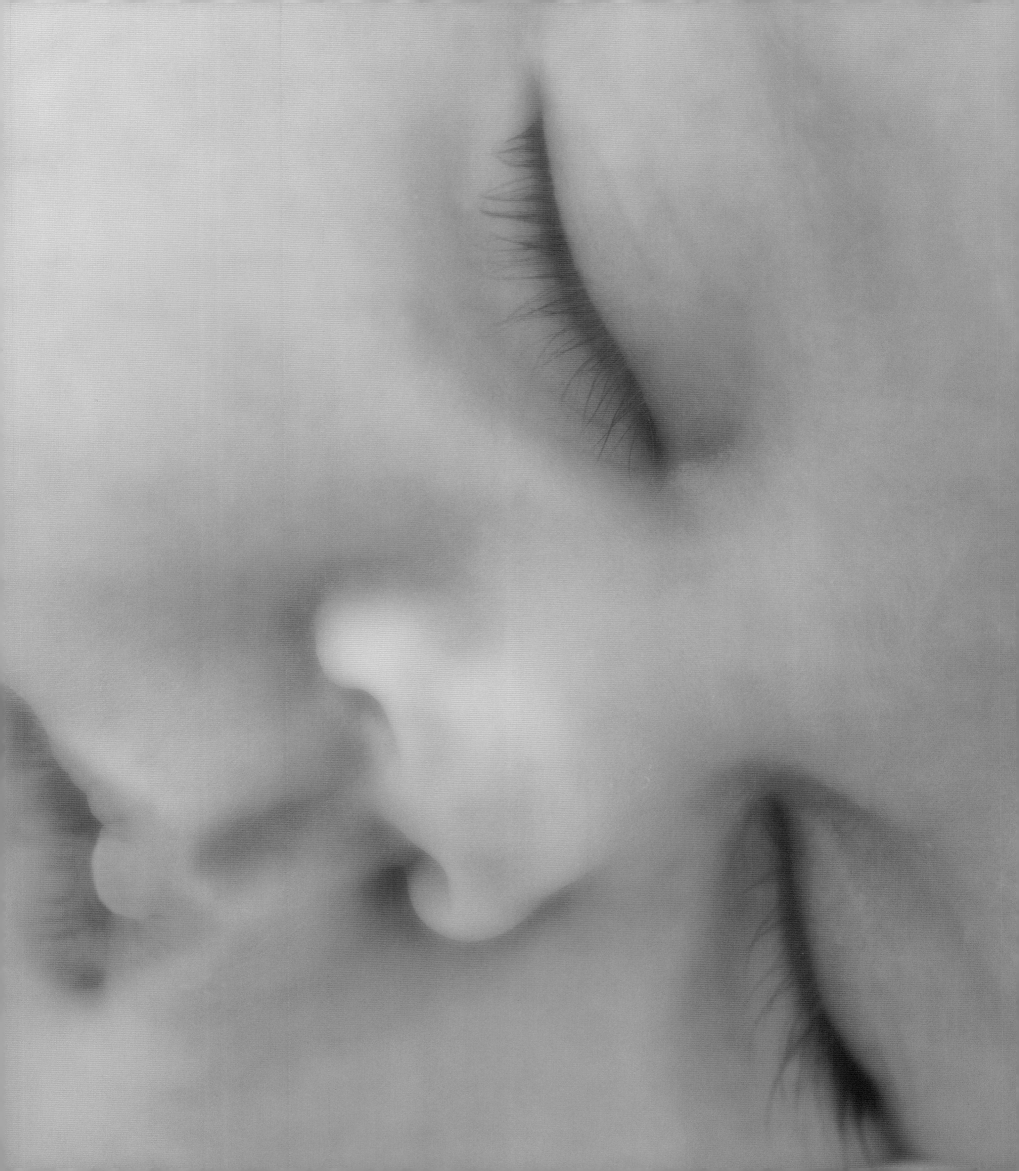

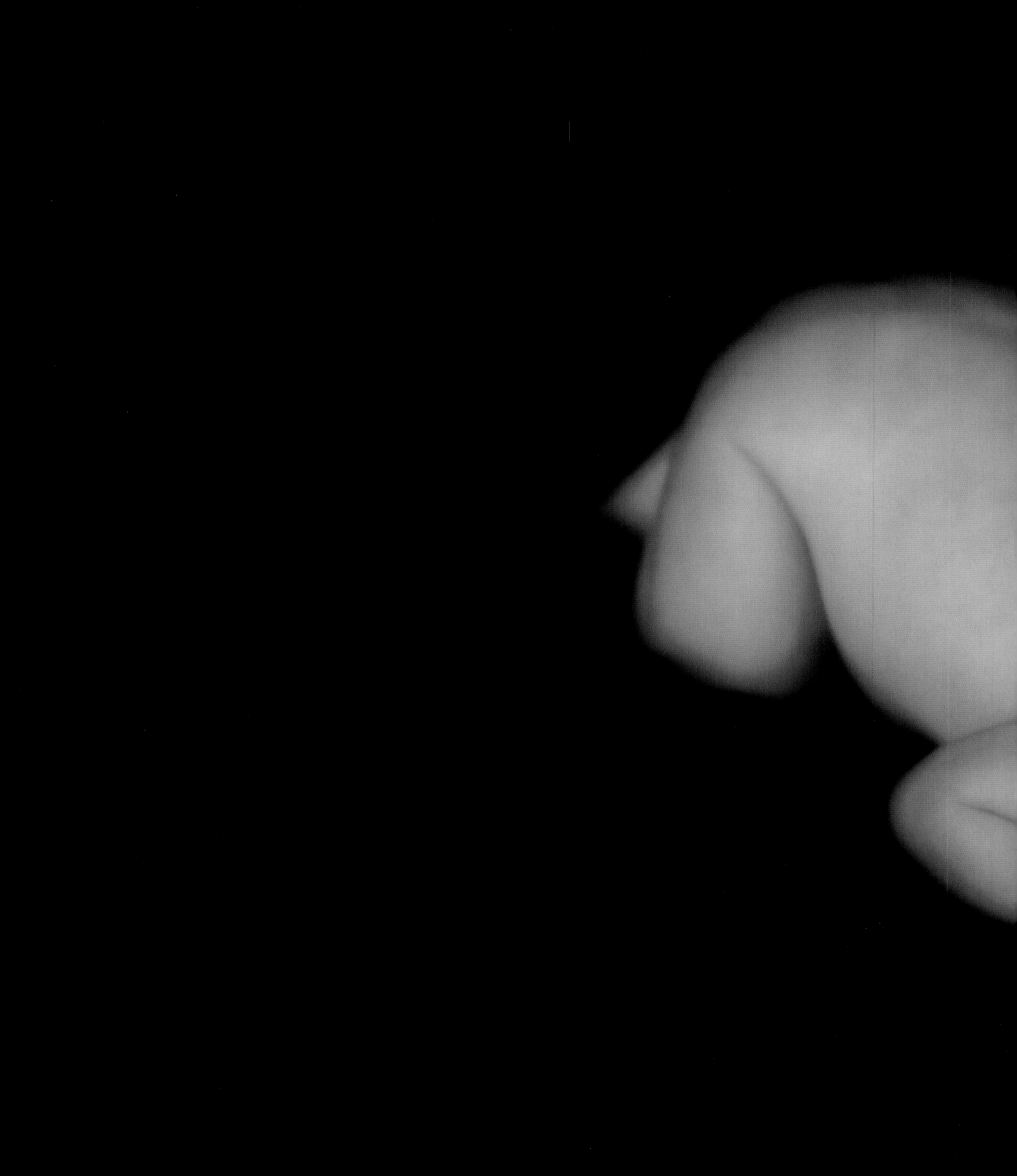

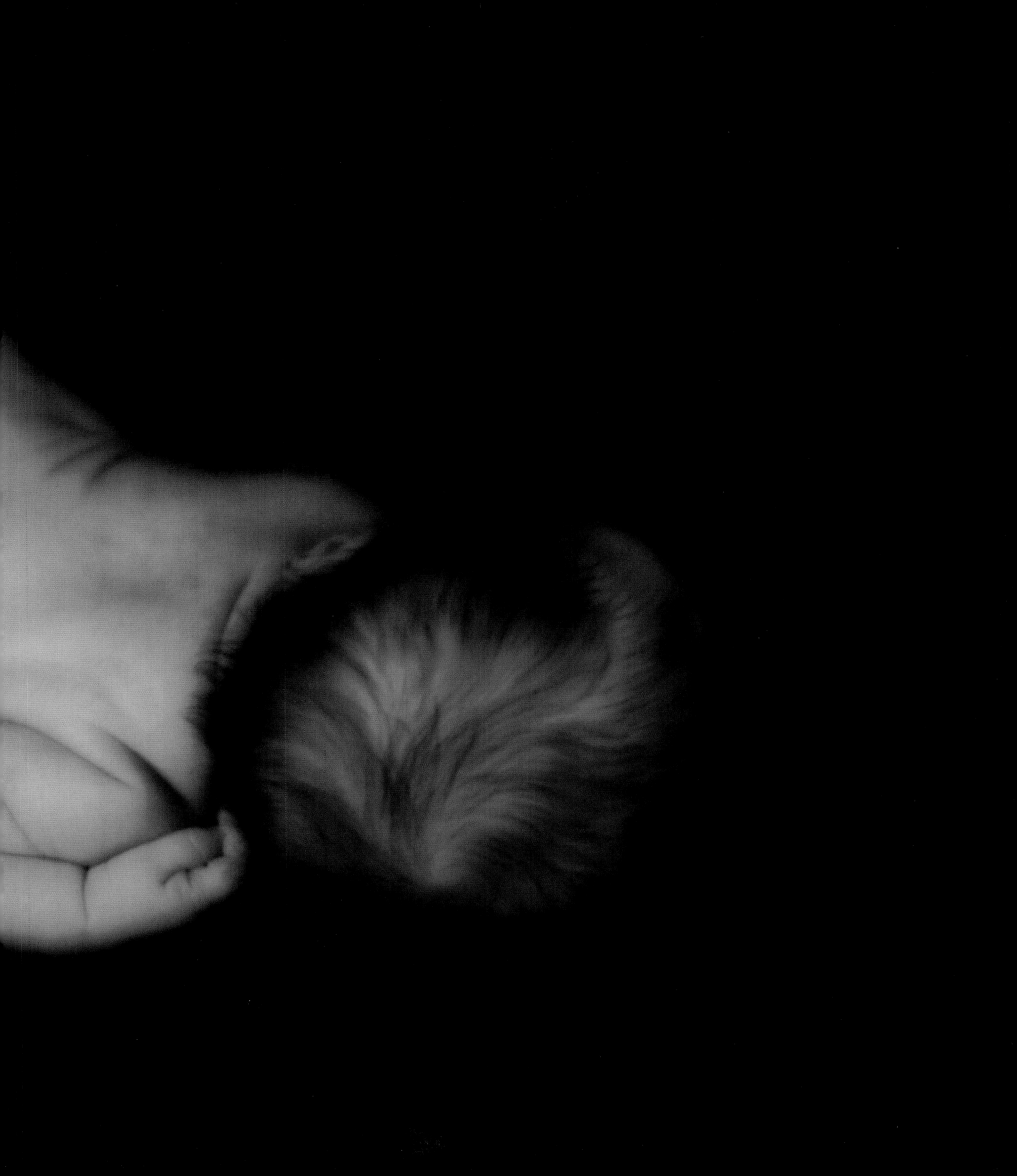

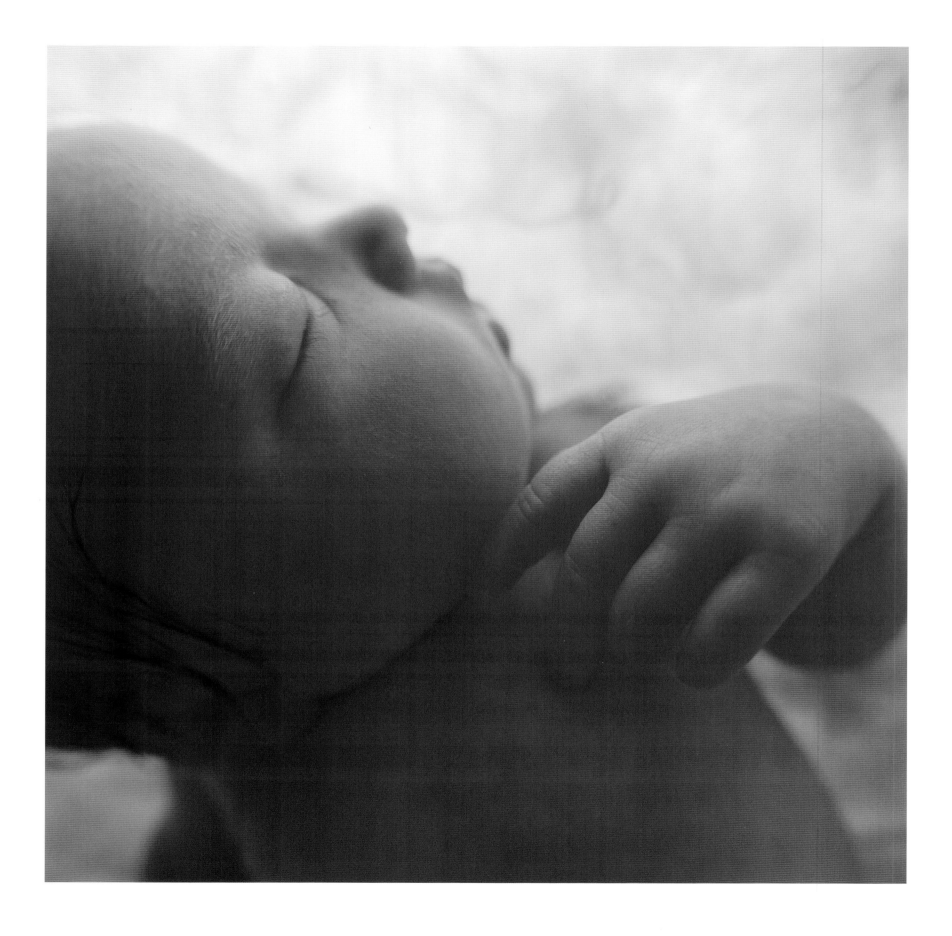

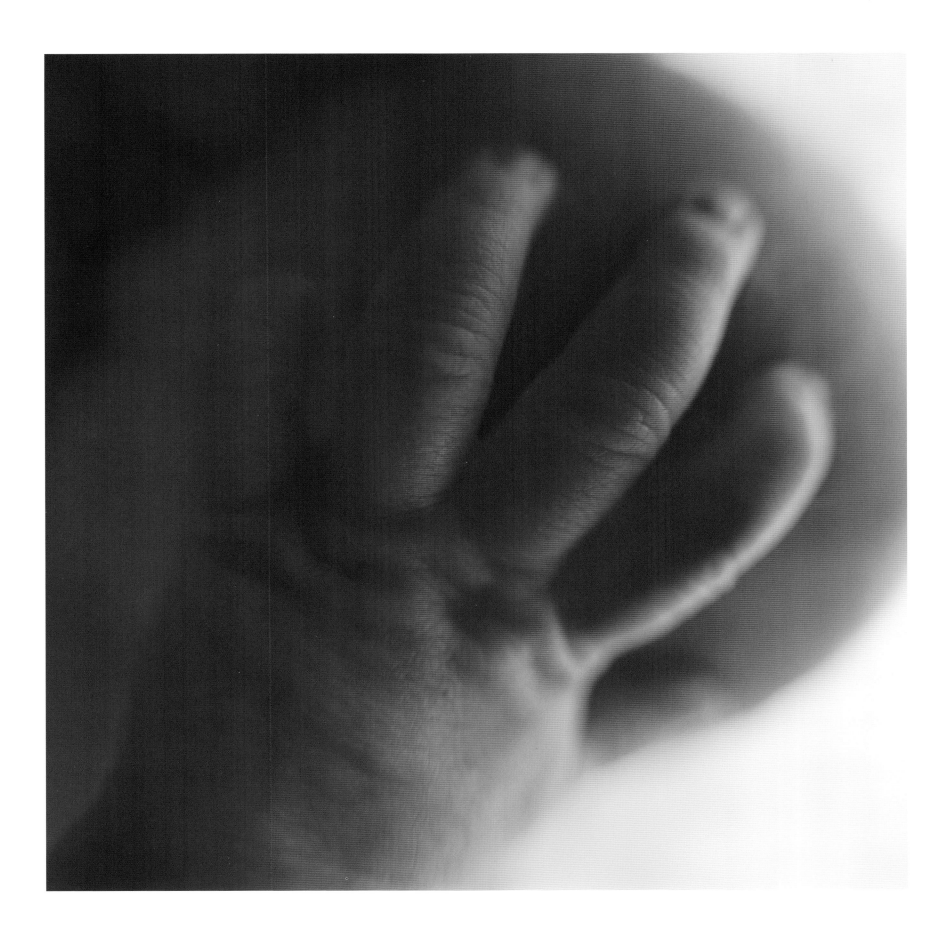

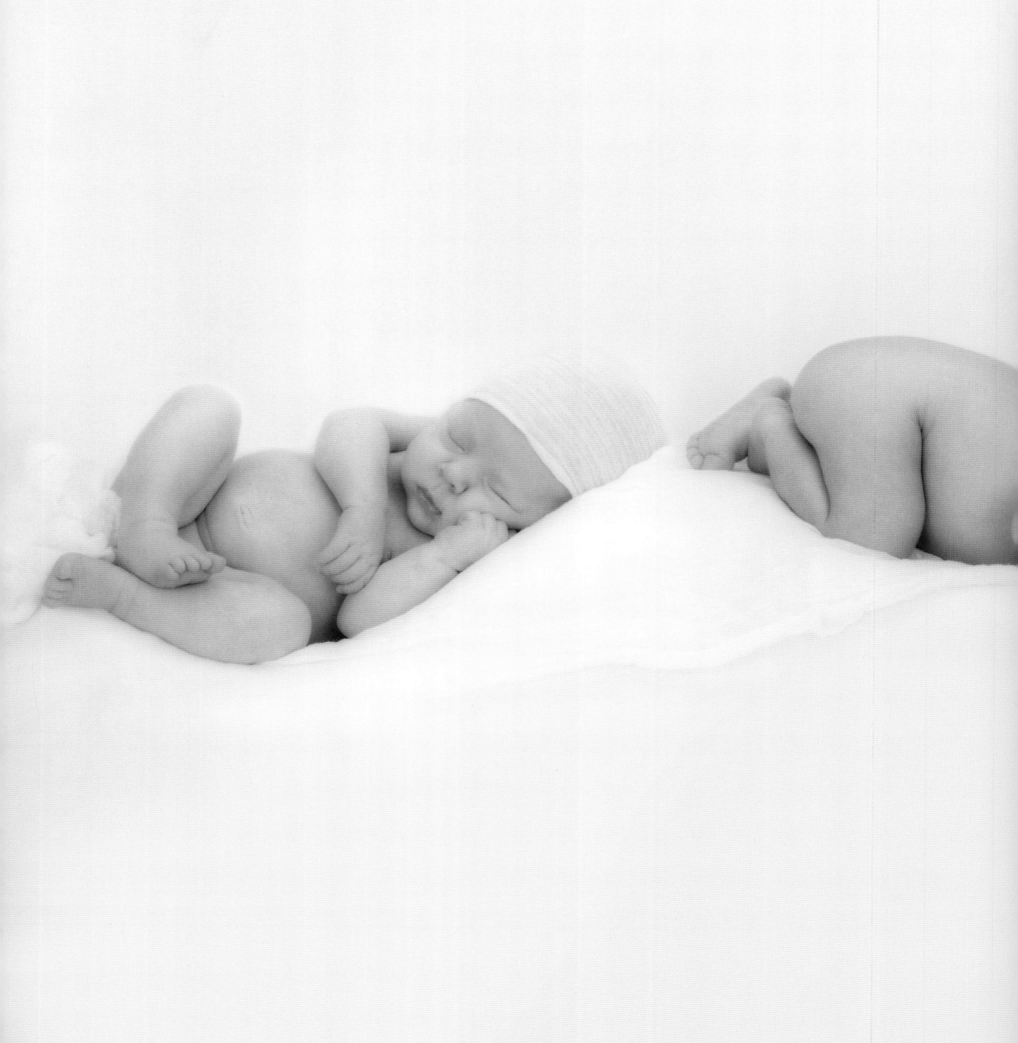

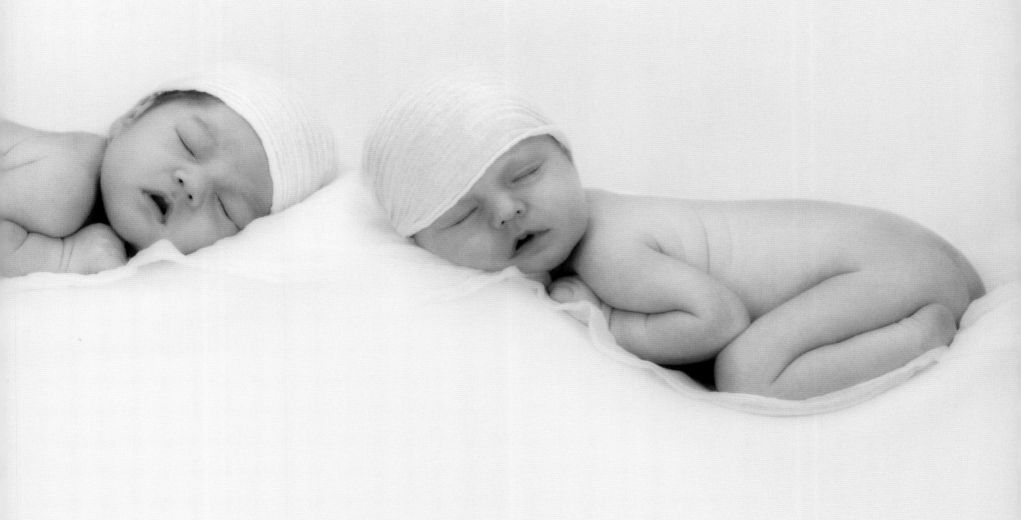

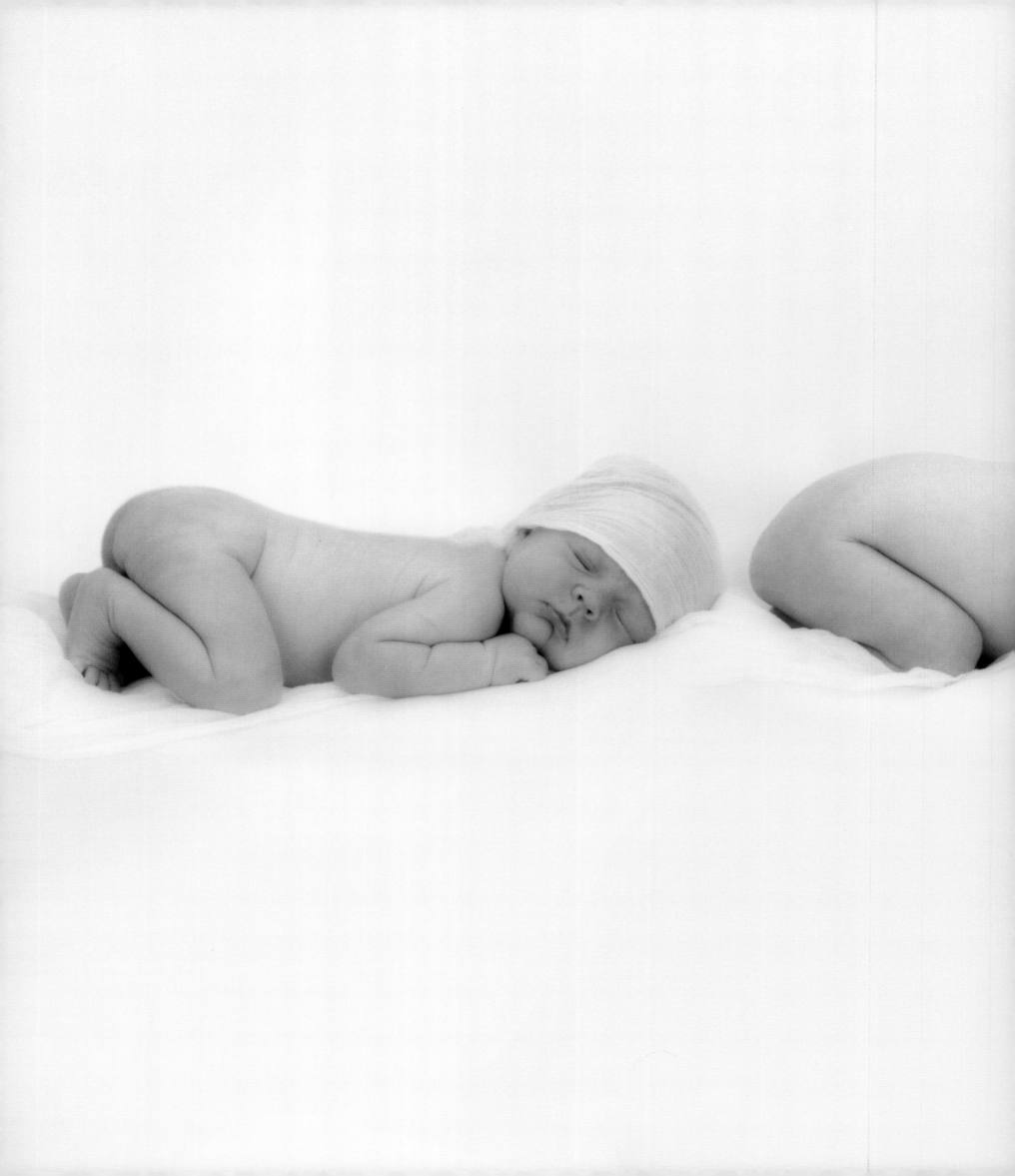

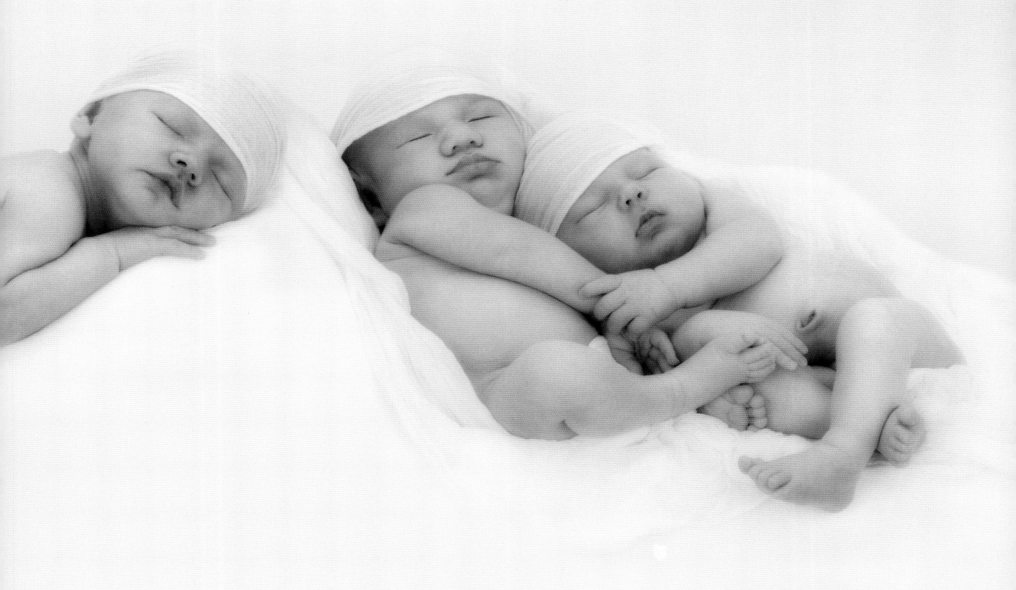

SAFE

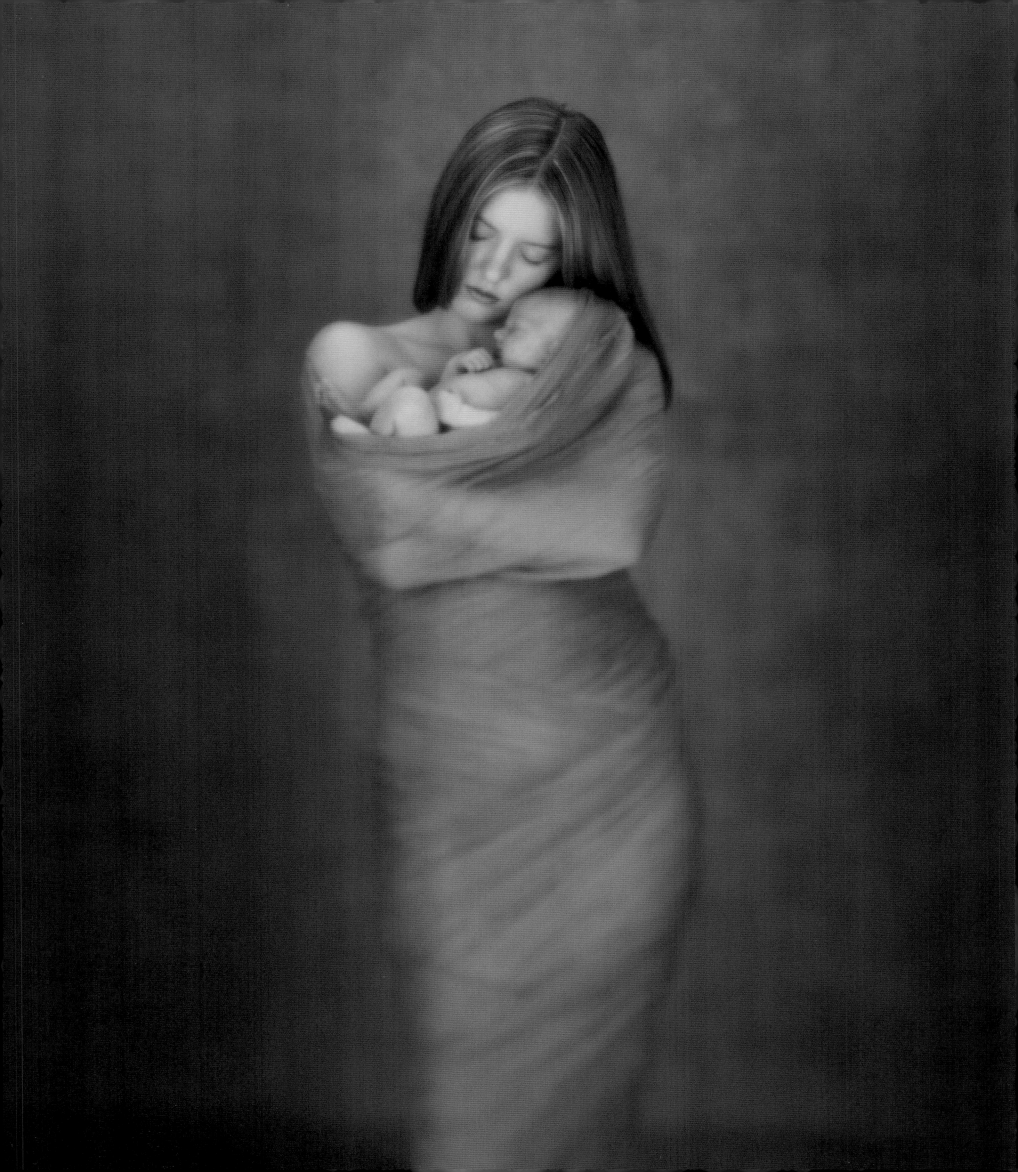

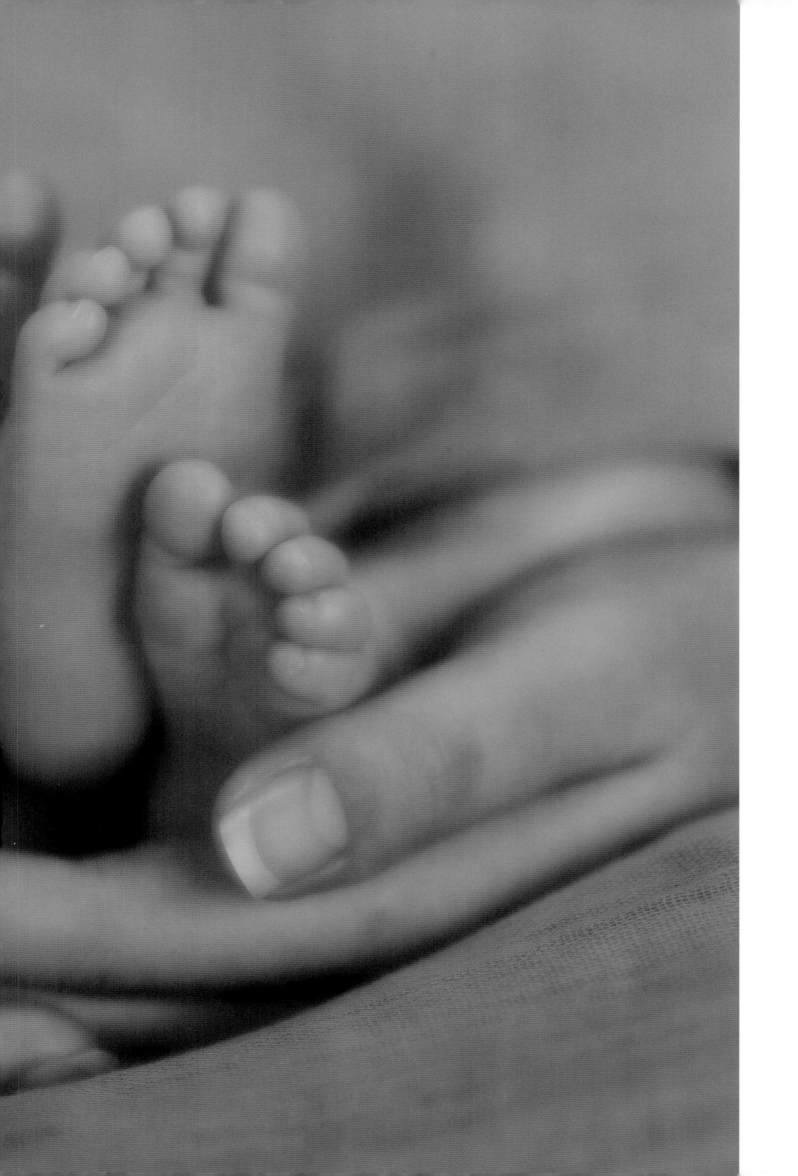

PRICELESS

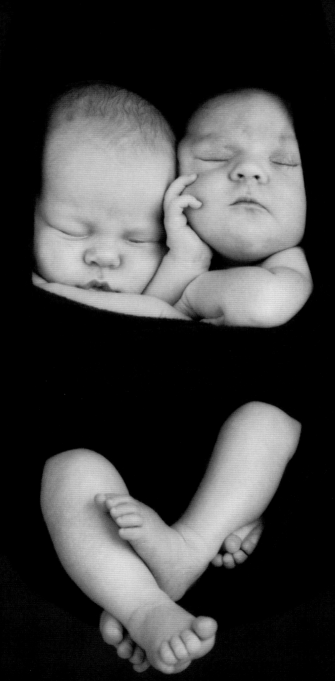

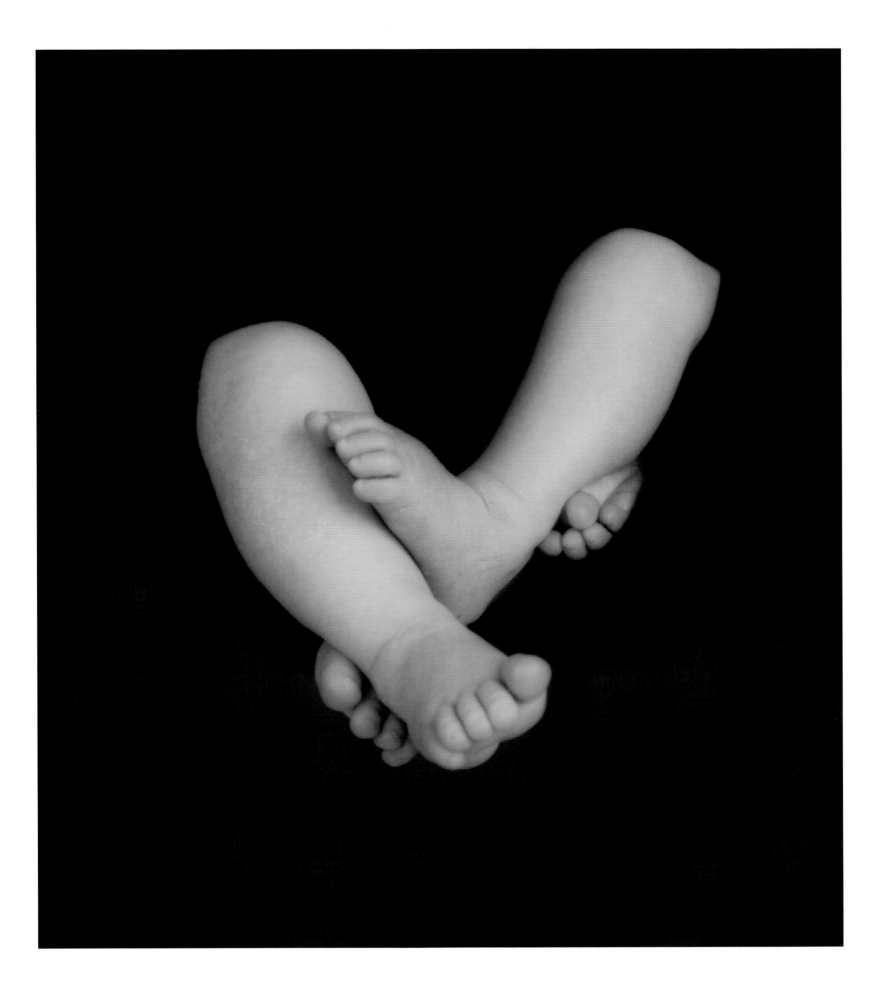

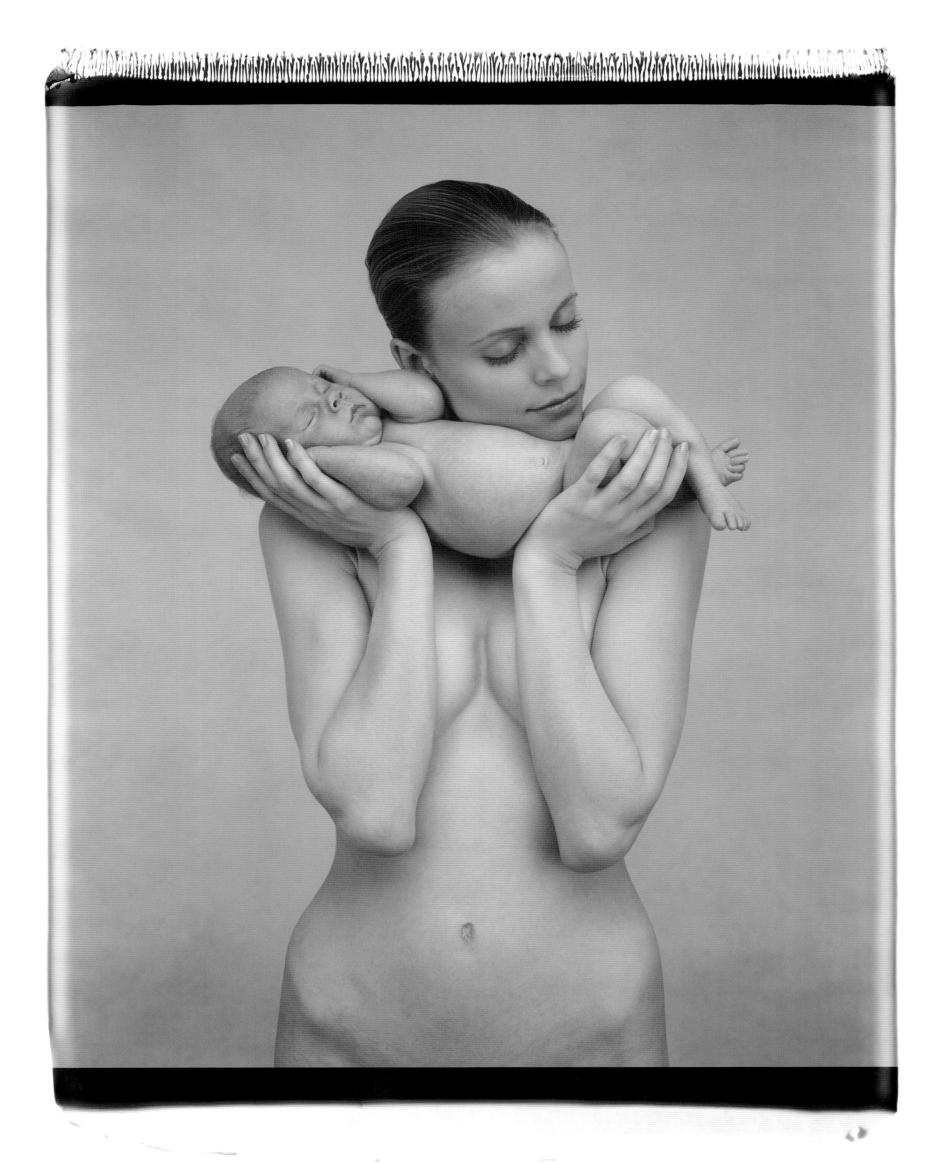

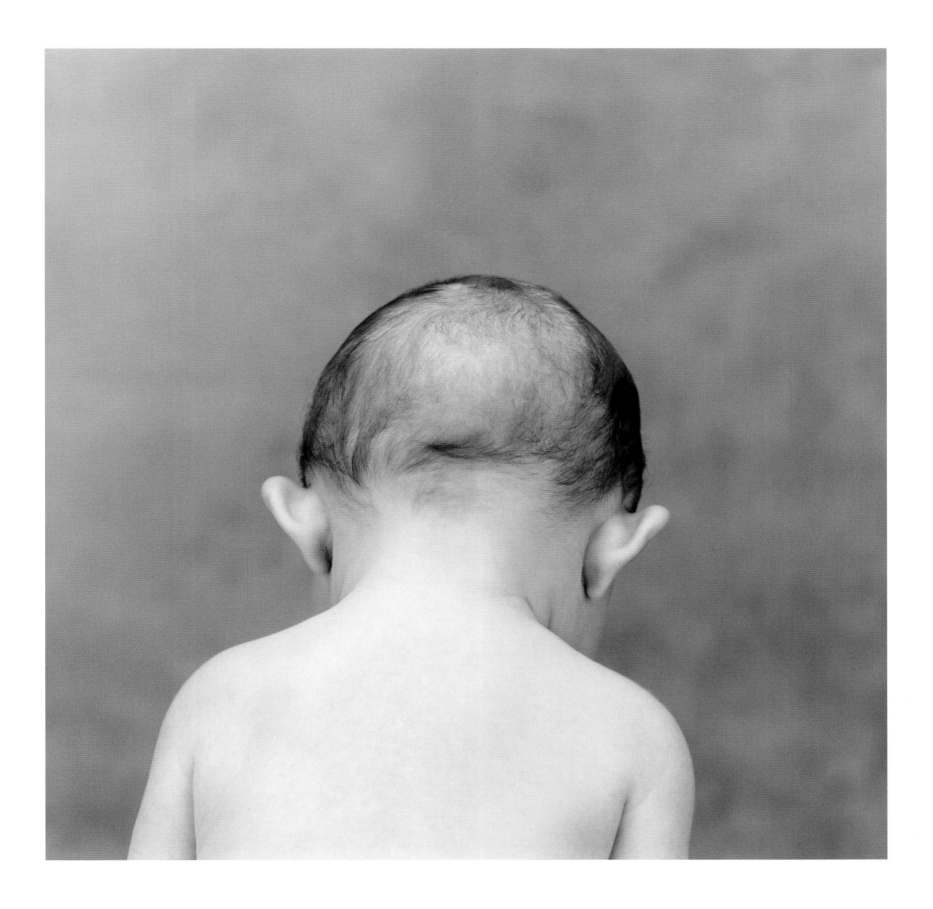

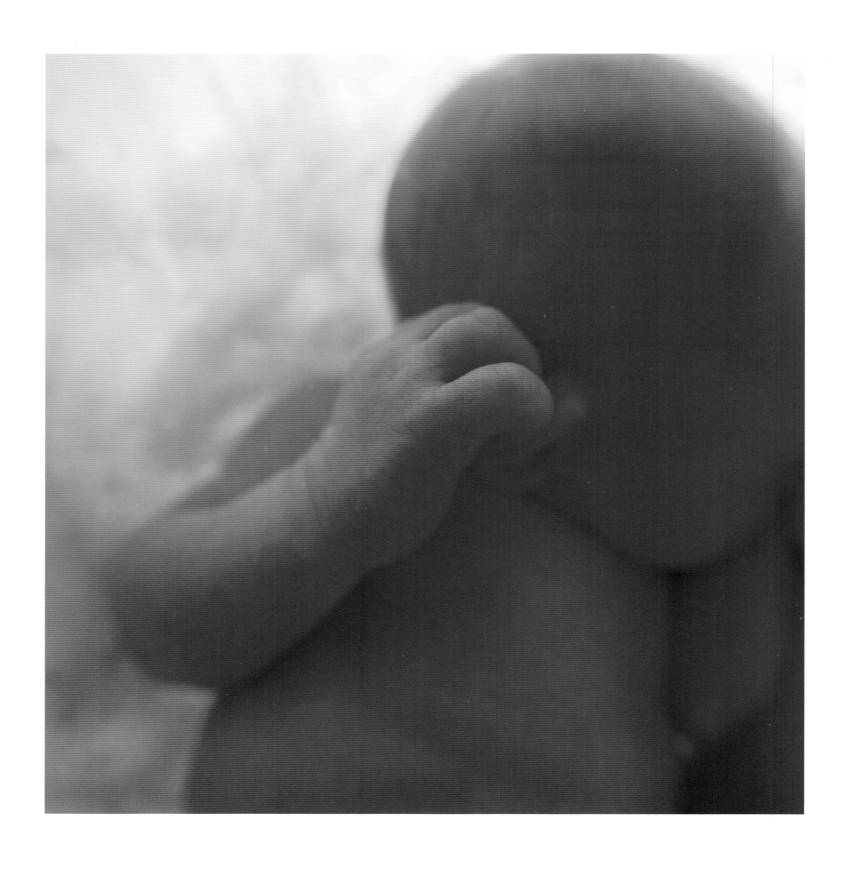

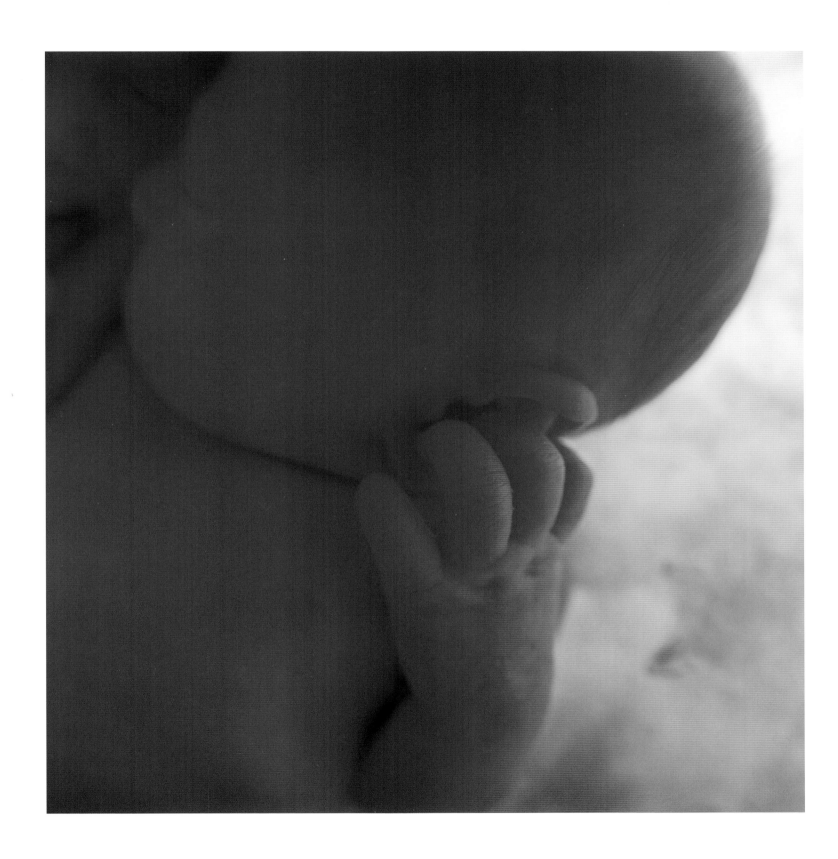

DELIGHTFUL

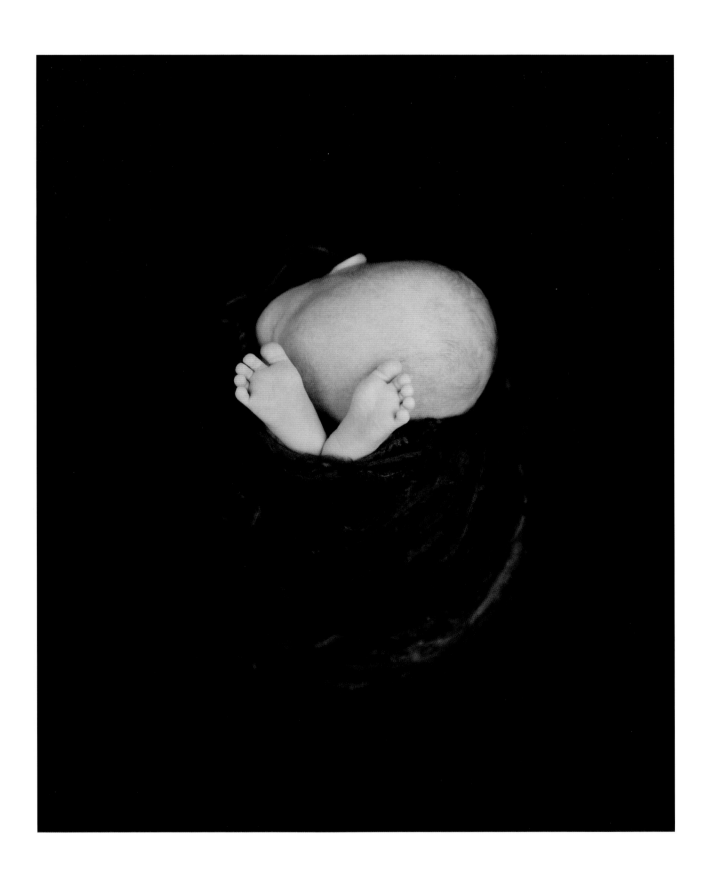

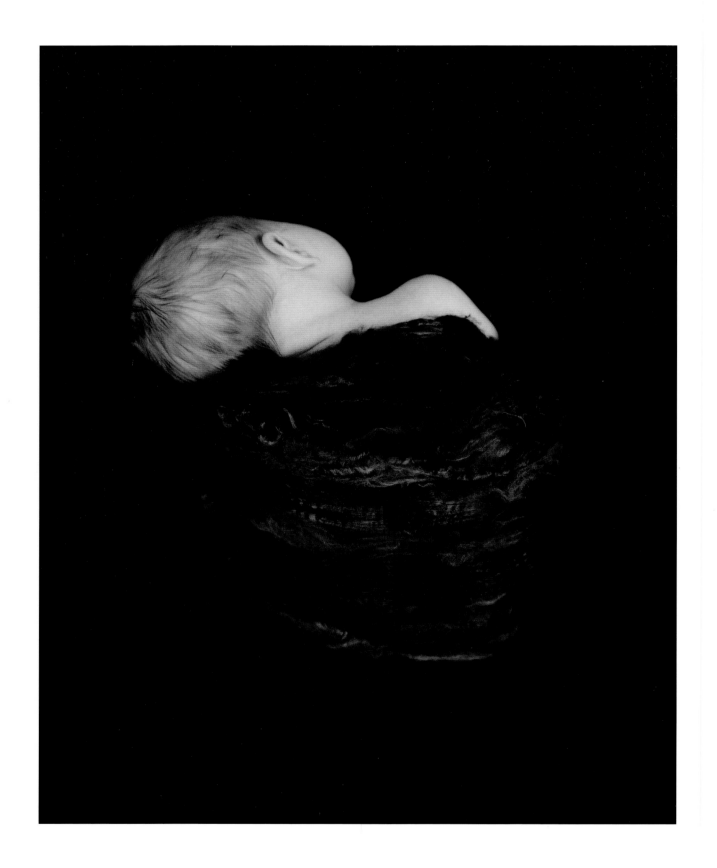

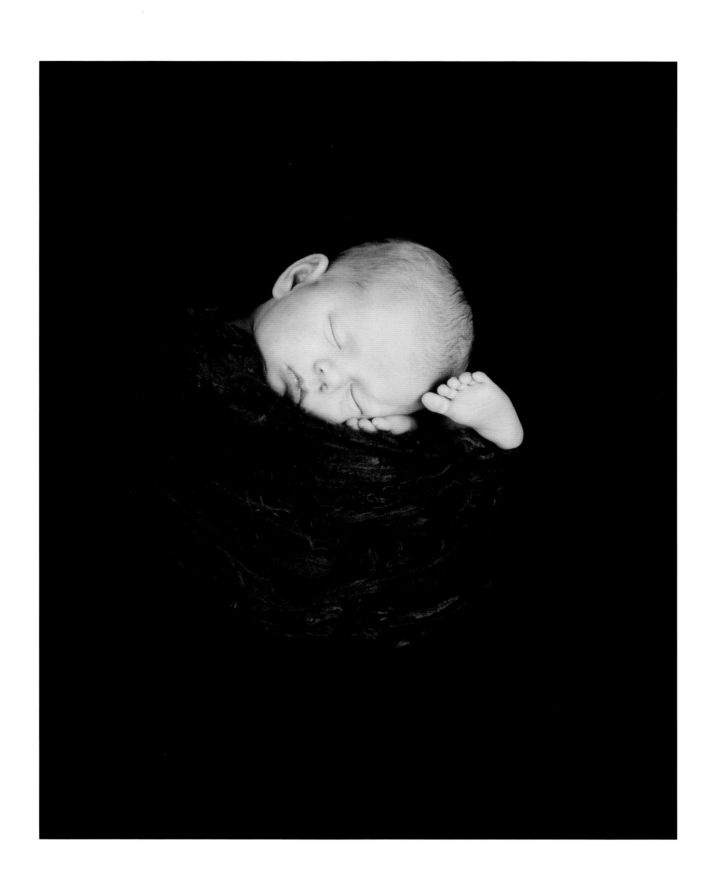

DEFENSELESS

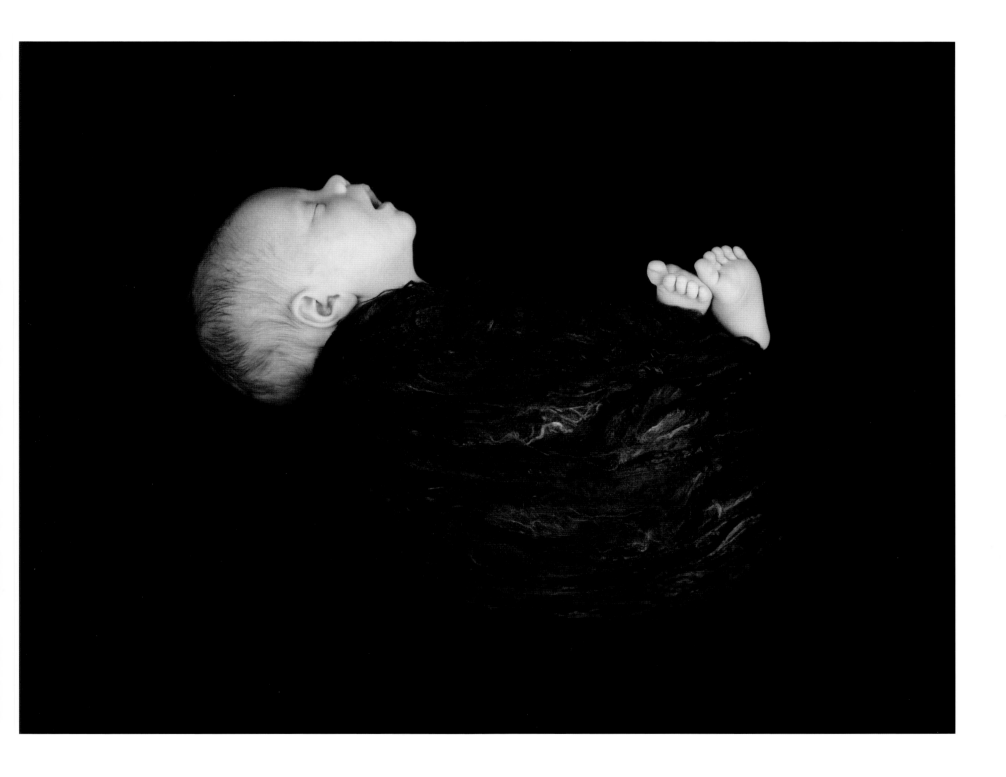

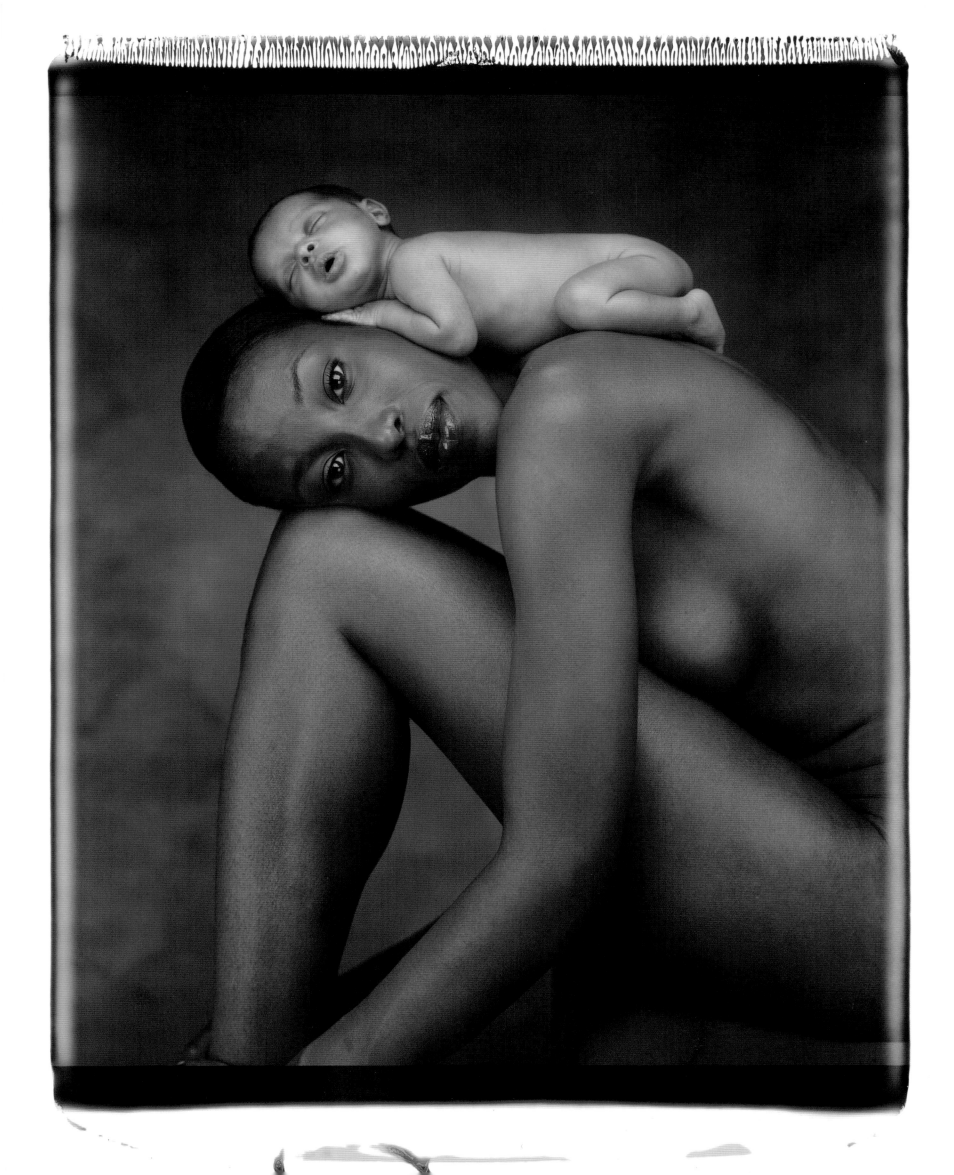

TREASURED

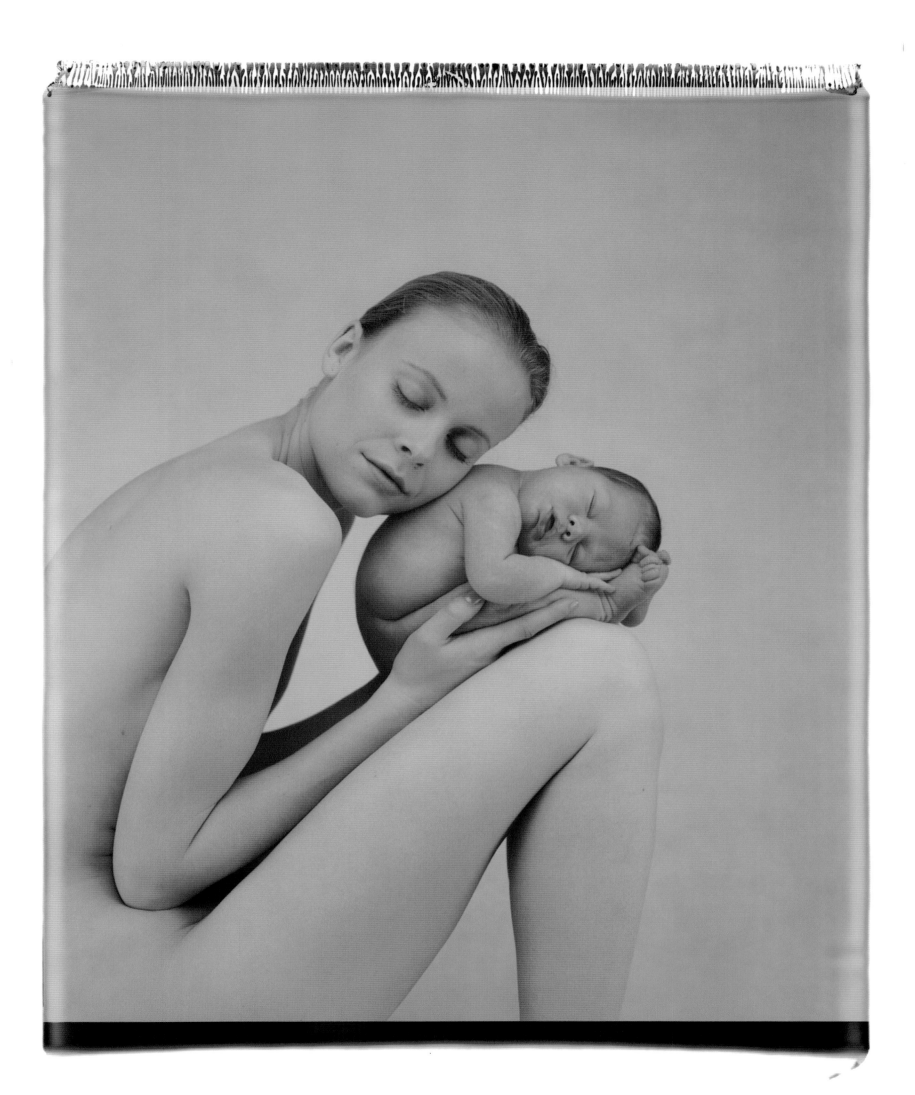

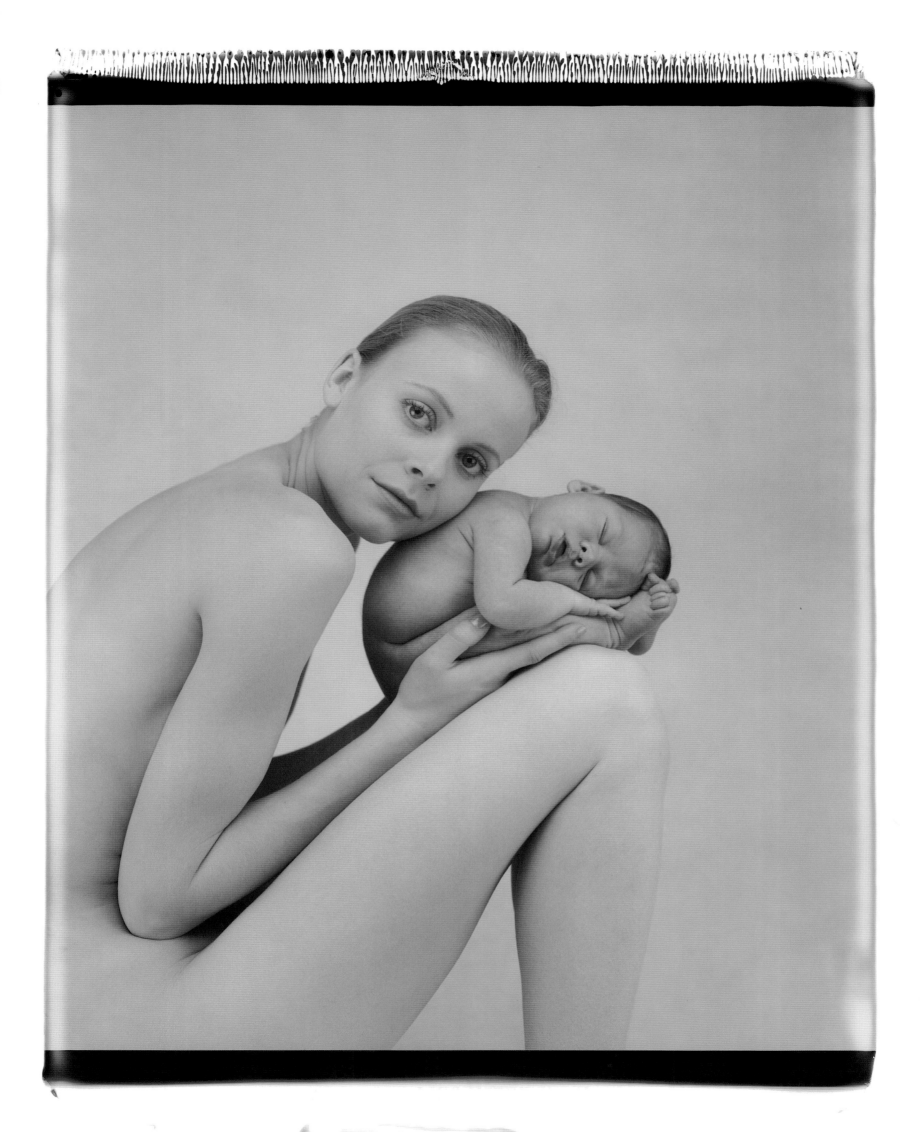

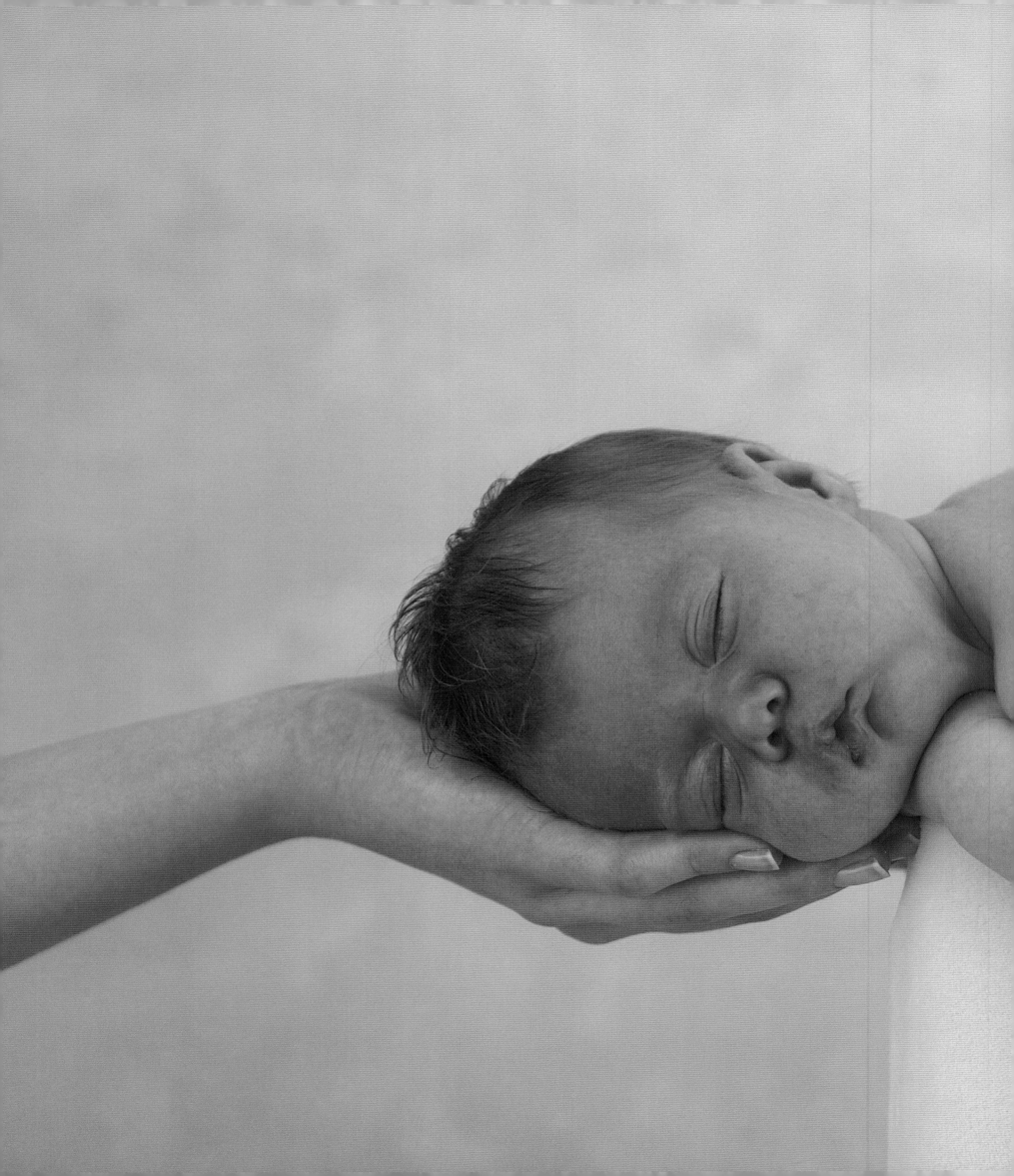

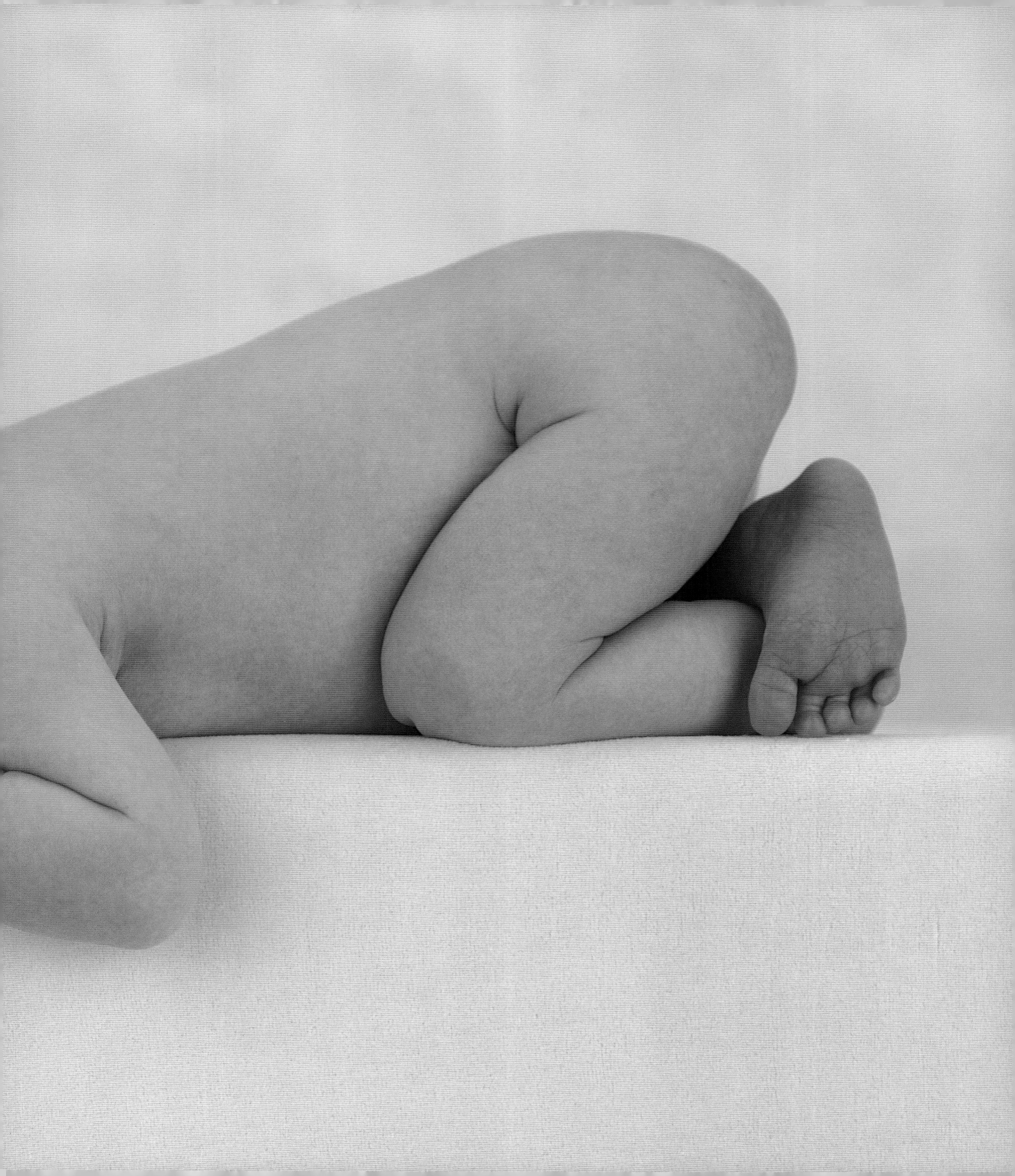

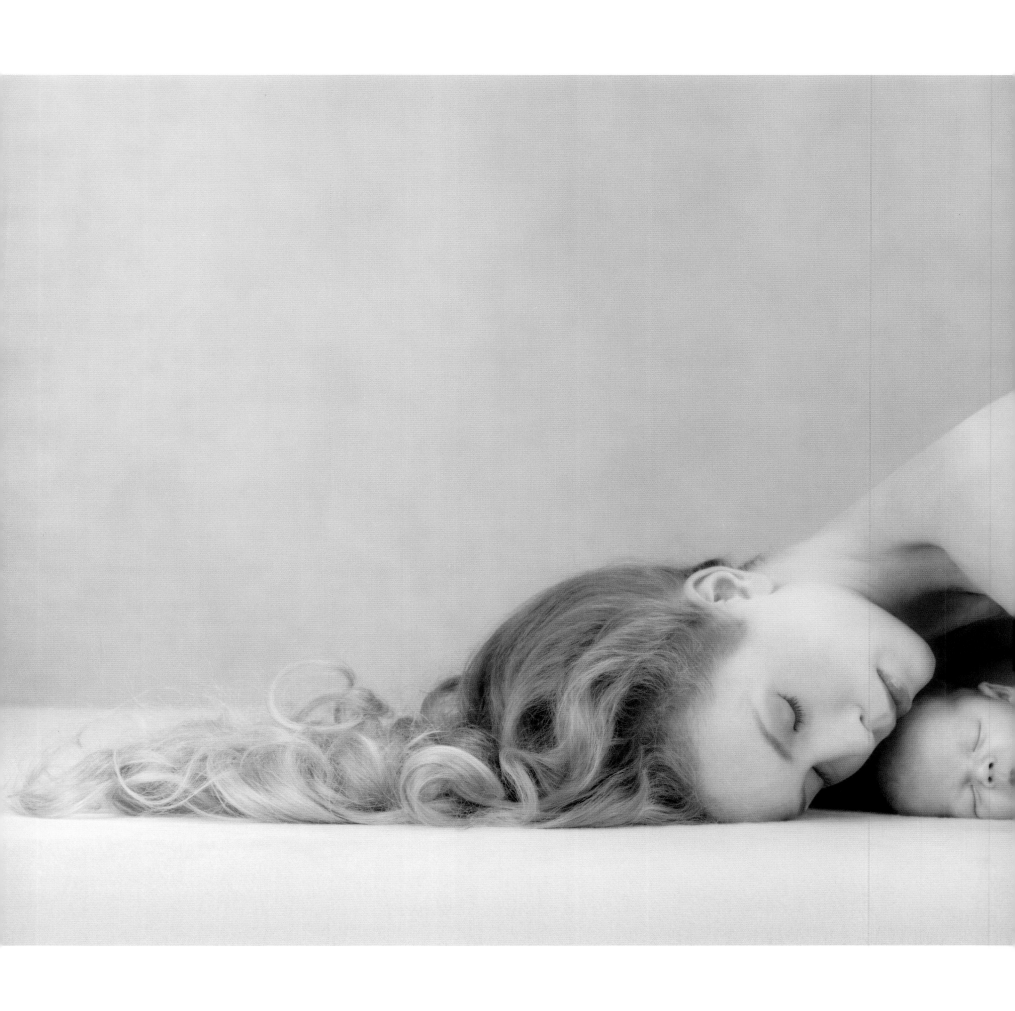

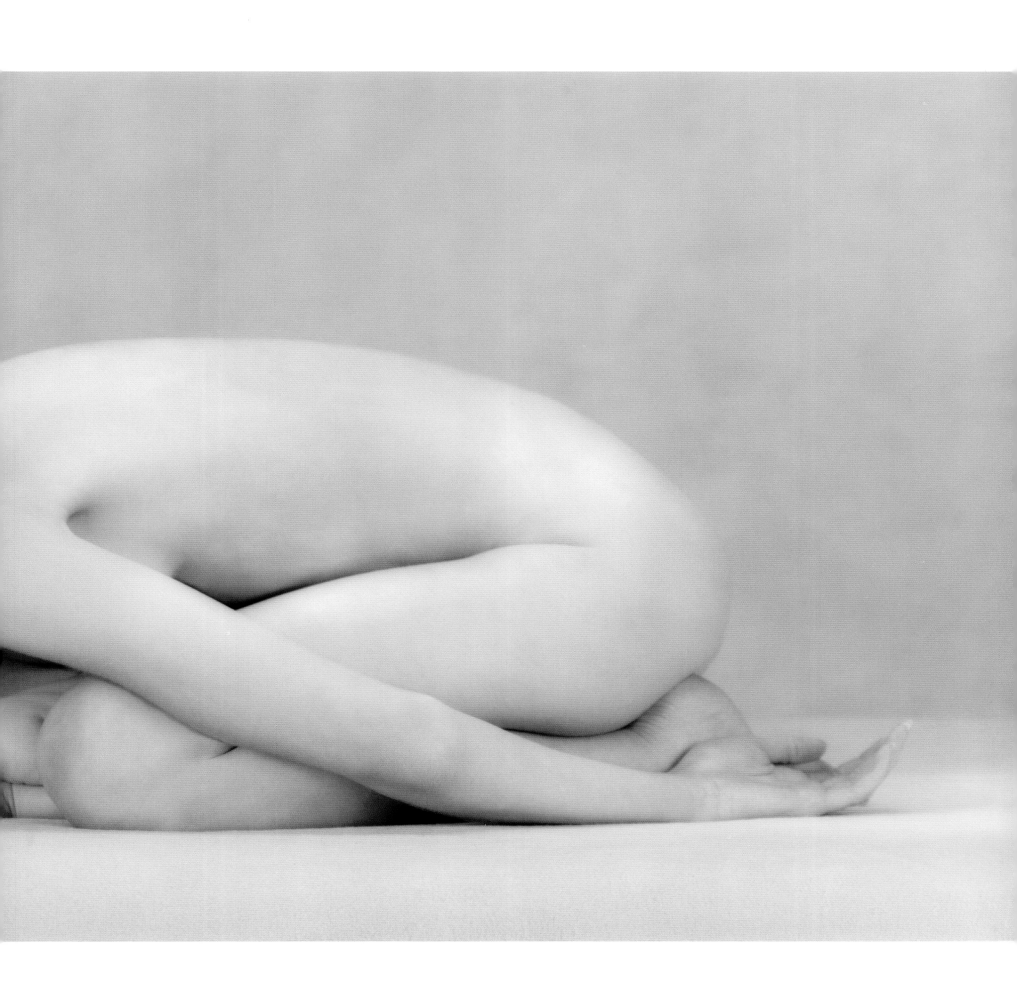

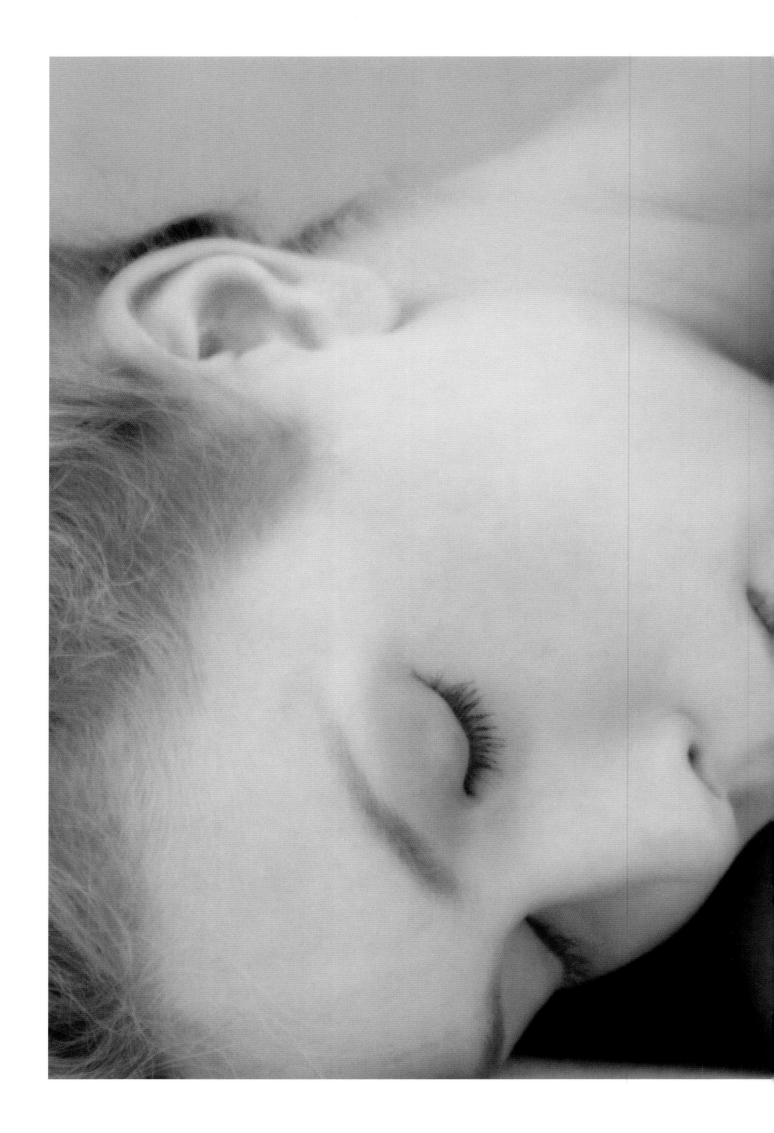

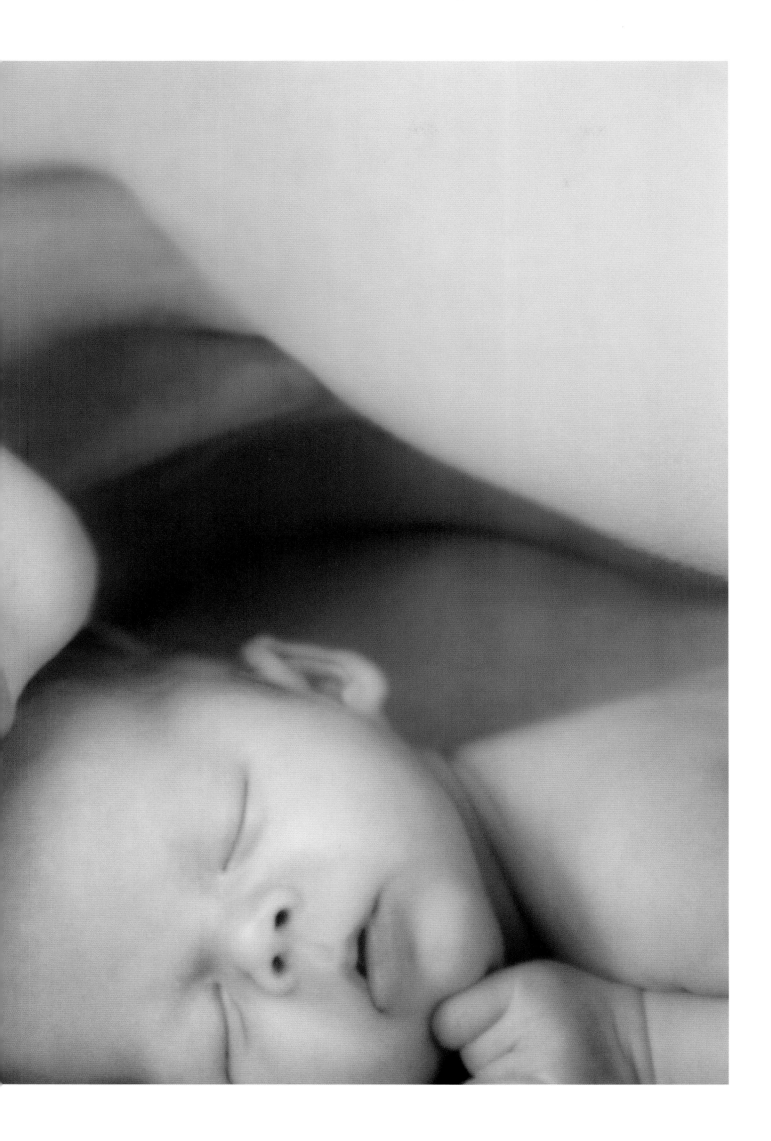

CHERISHED

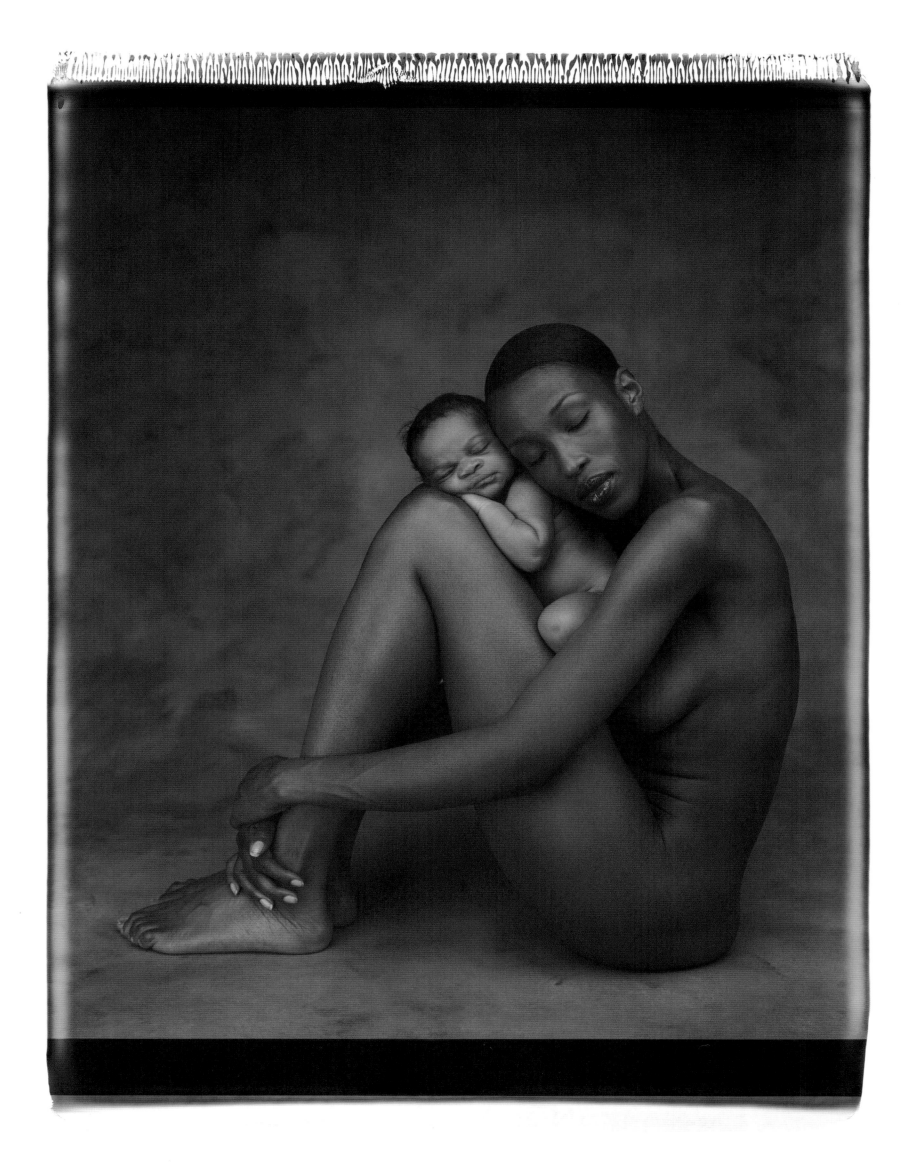

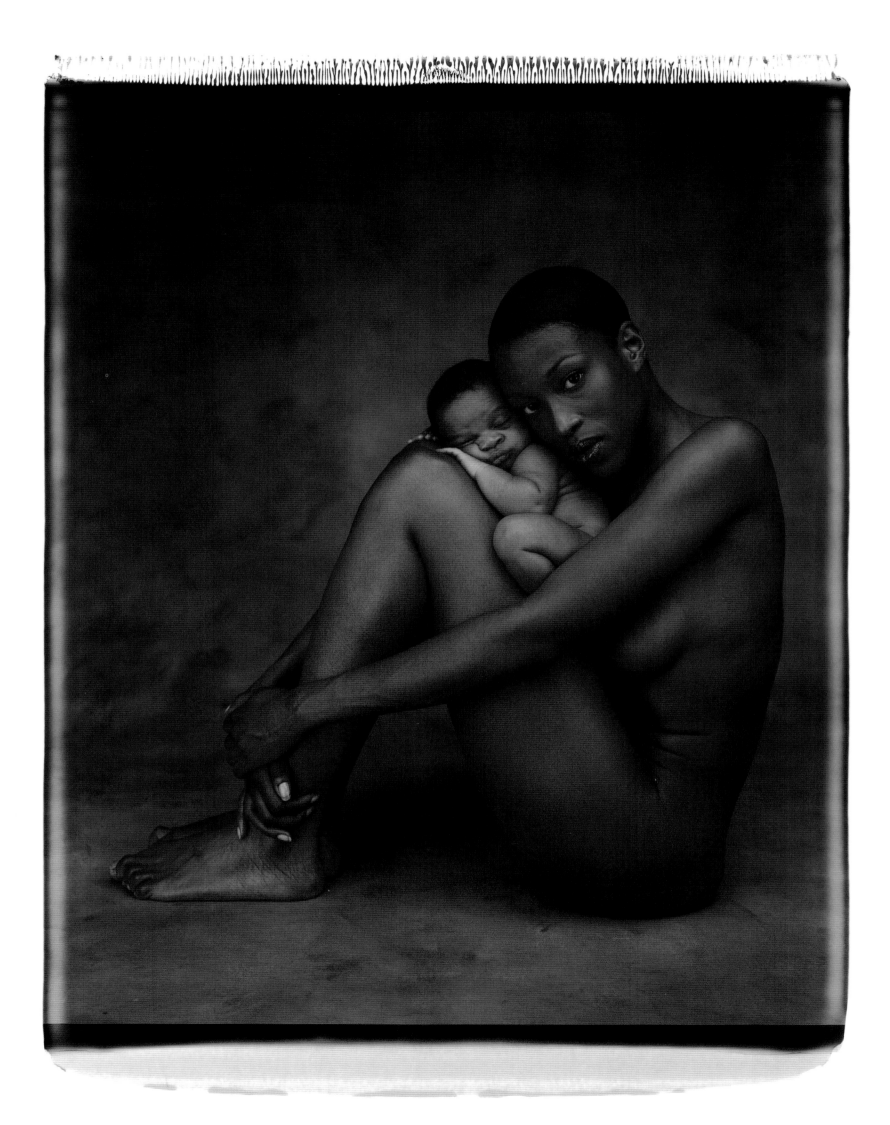

P R E G N A N T

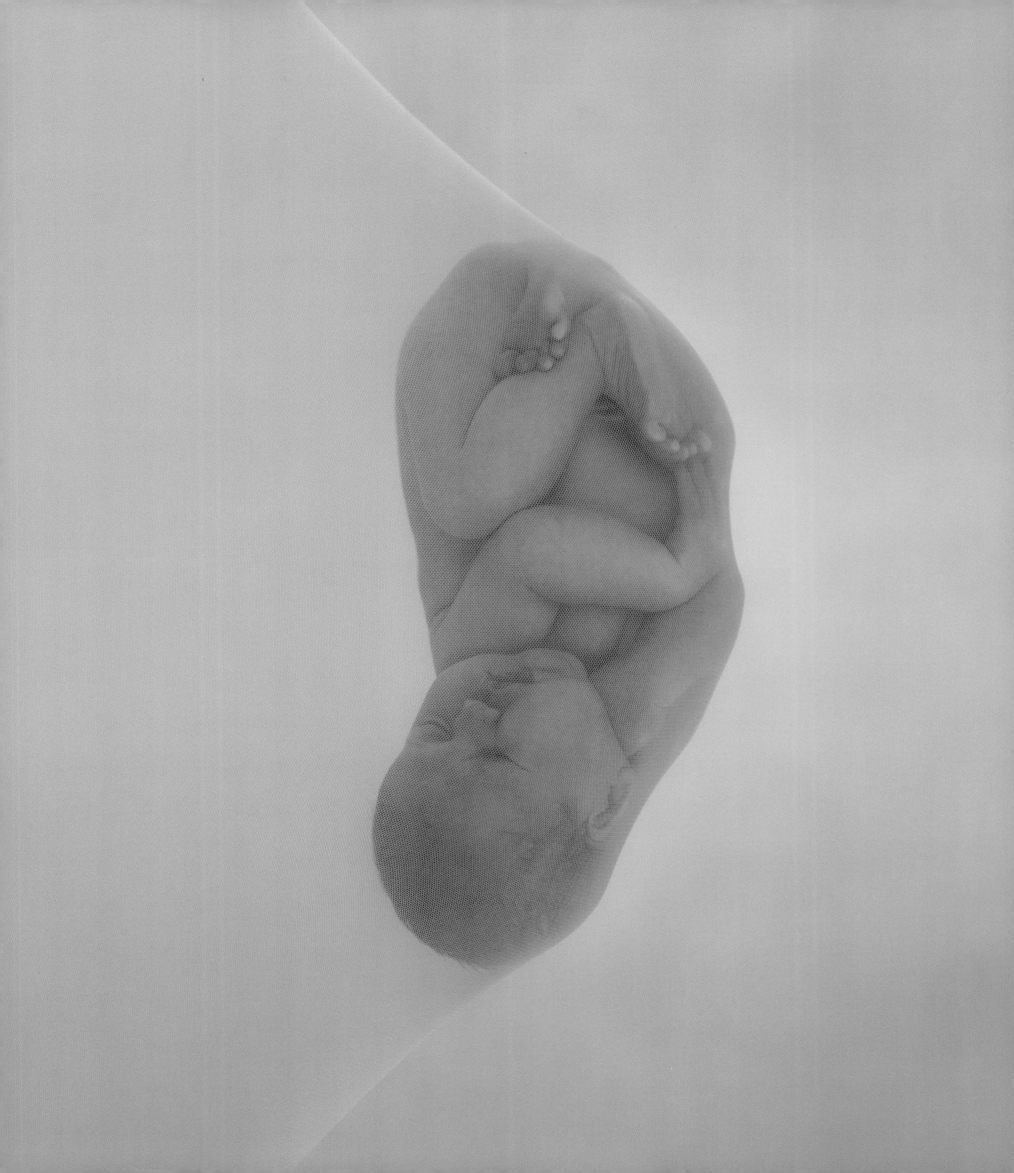

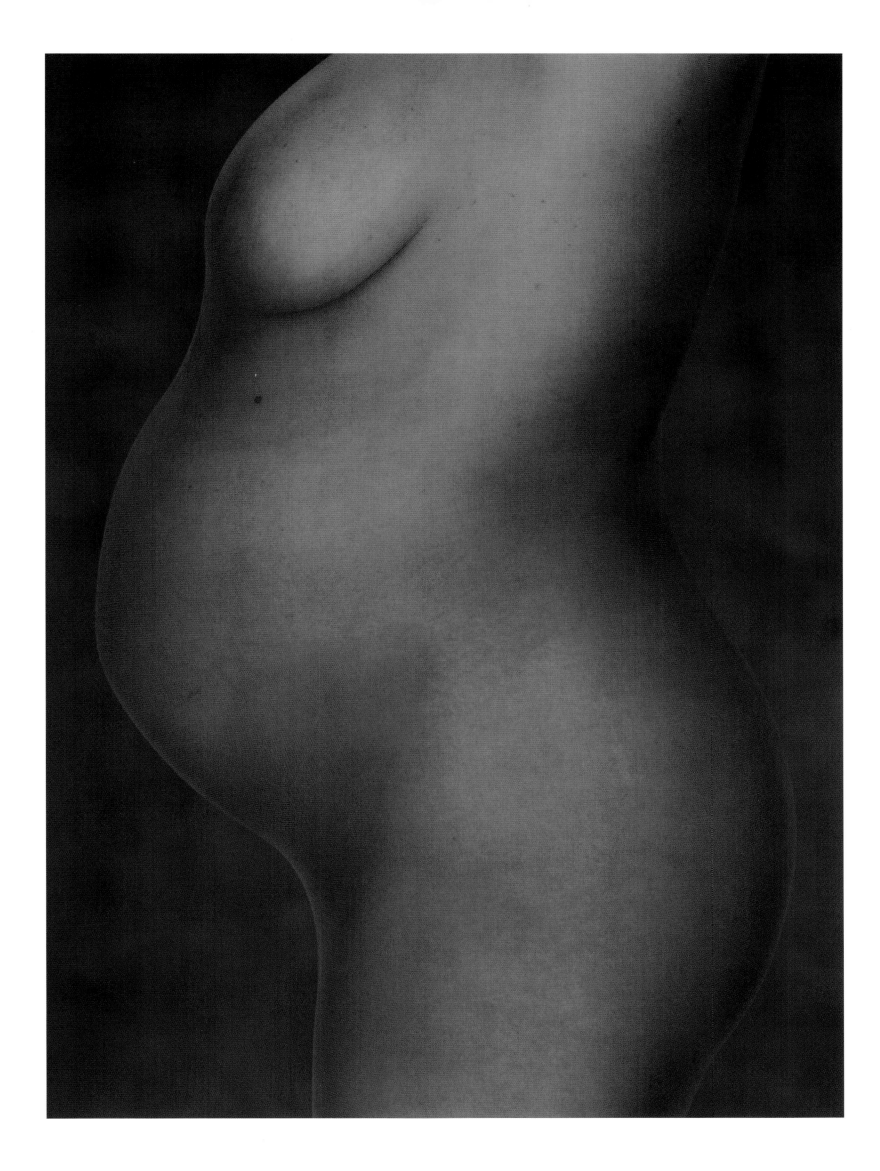

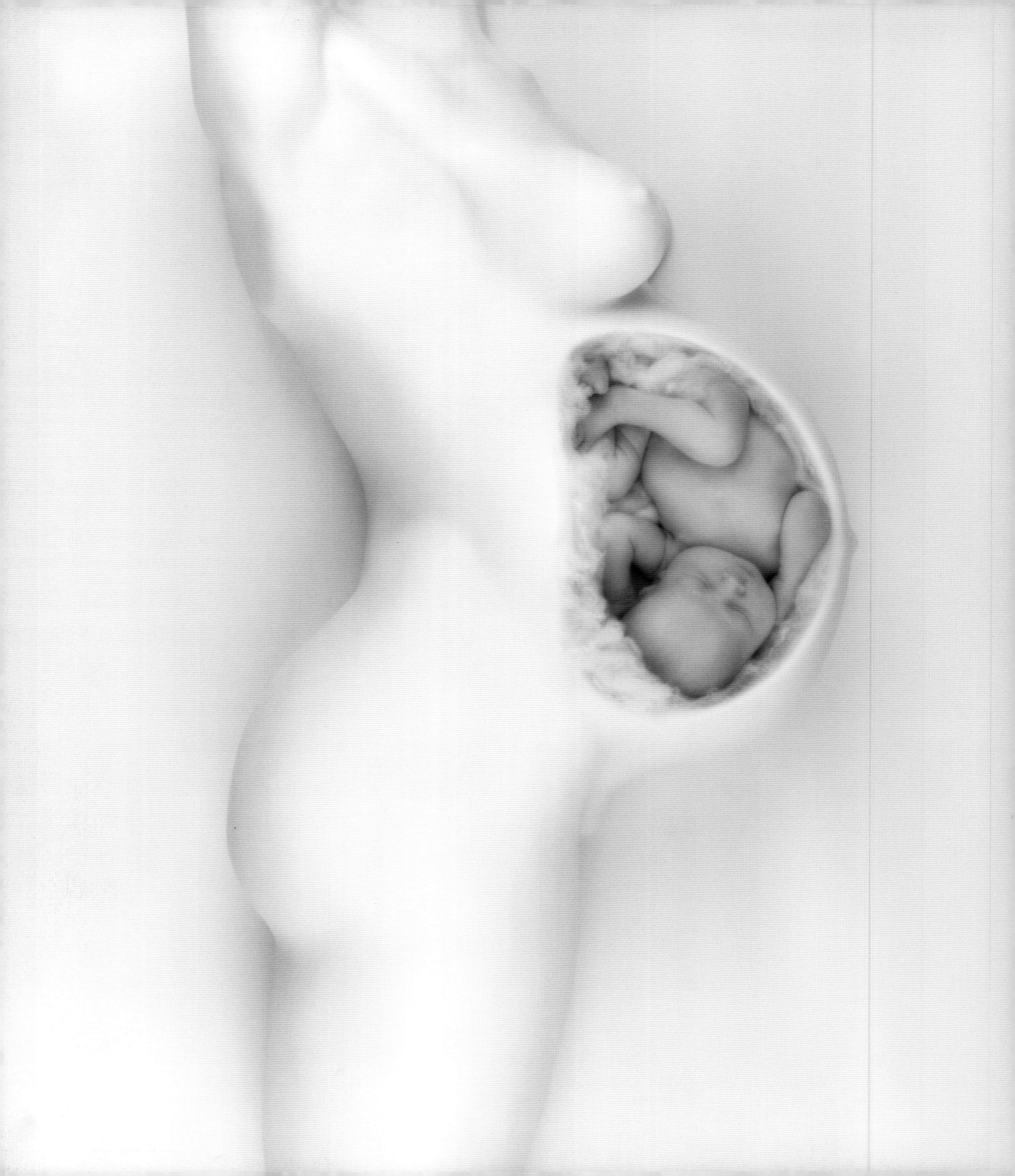

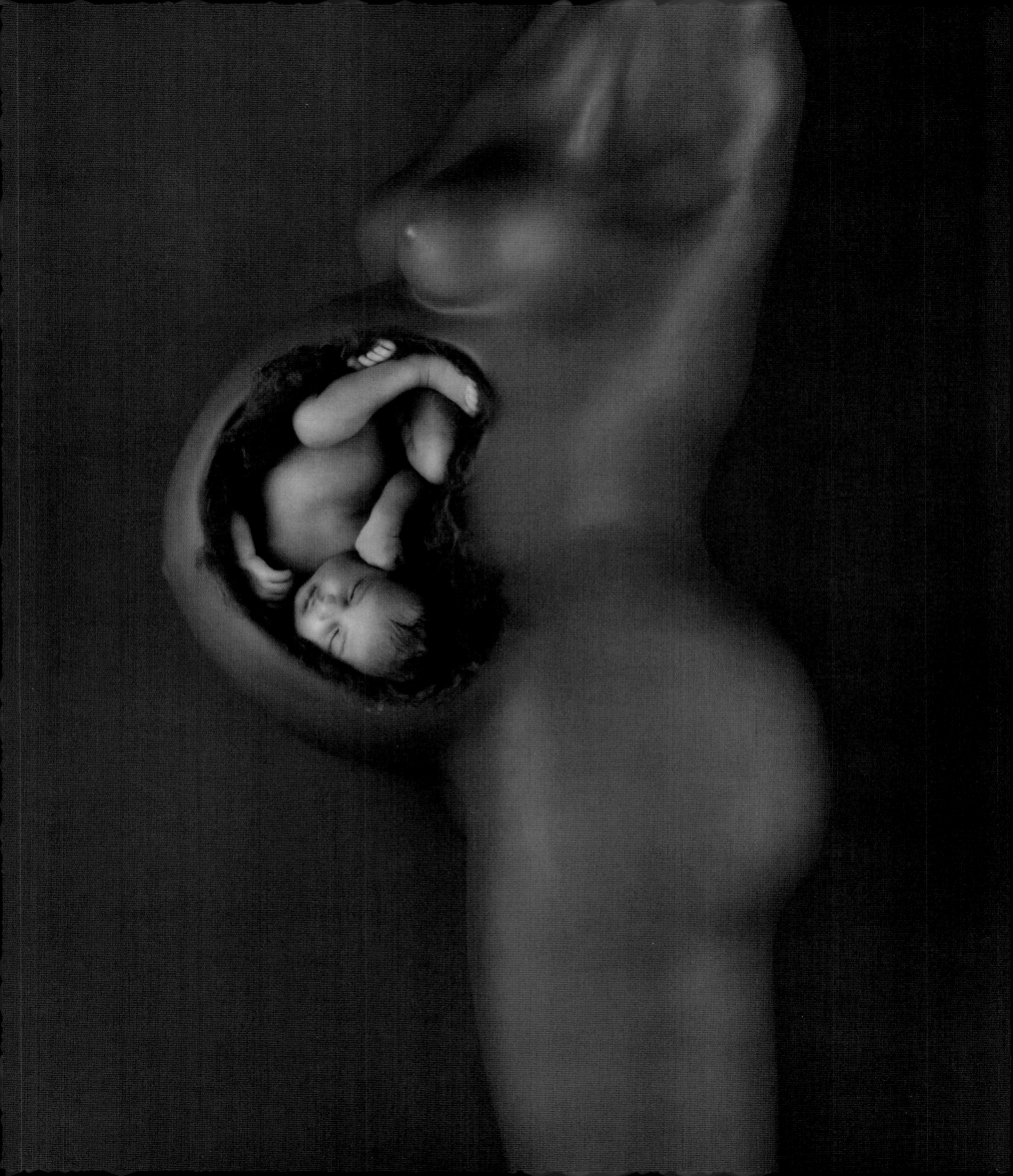

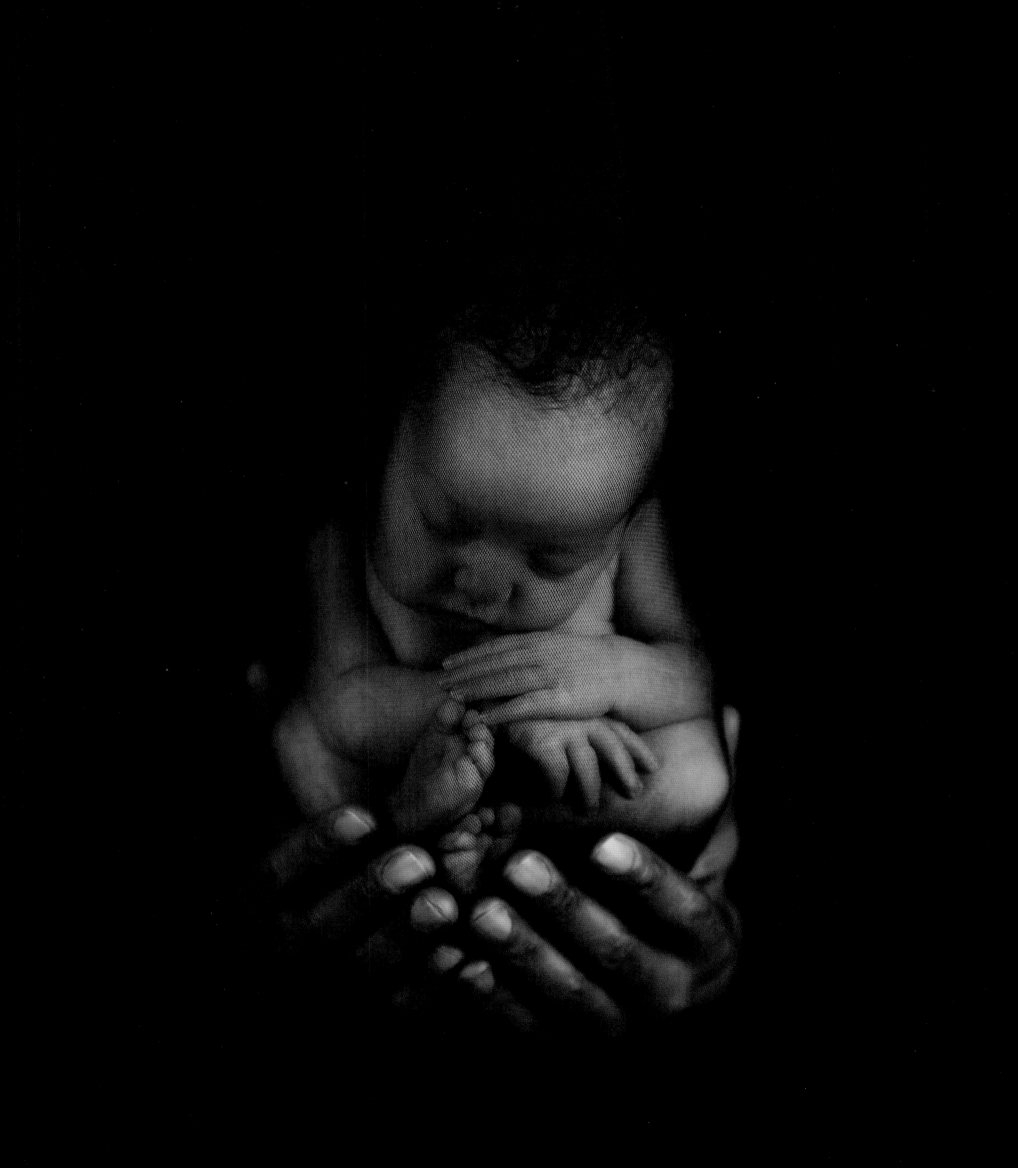

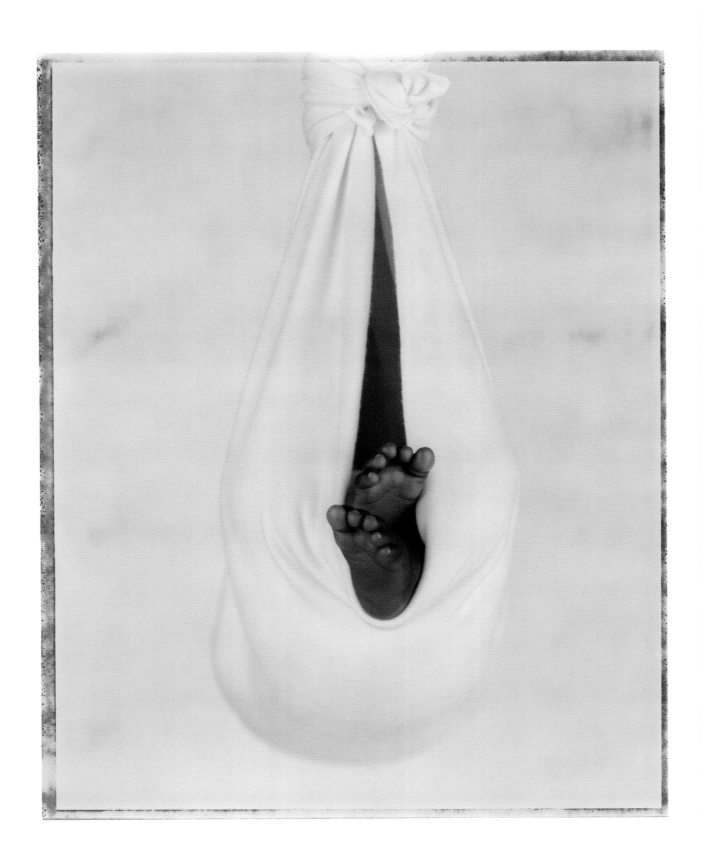

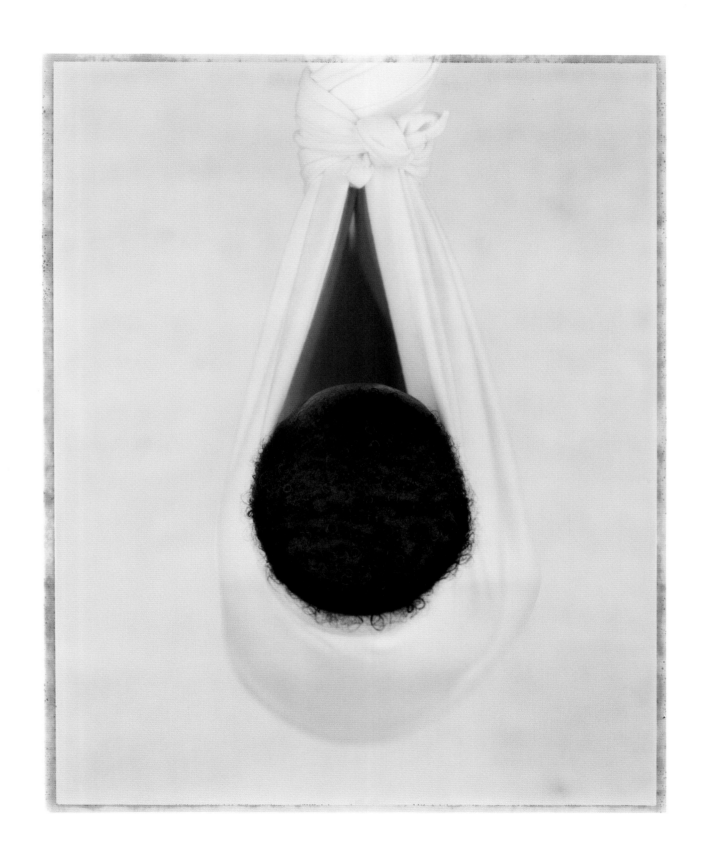

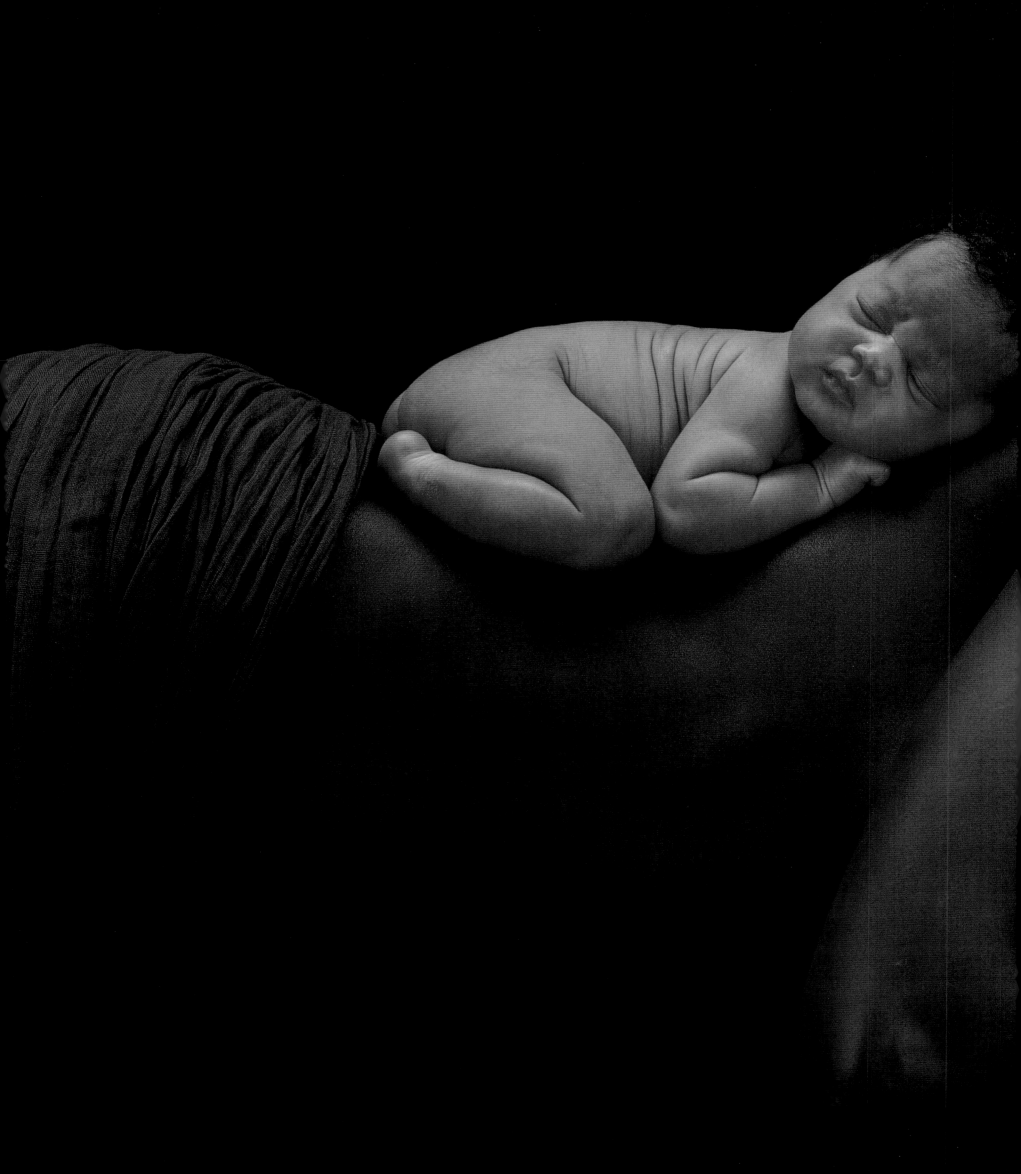

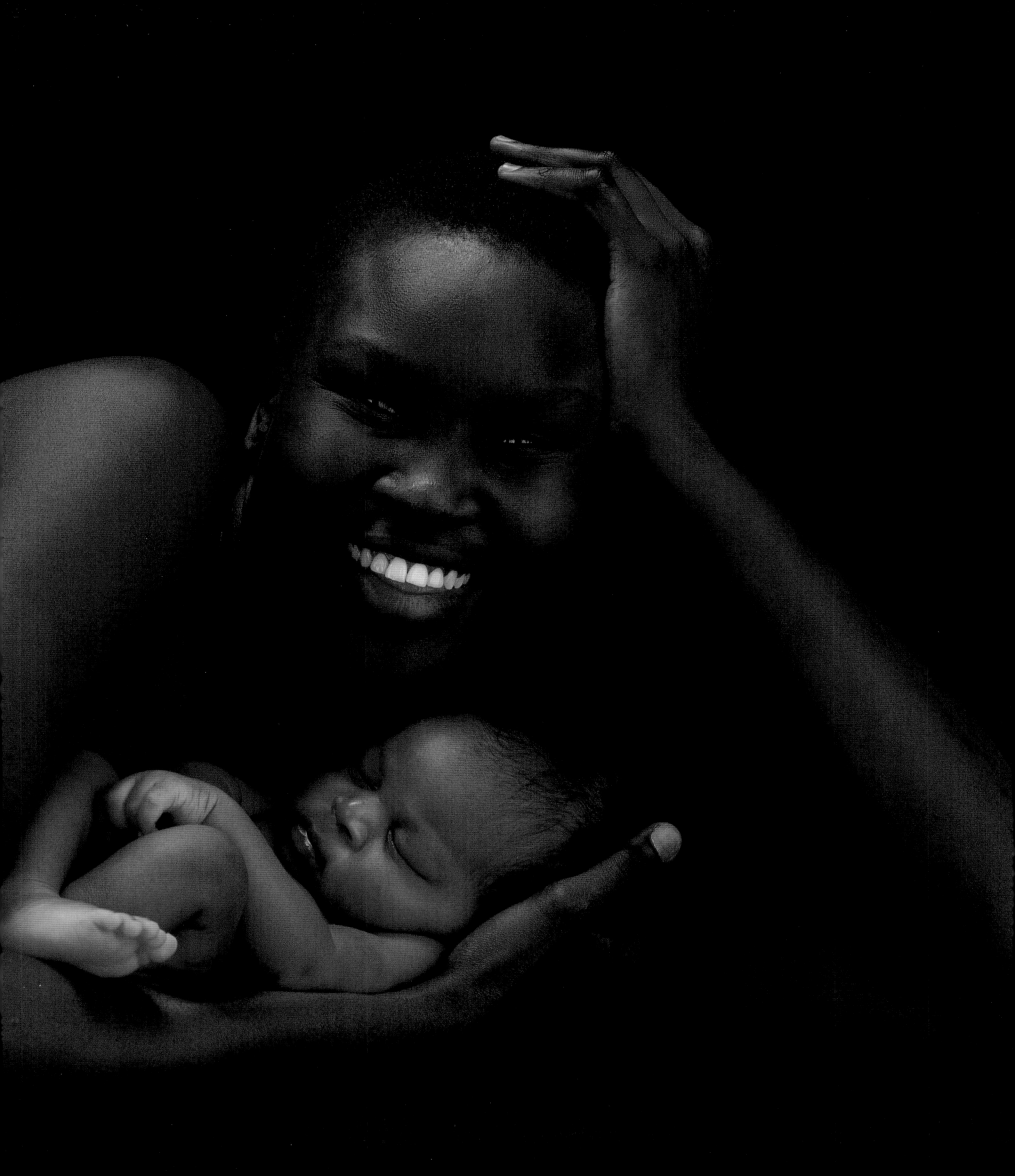

LOVELY

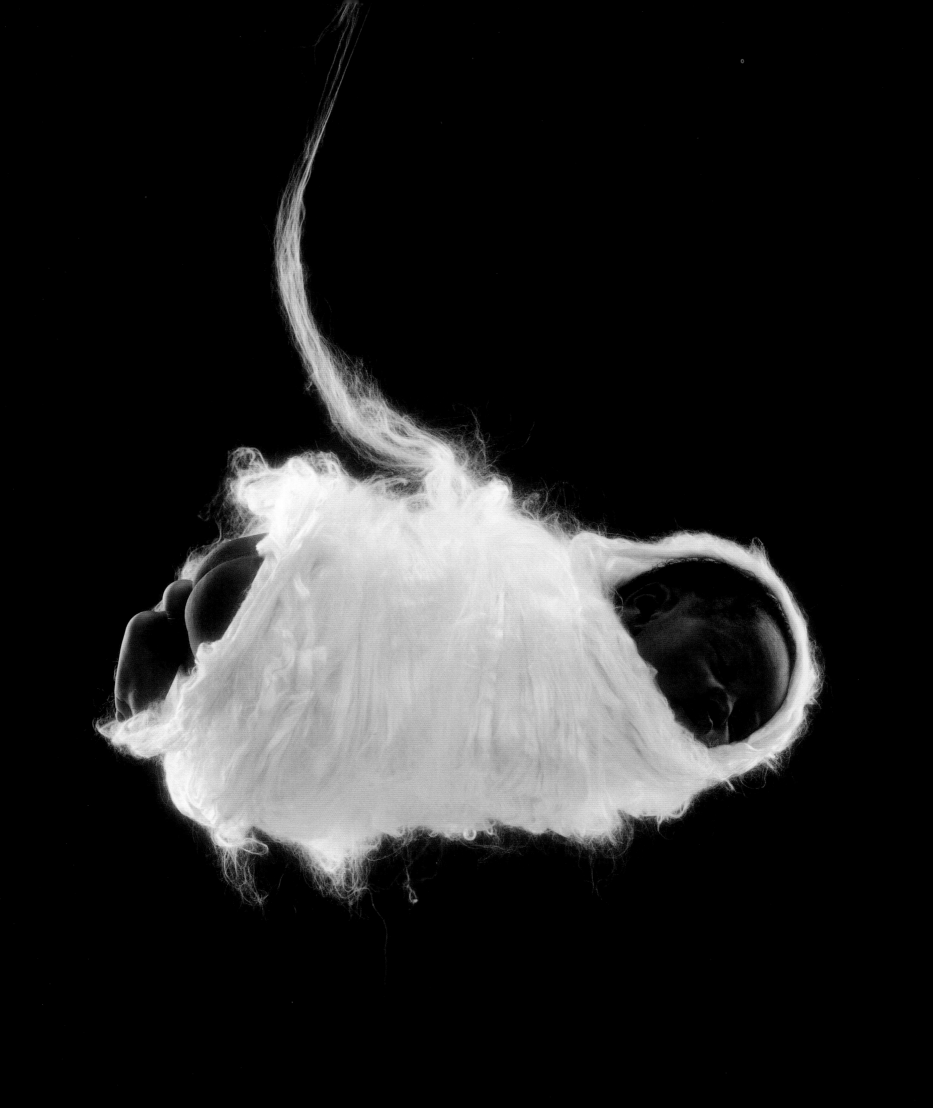

PURE

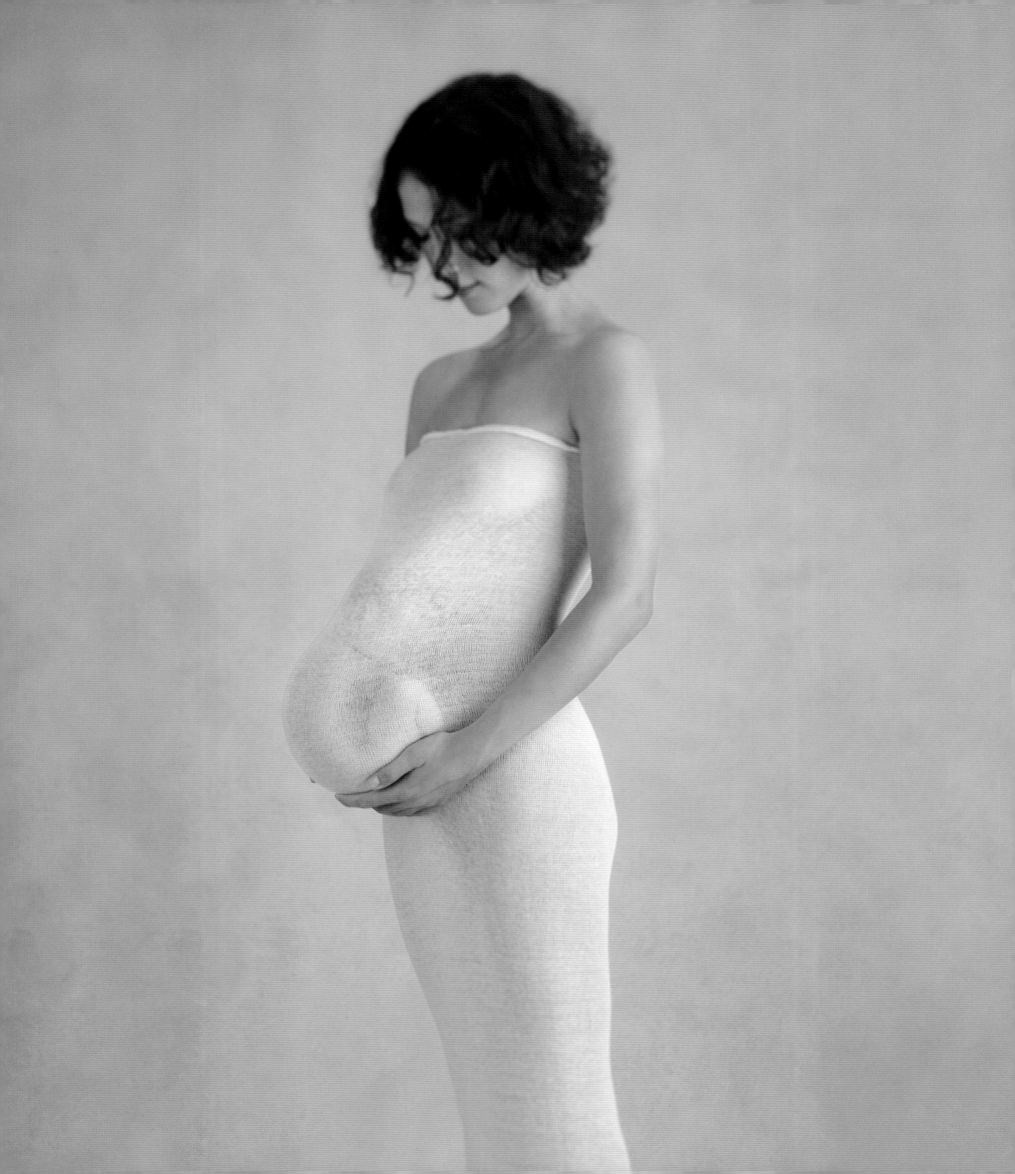

STRONG

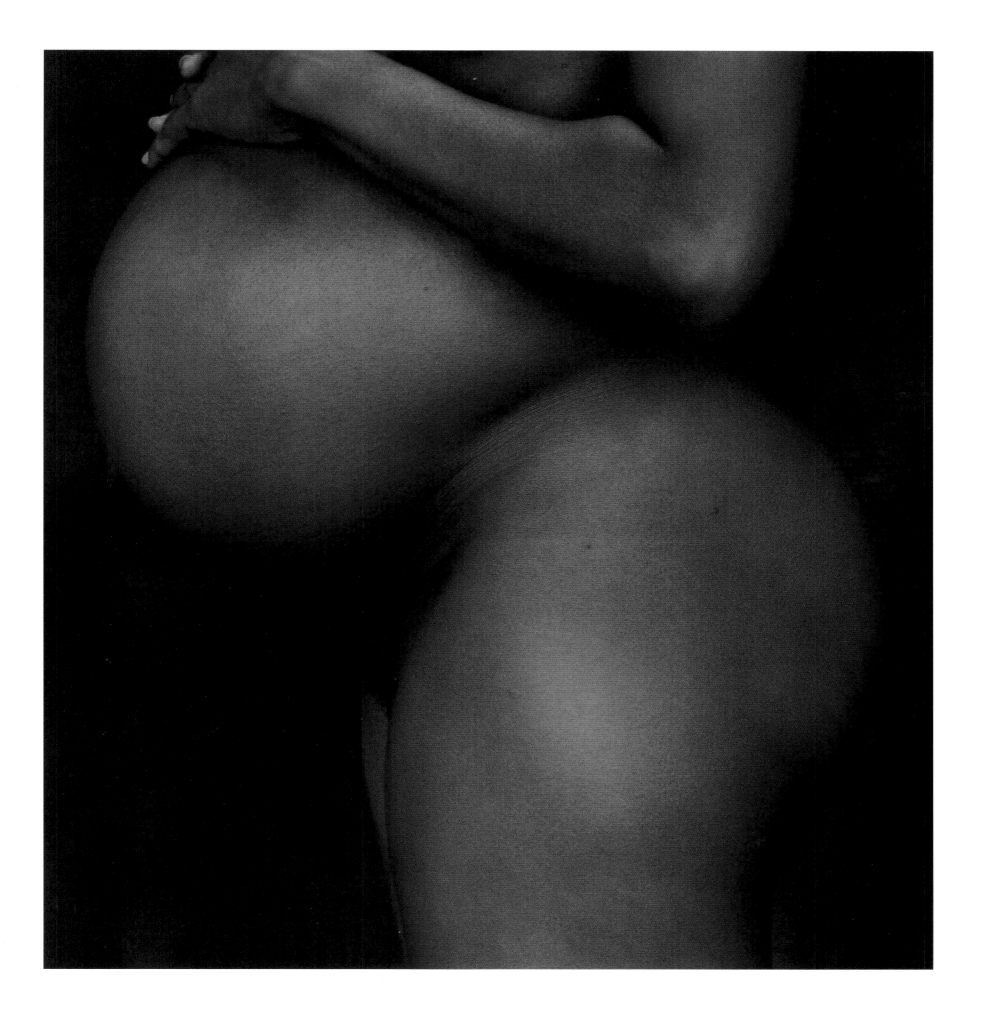

PROMISING

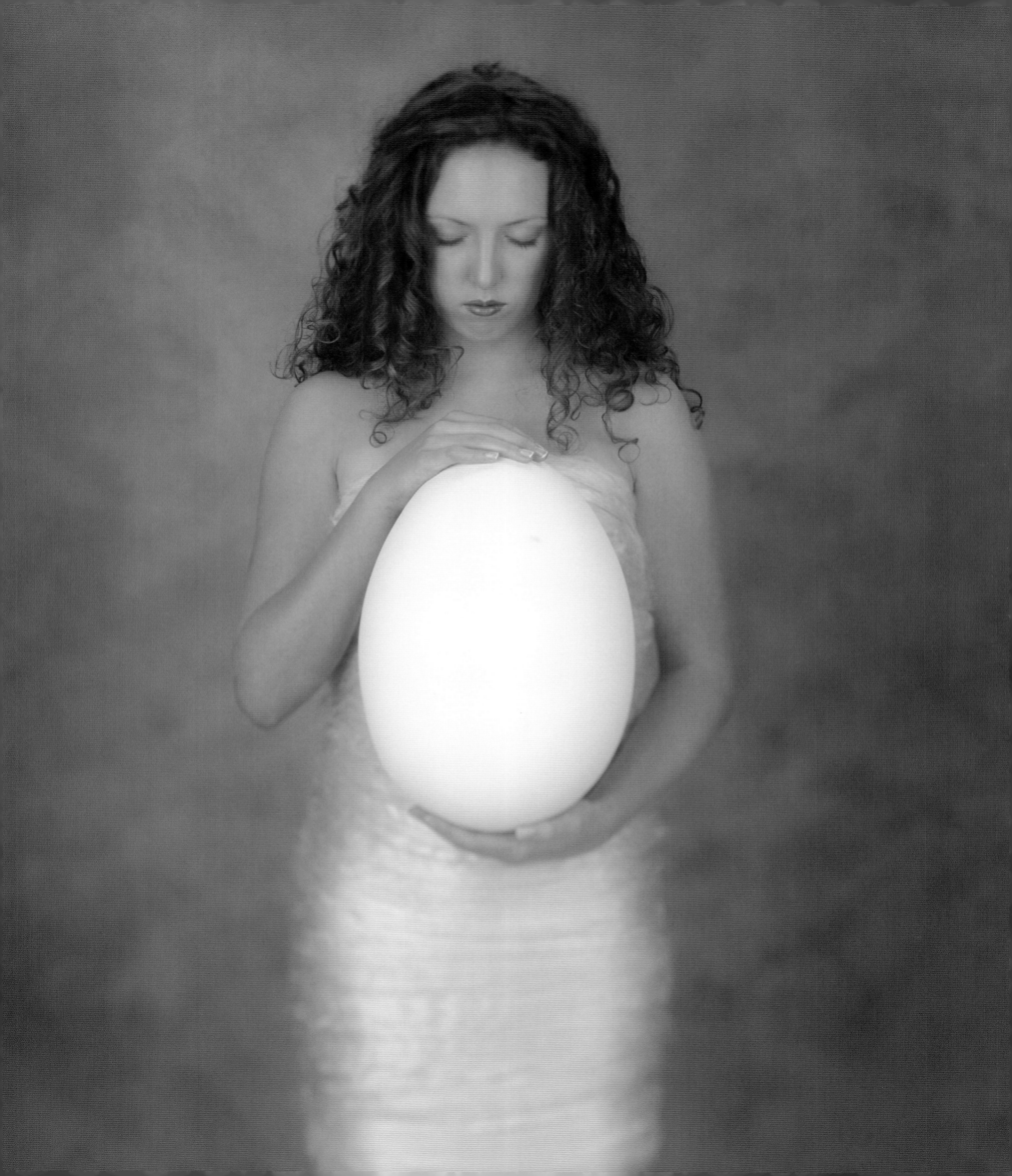

BEGINNING

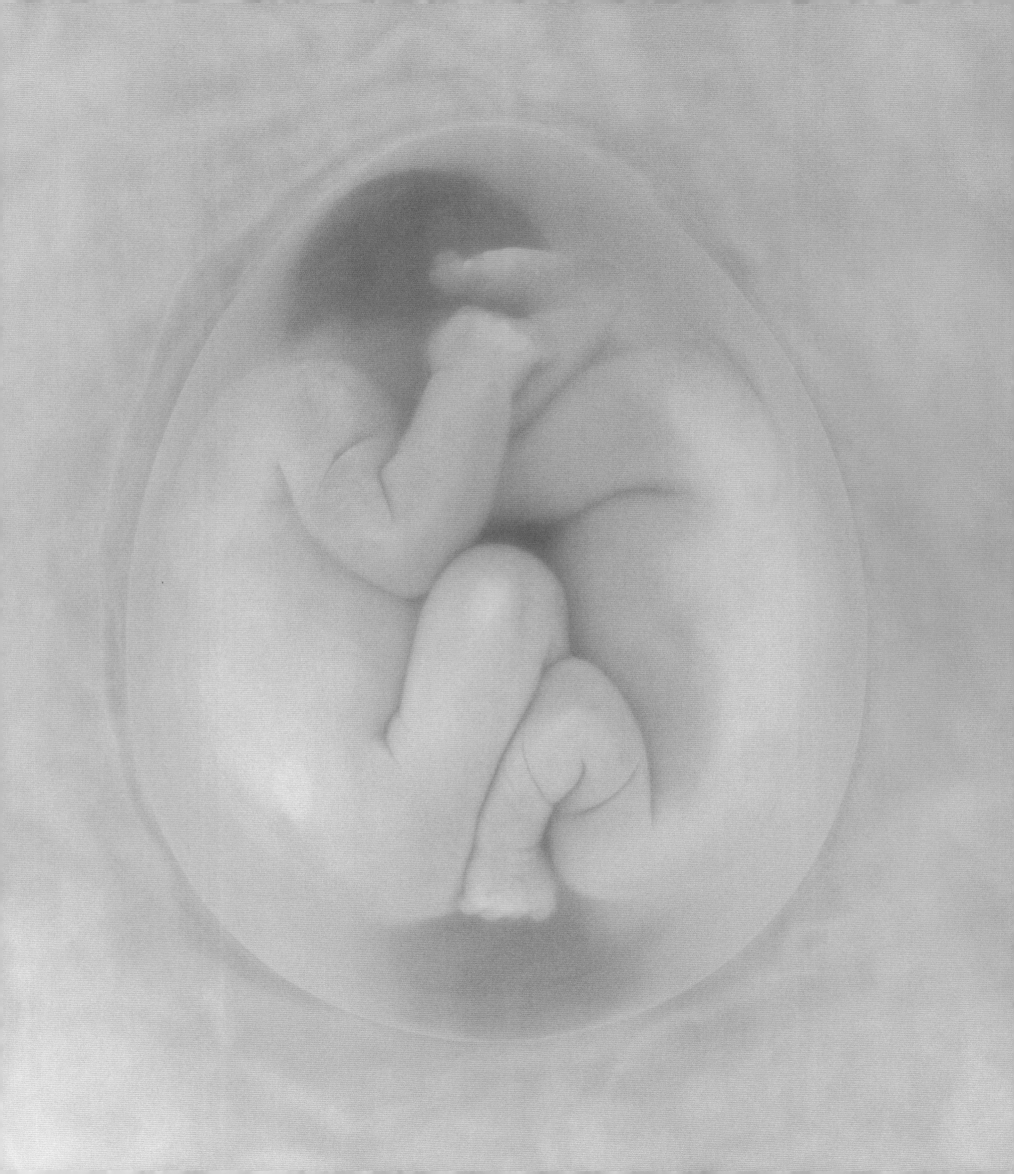

INCOMPARABLE

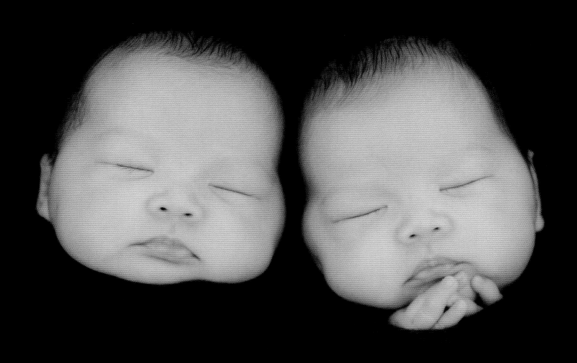

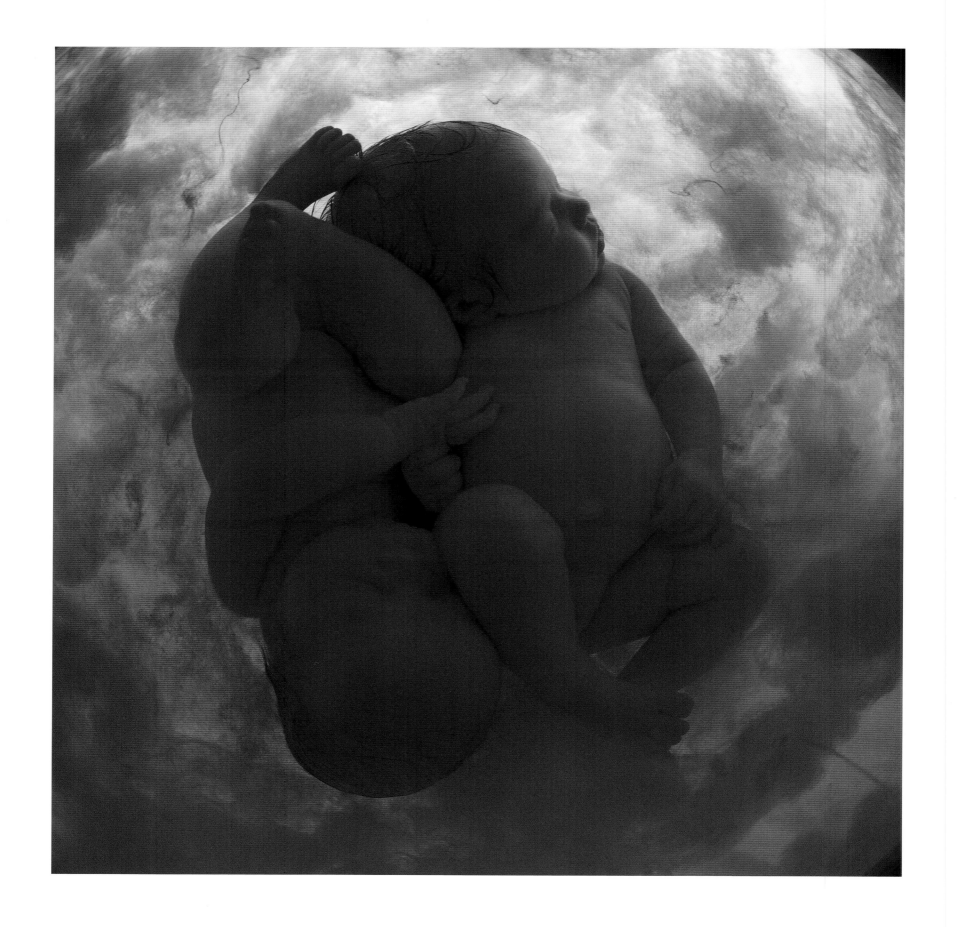

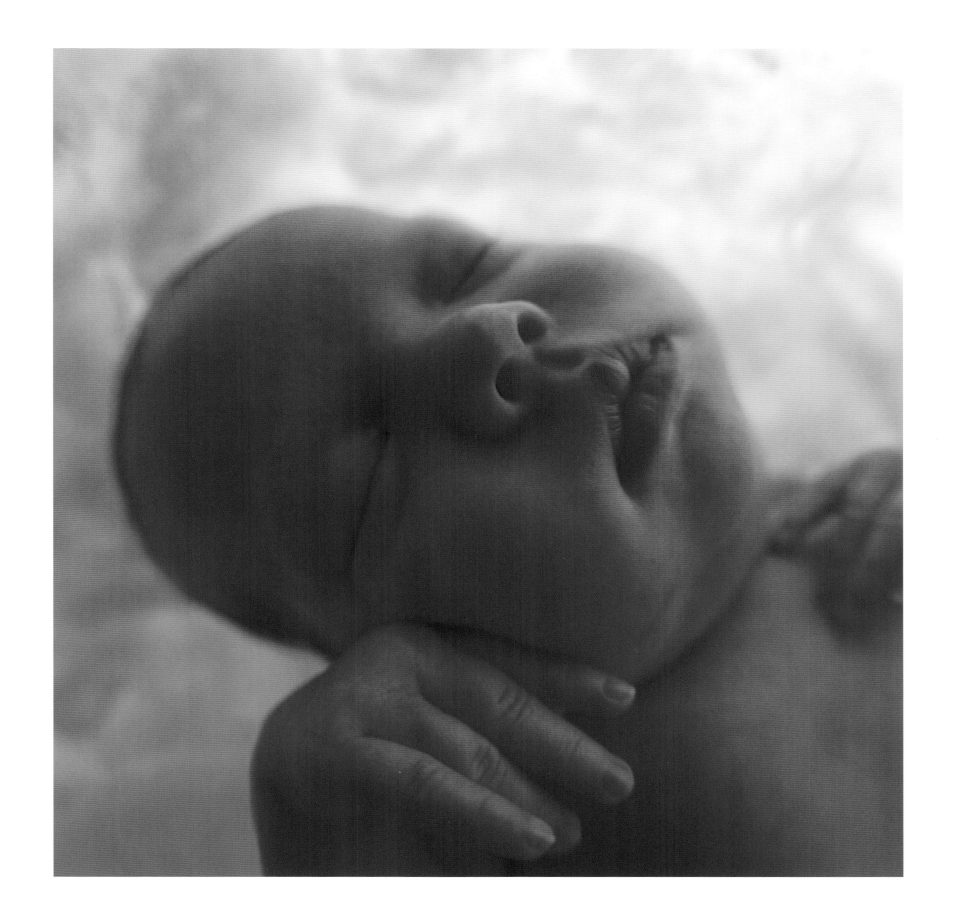

AWESOME

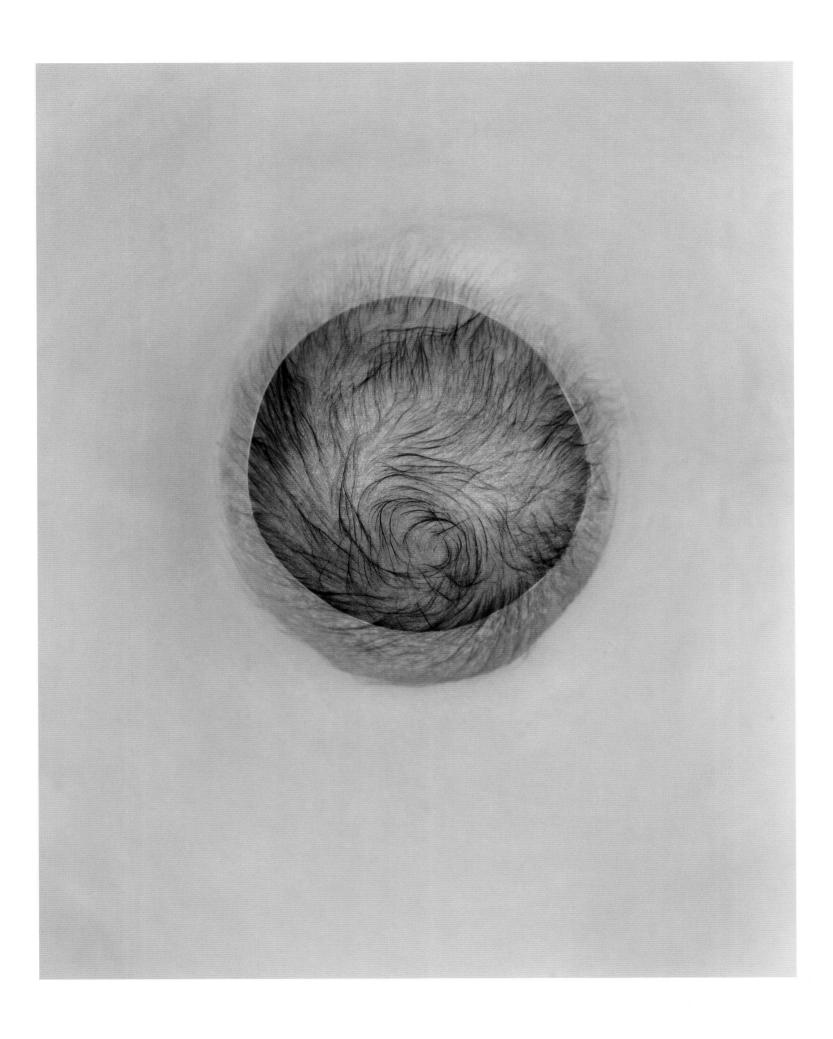

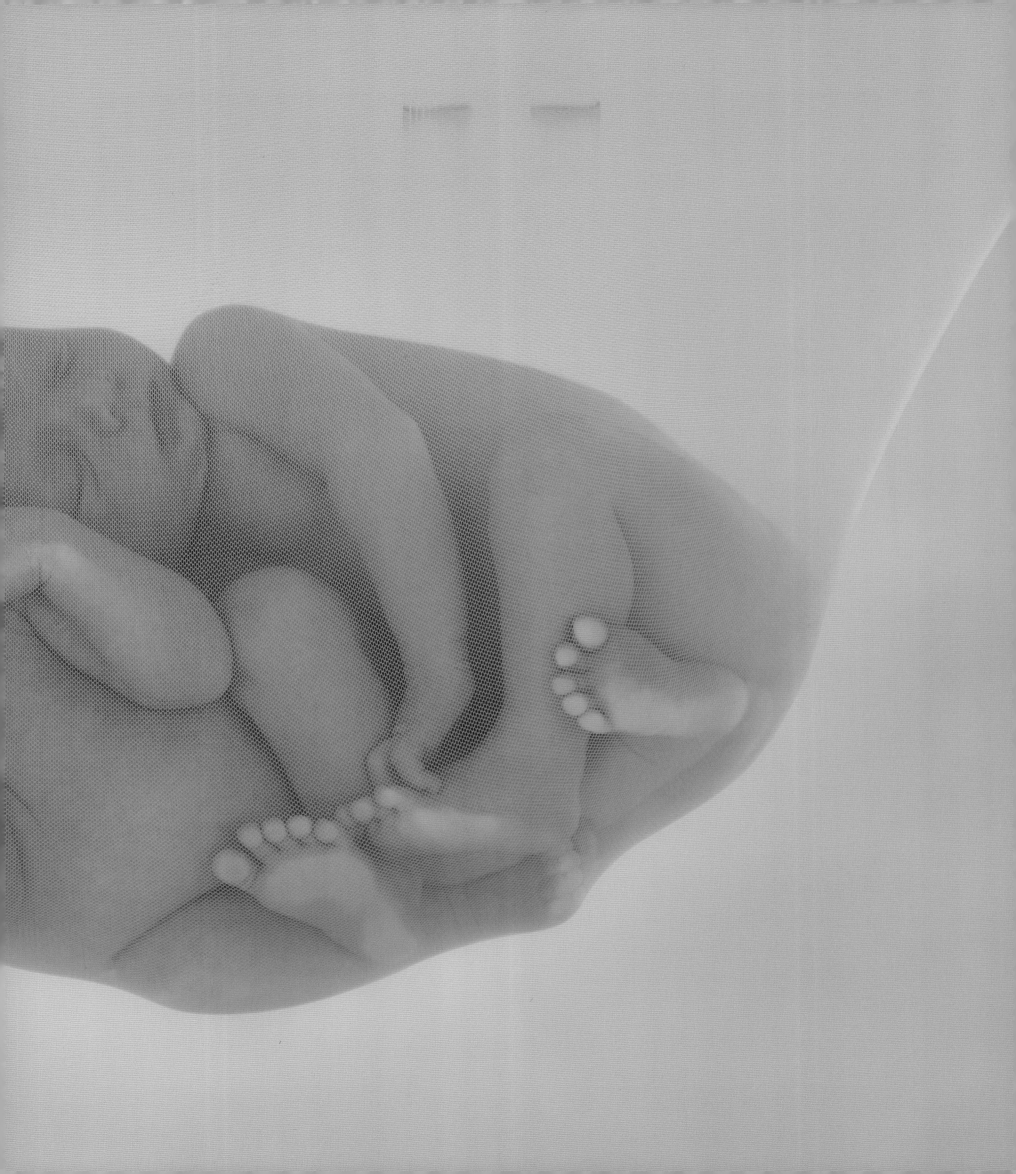

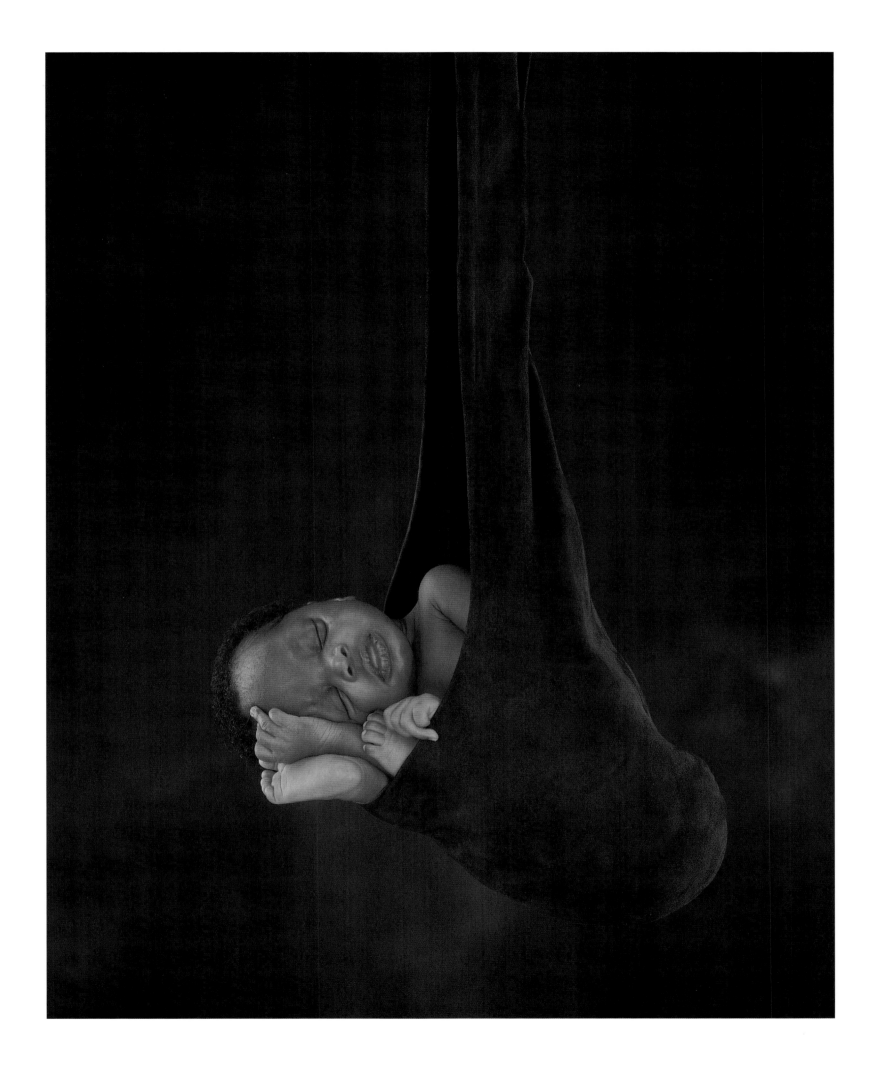

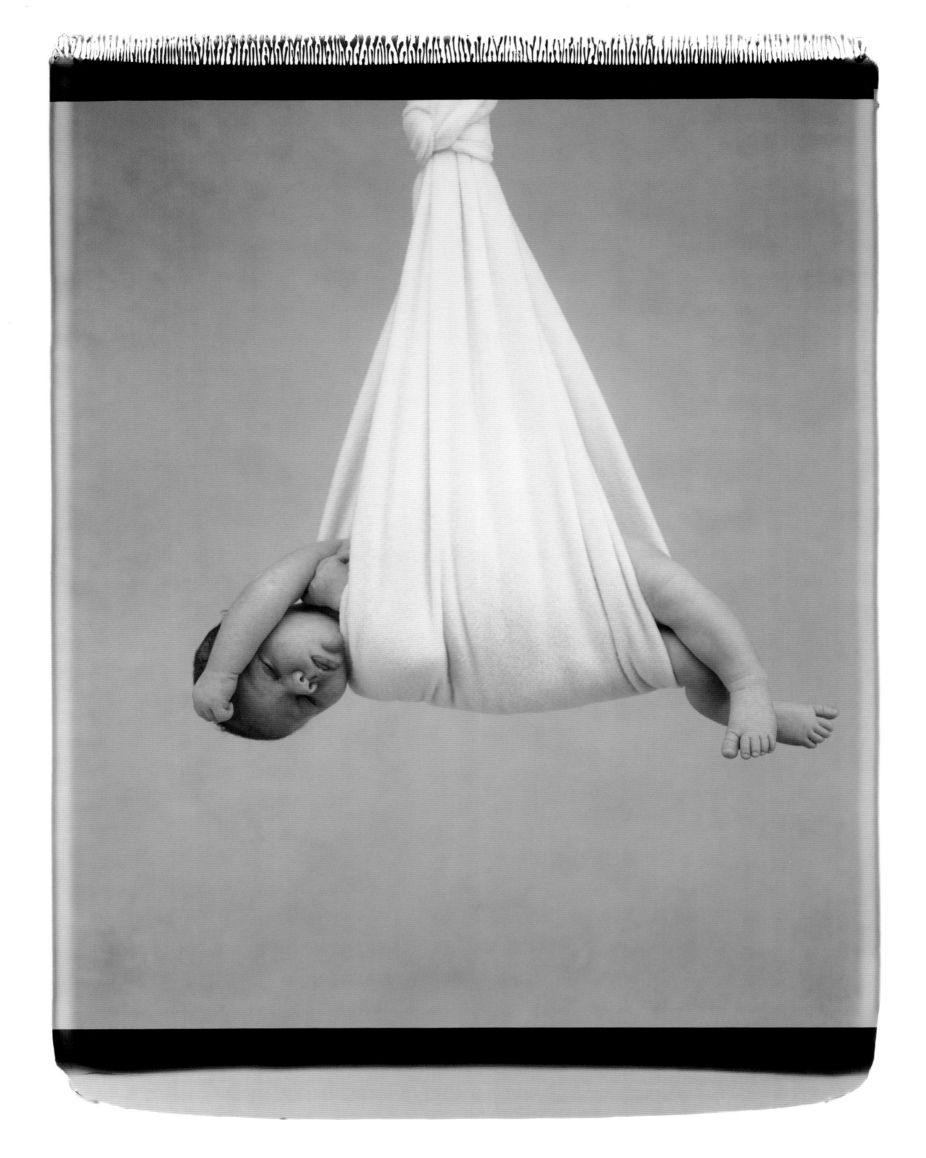

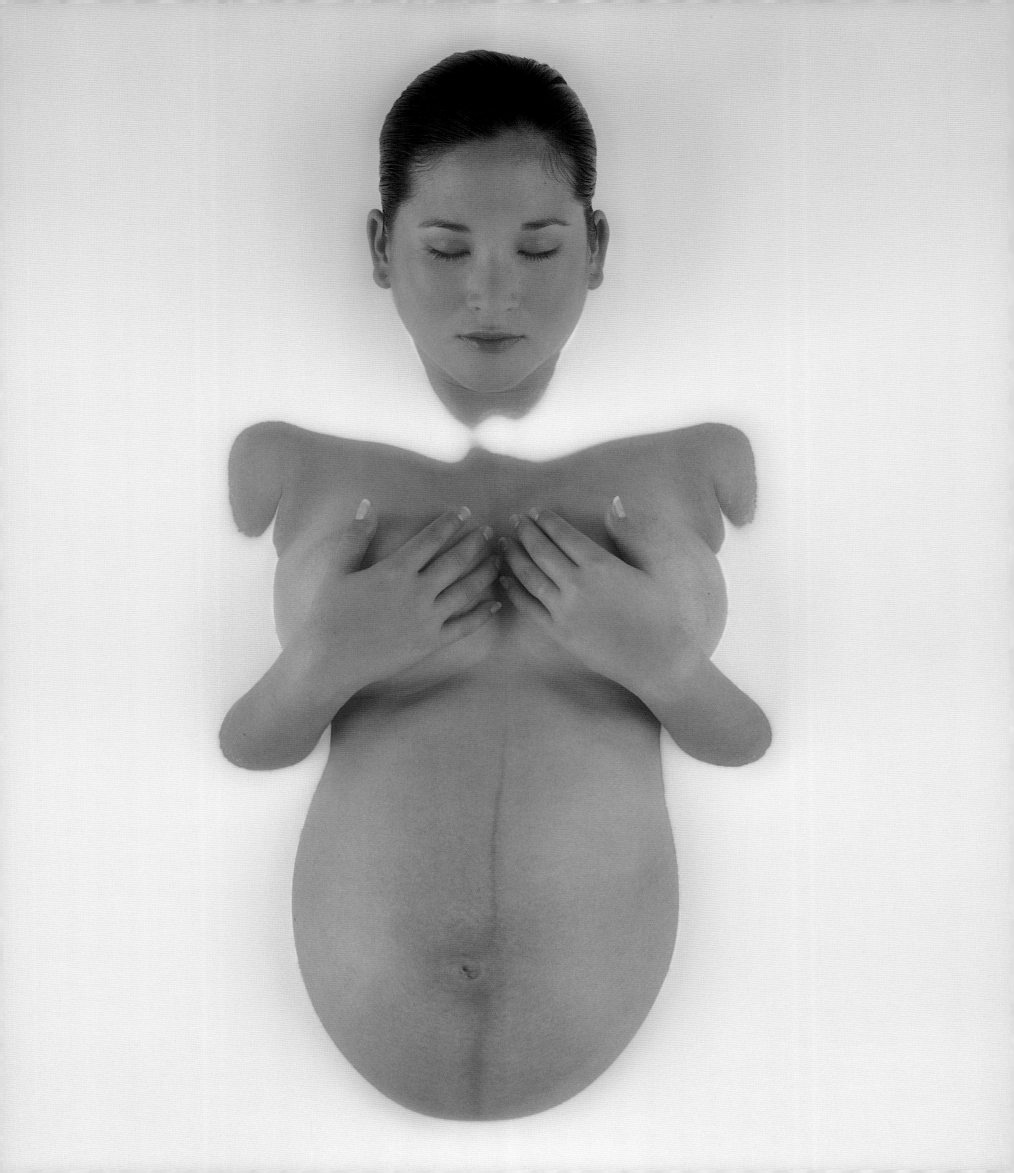

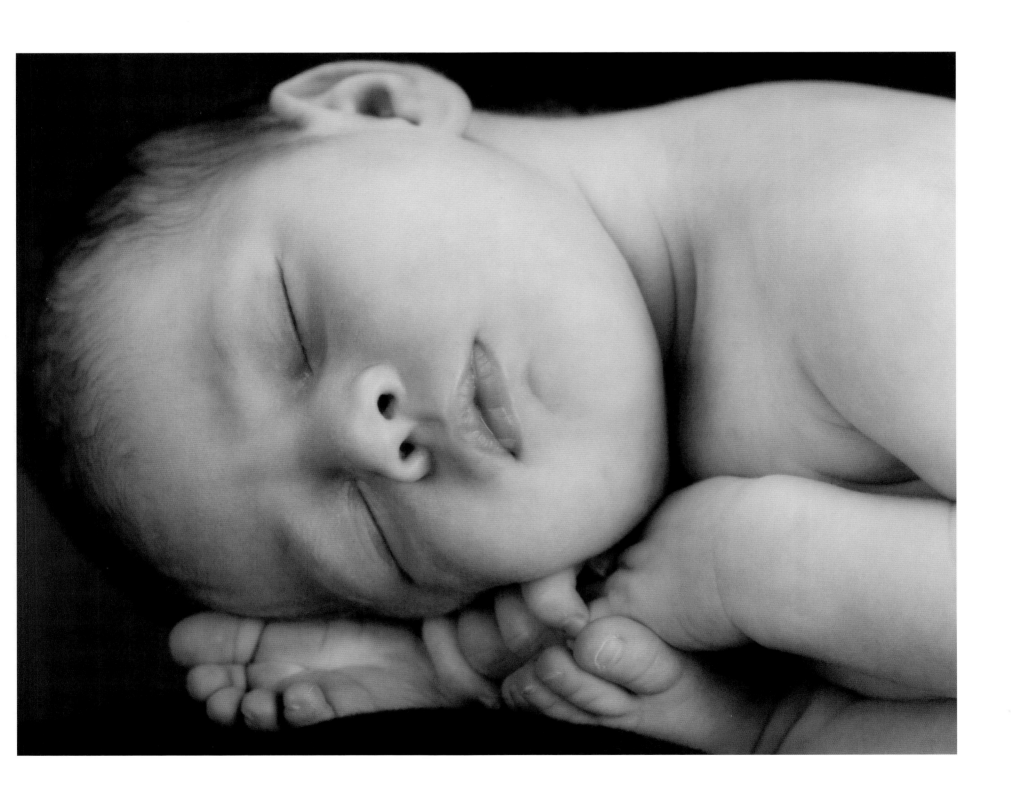

DELICATE

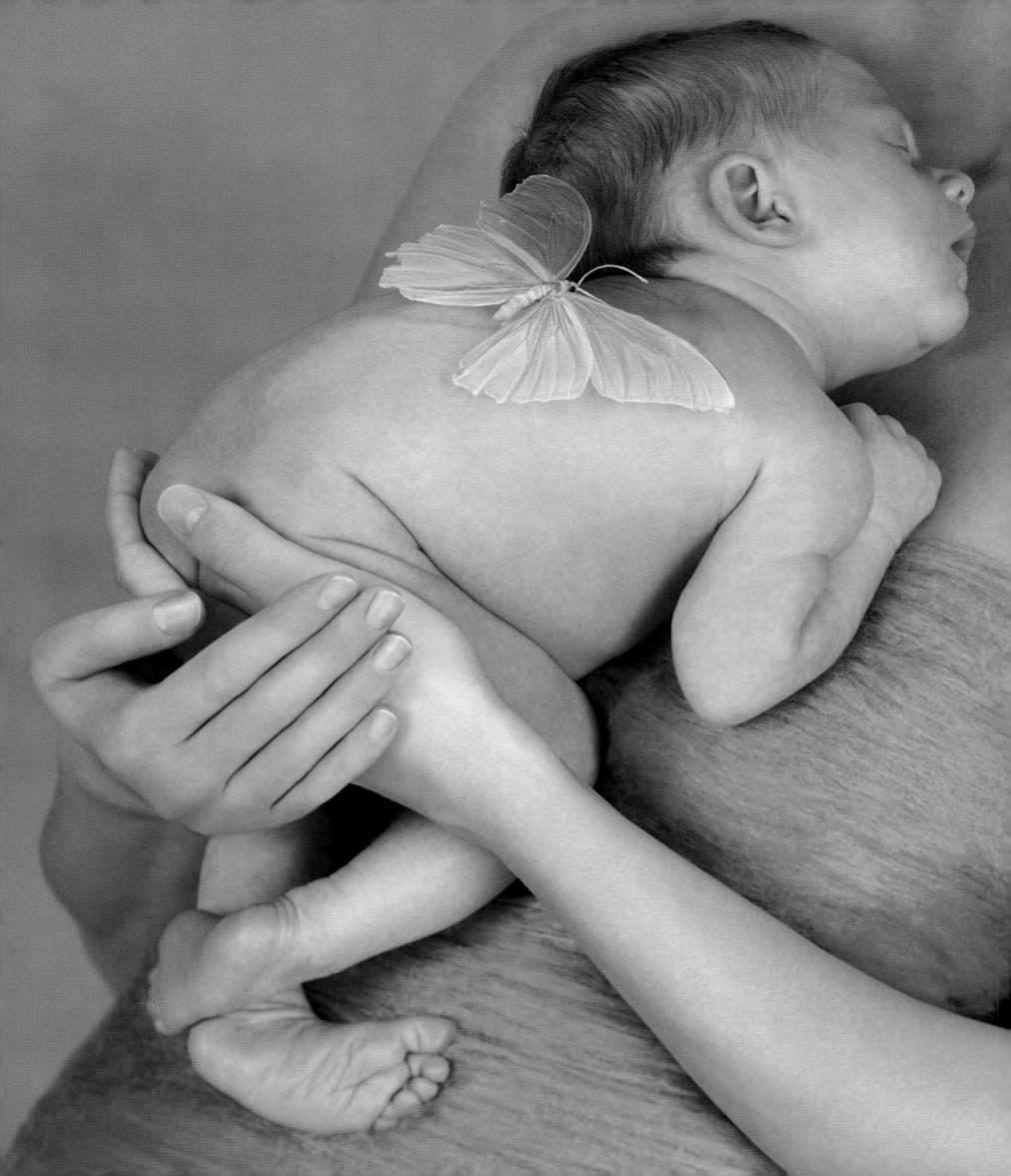

PROTECTED

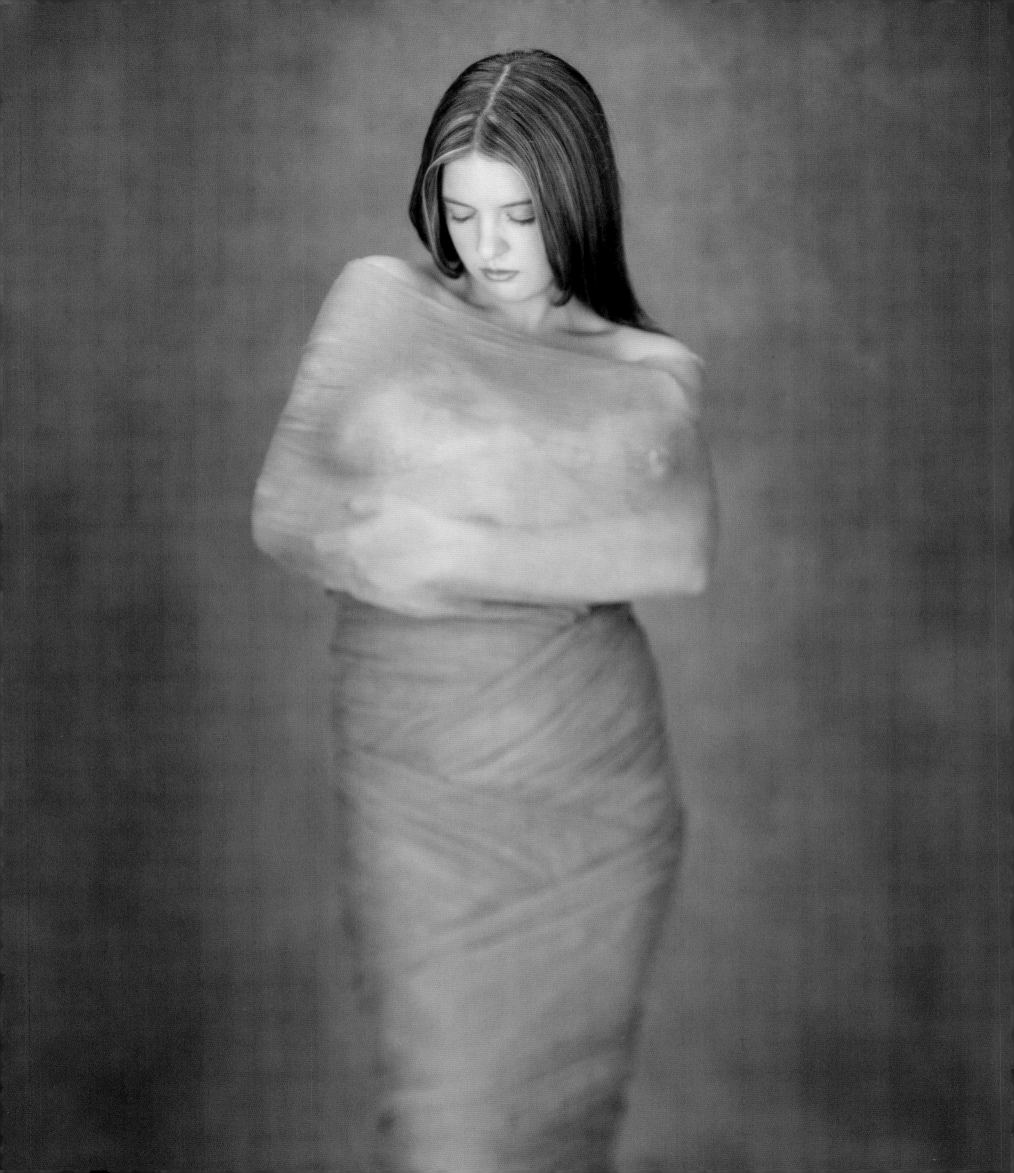

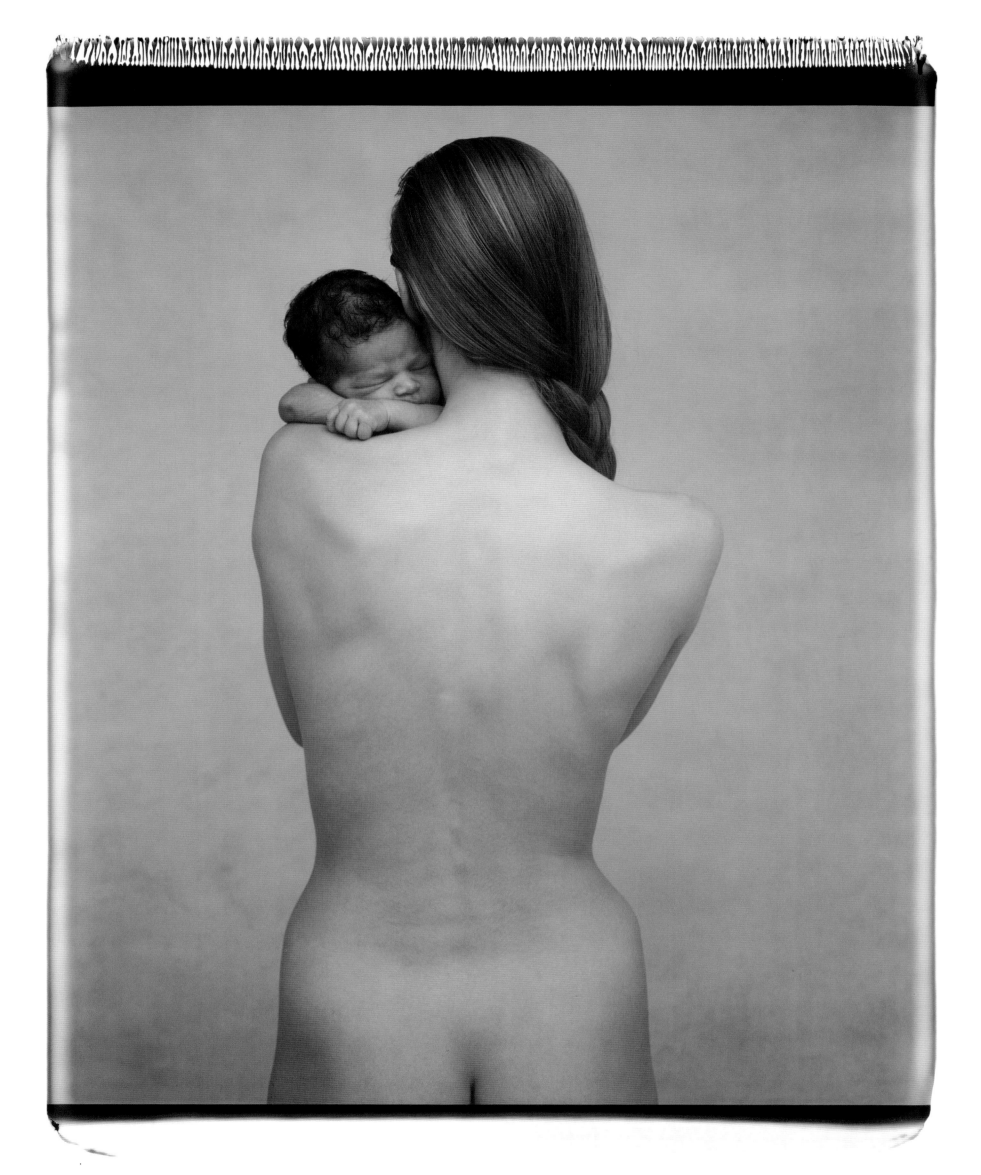

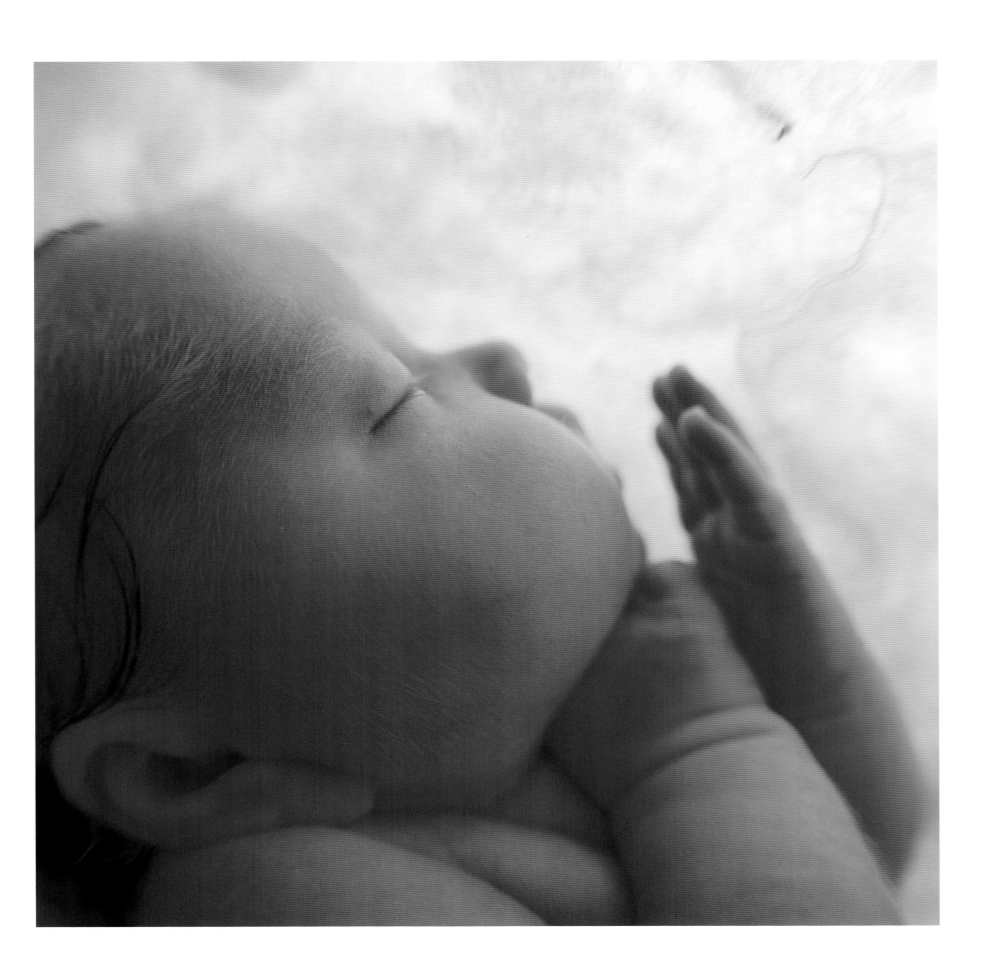

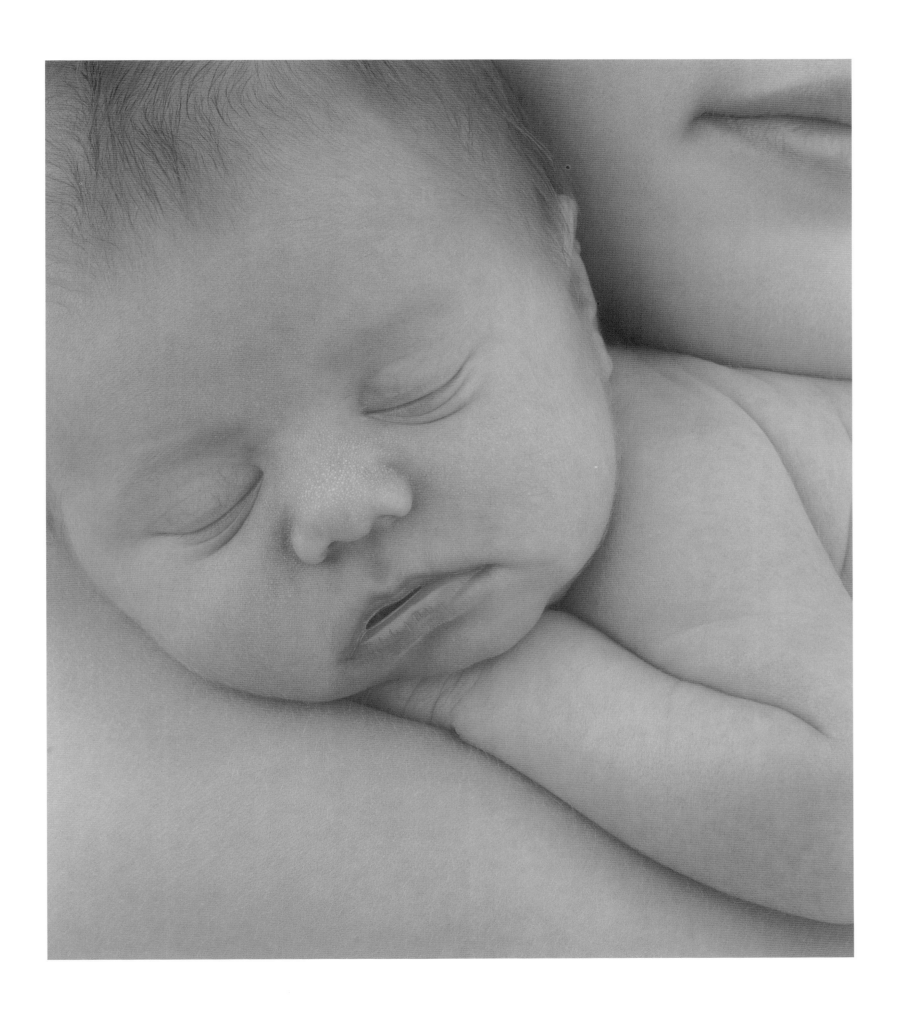

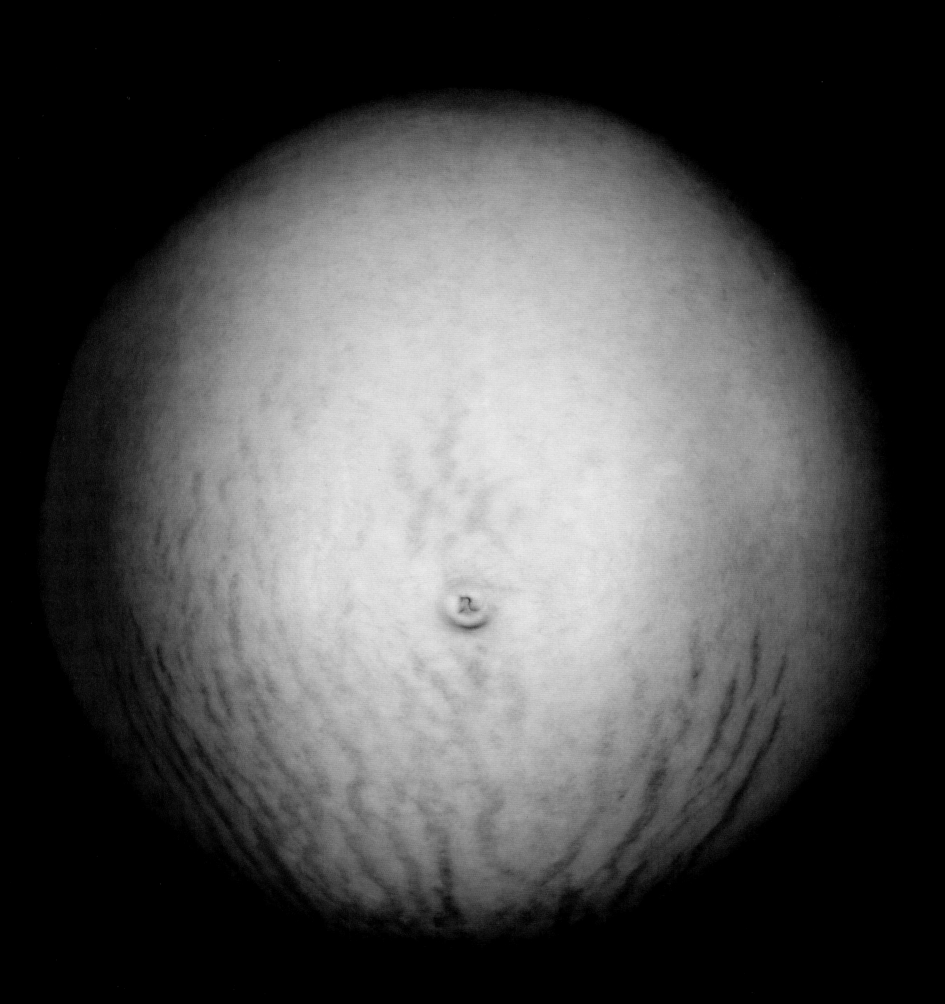

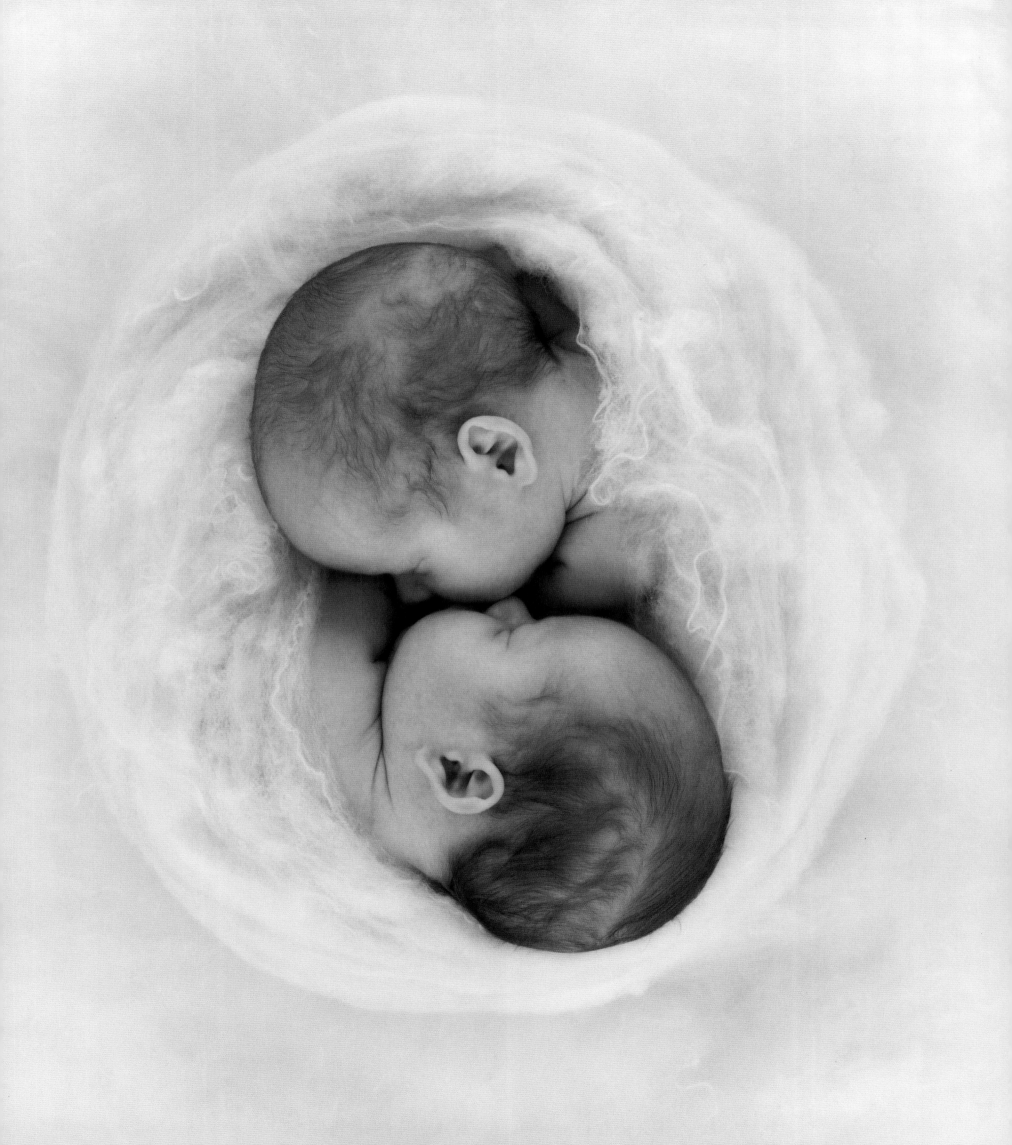

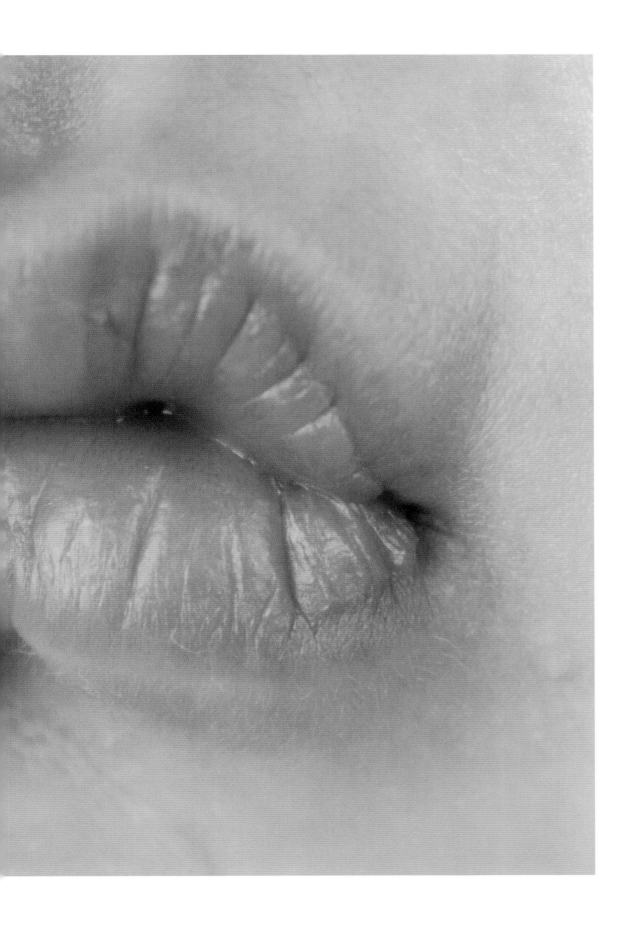

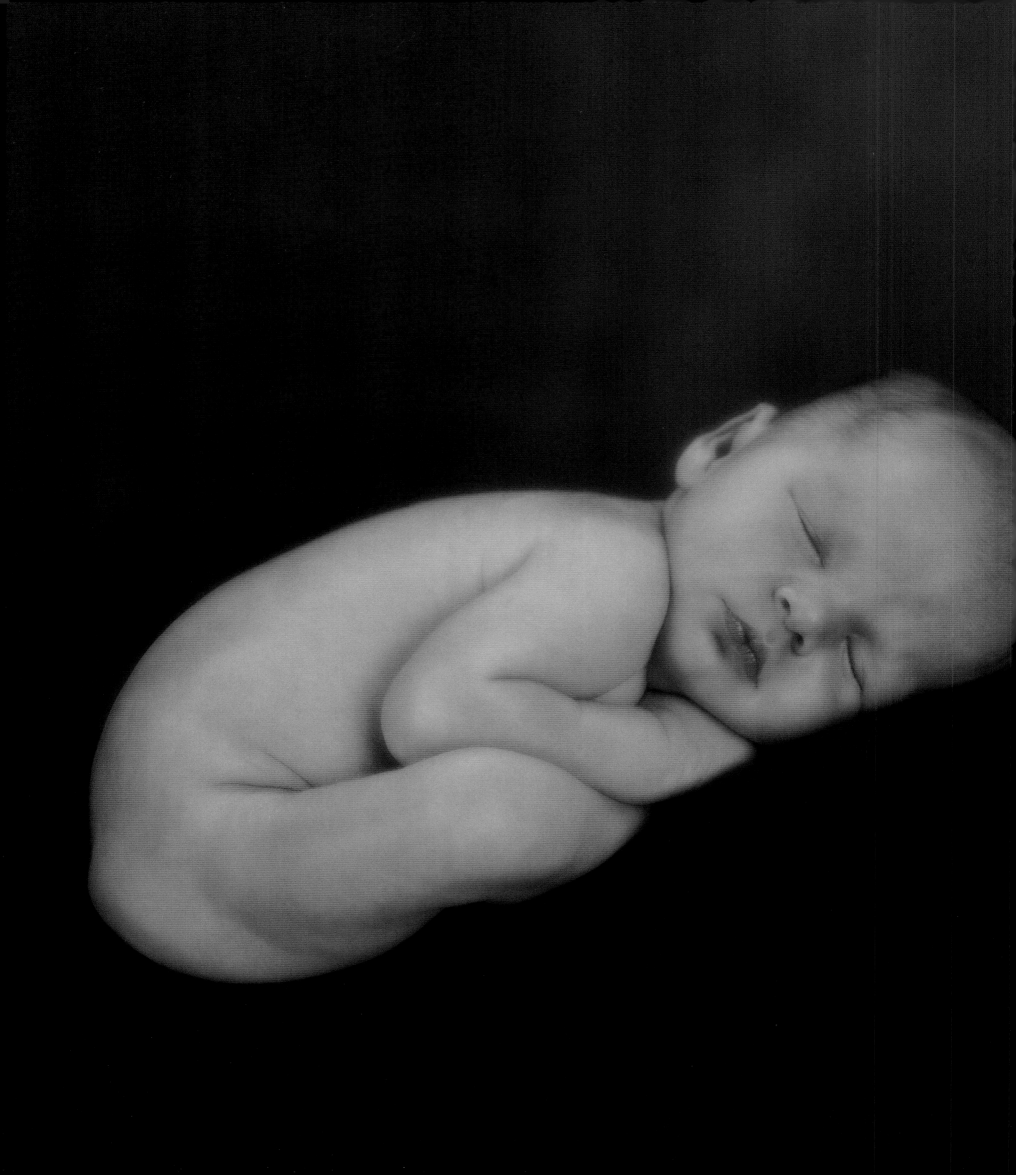

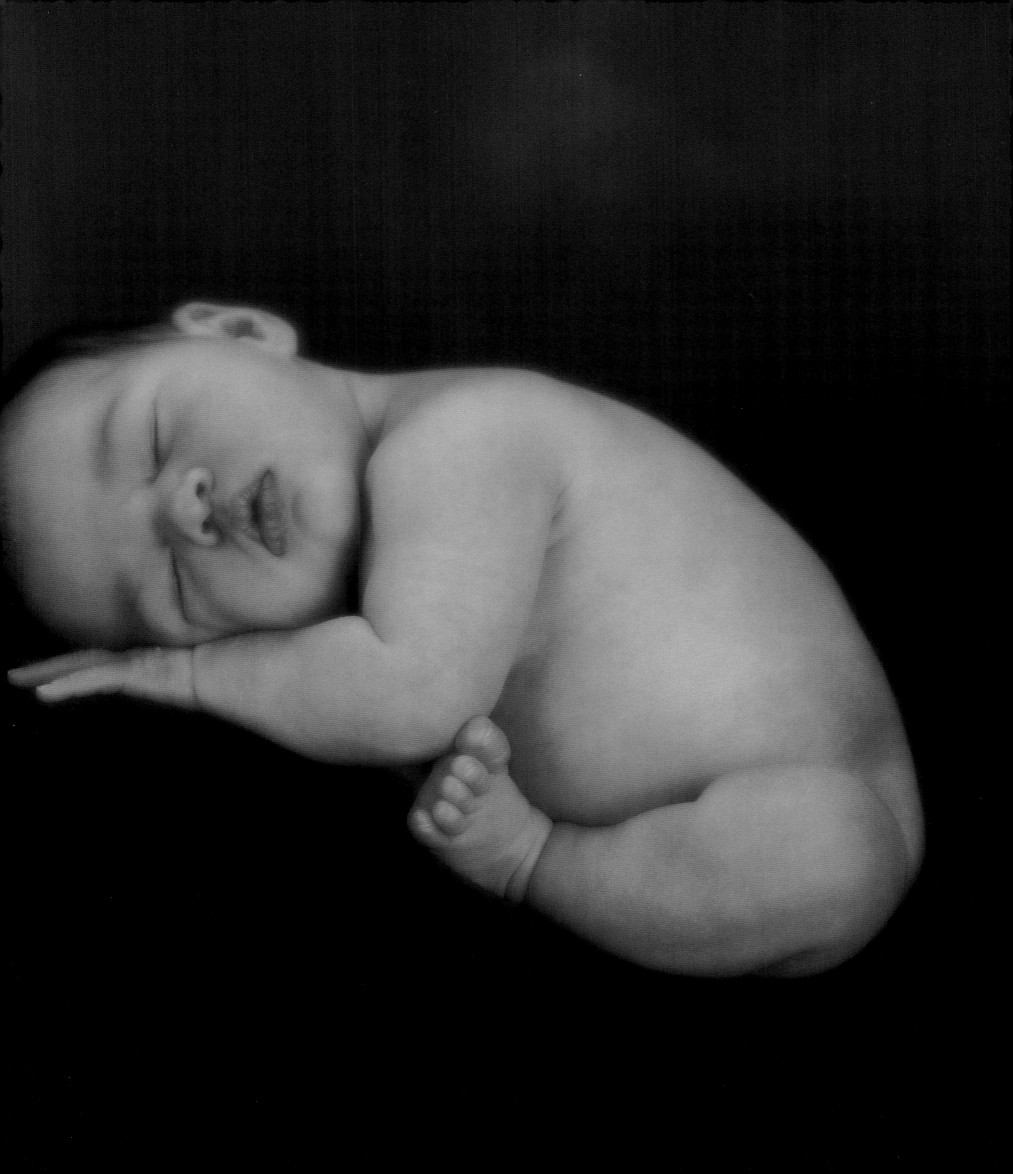

TRANSLUCENT

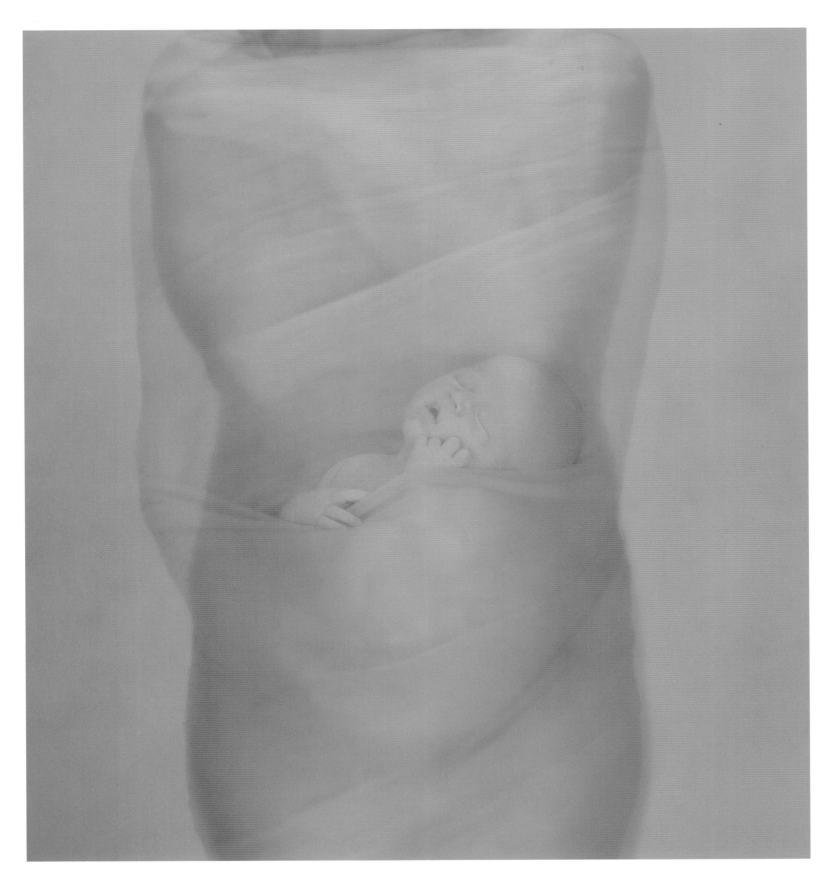

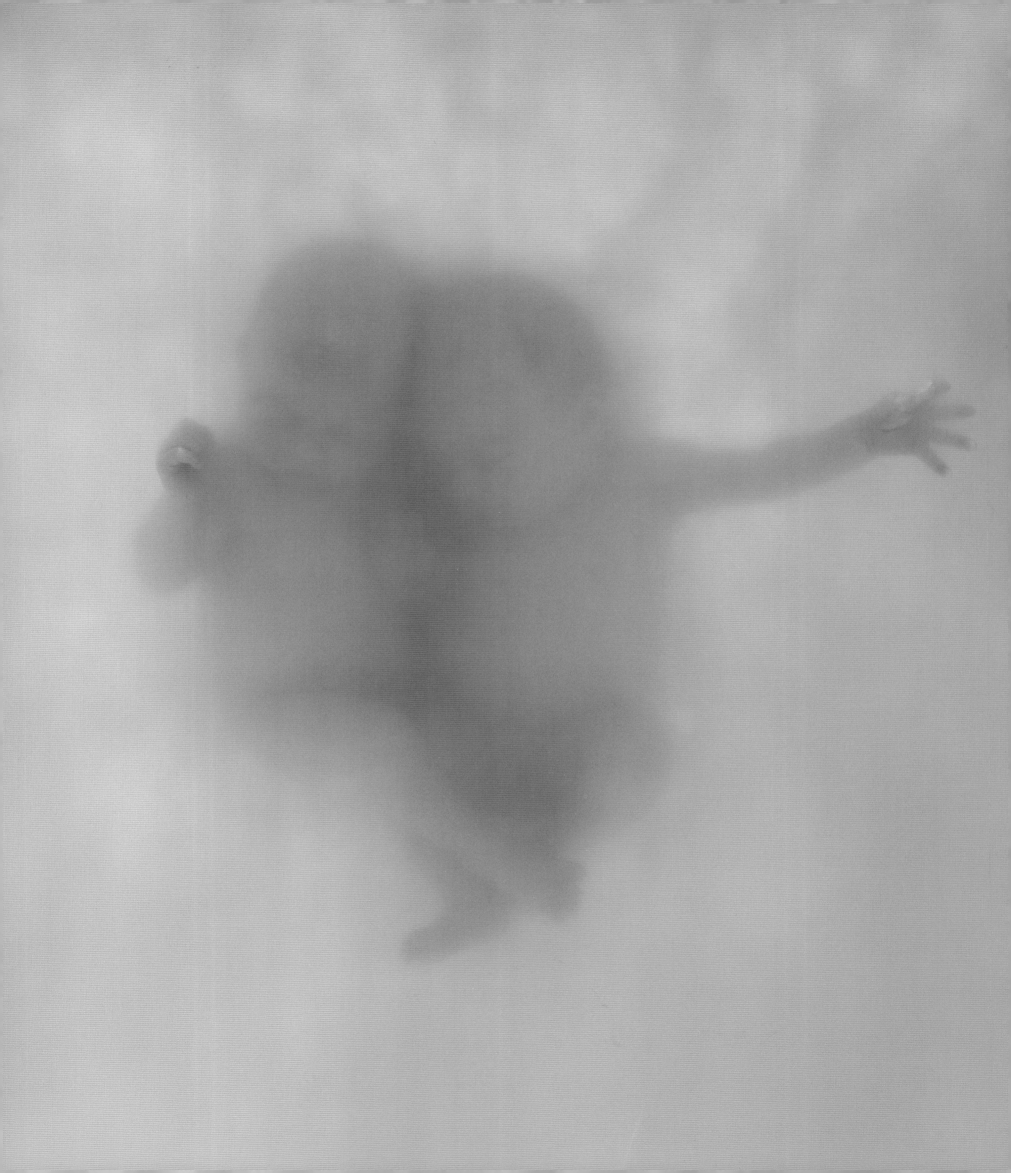

NURTURED

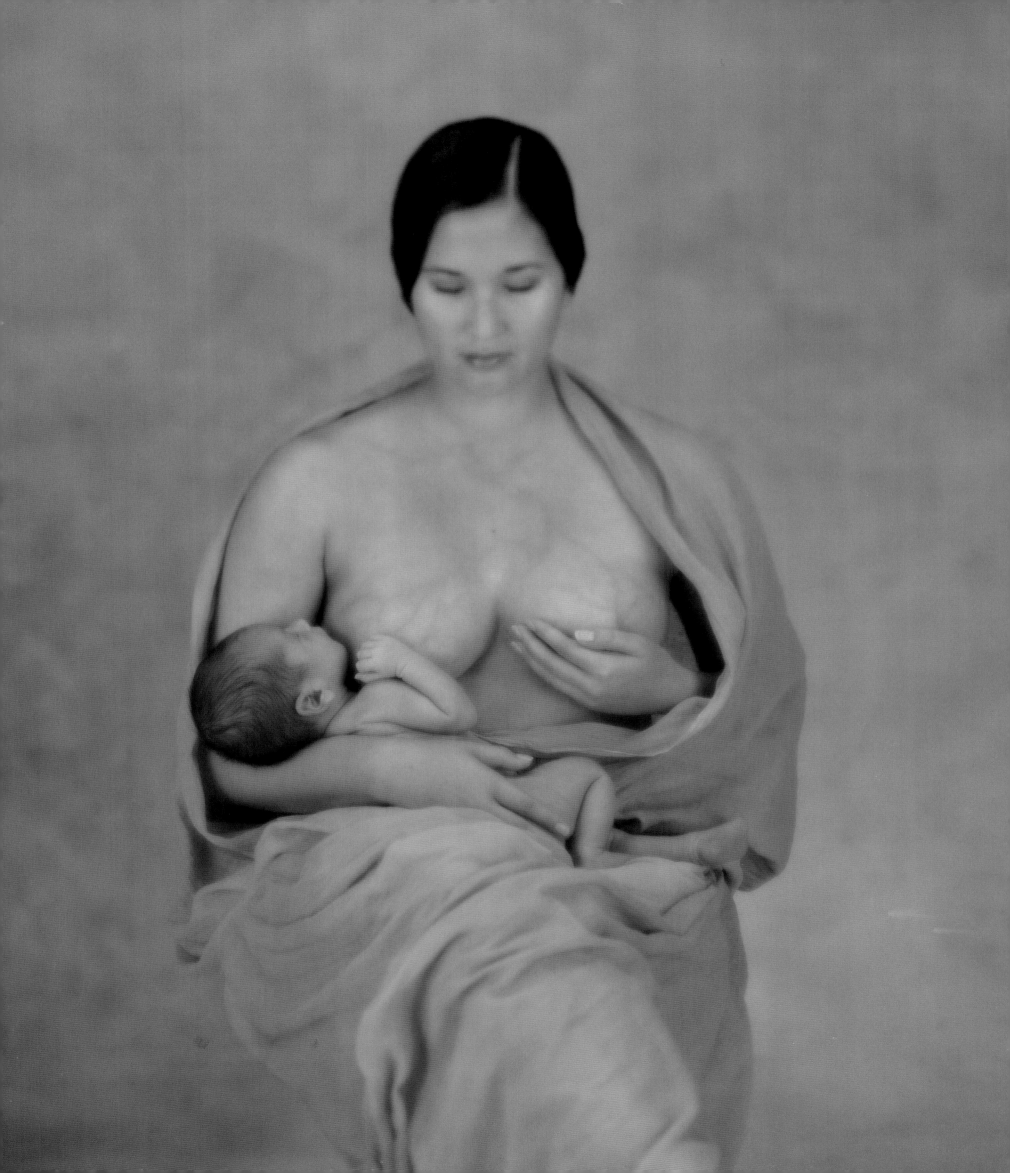

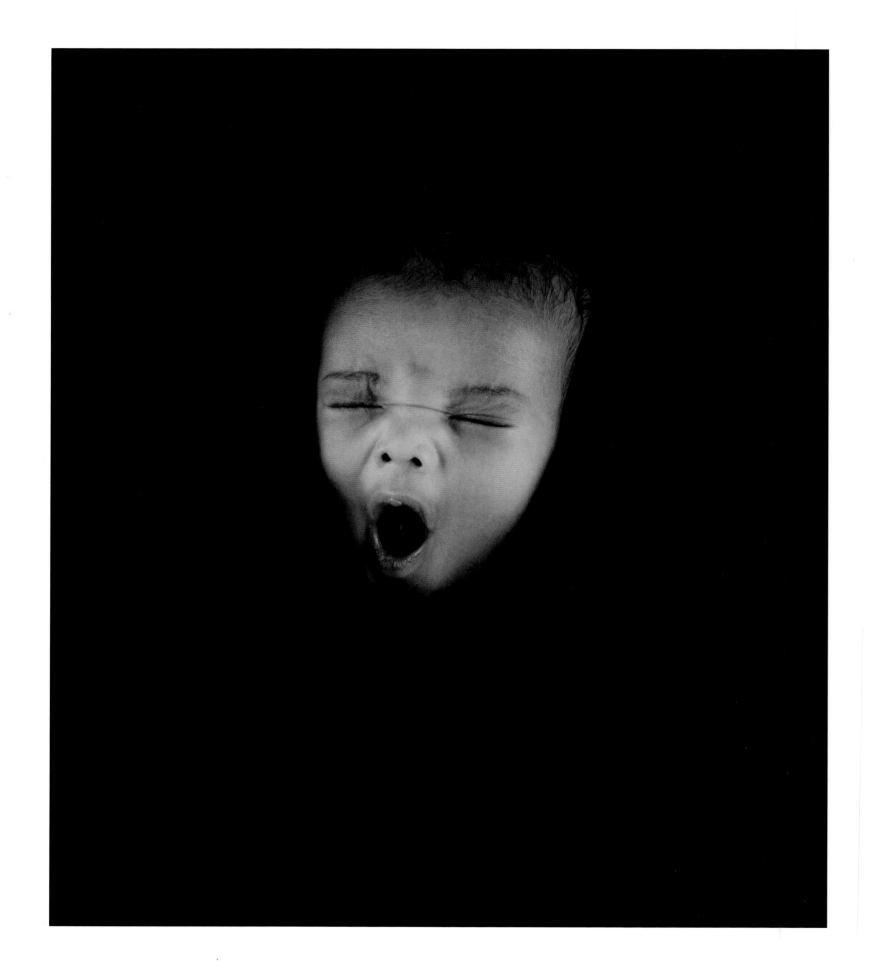

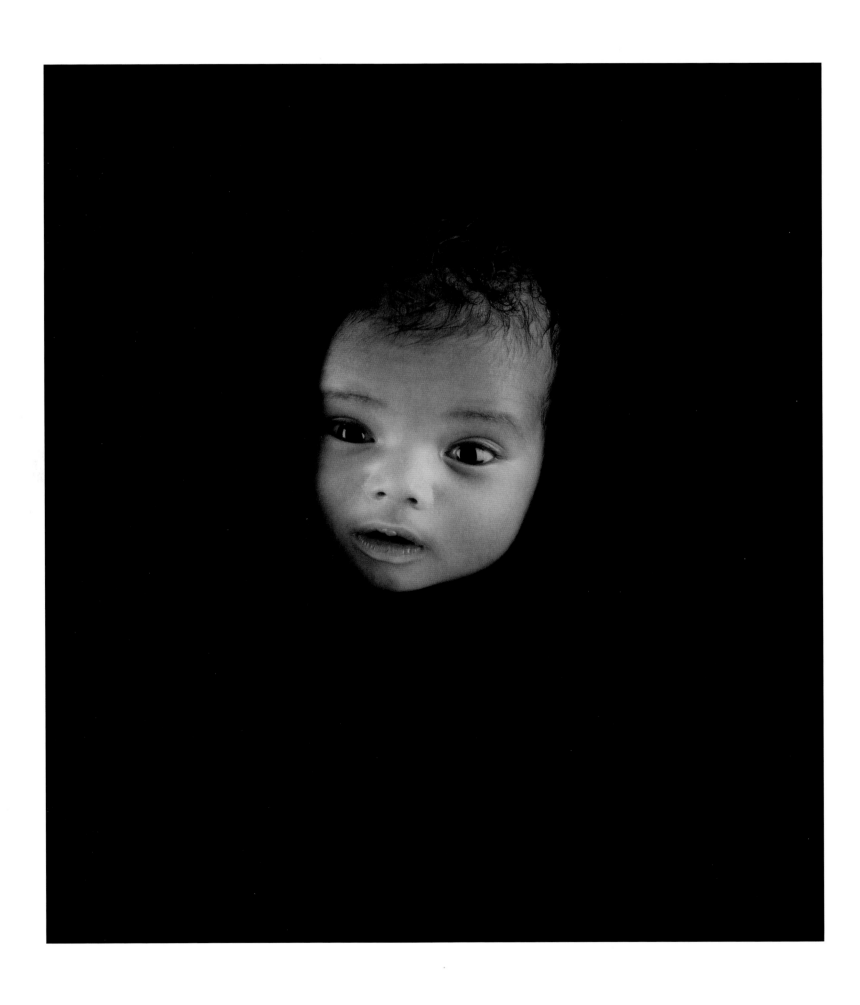

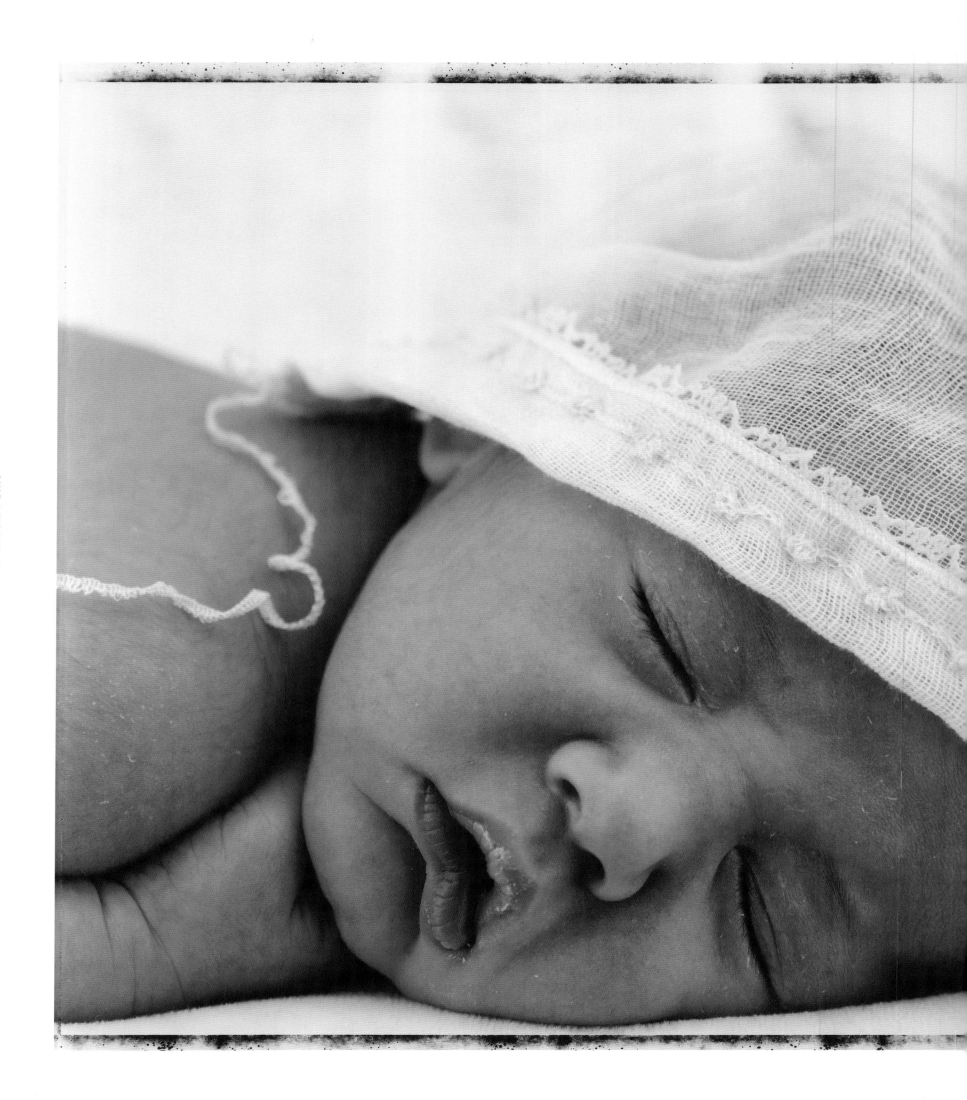

TUNGAROA. 9 DAYS

DEAR

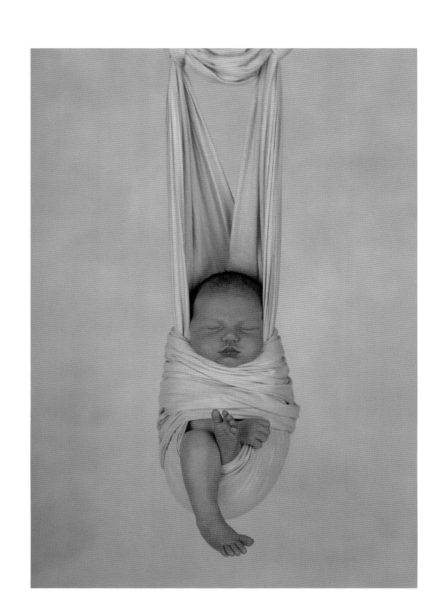

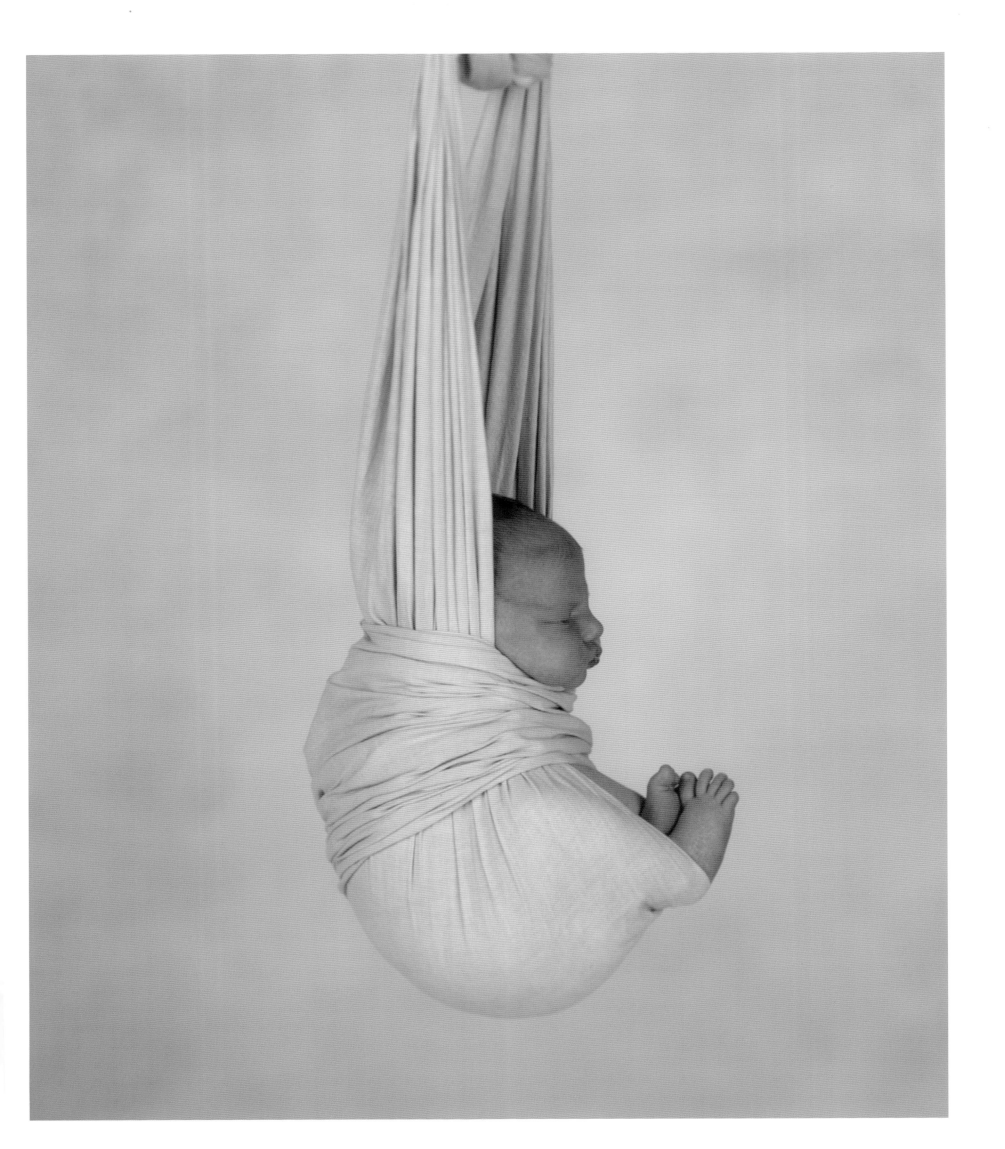

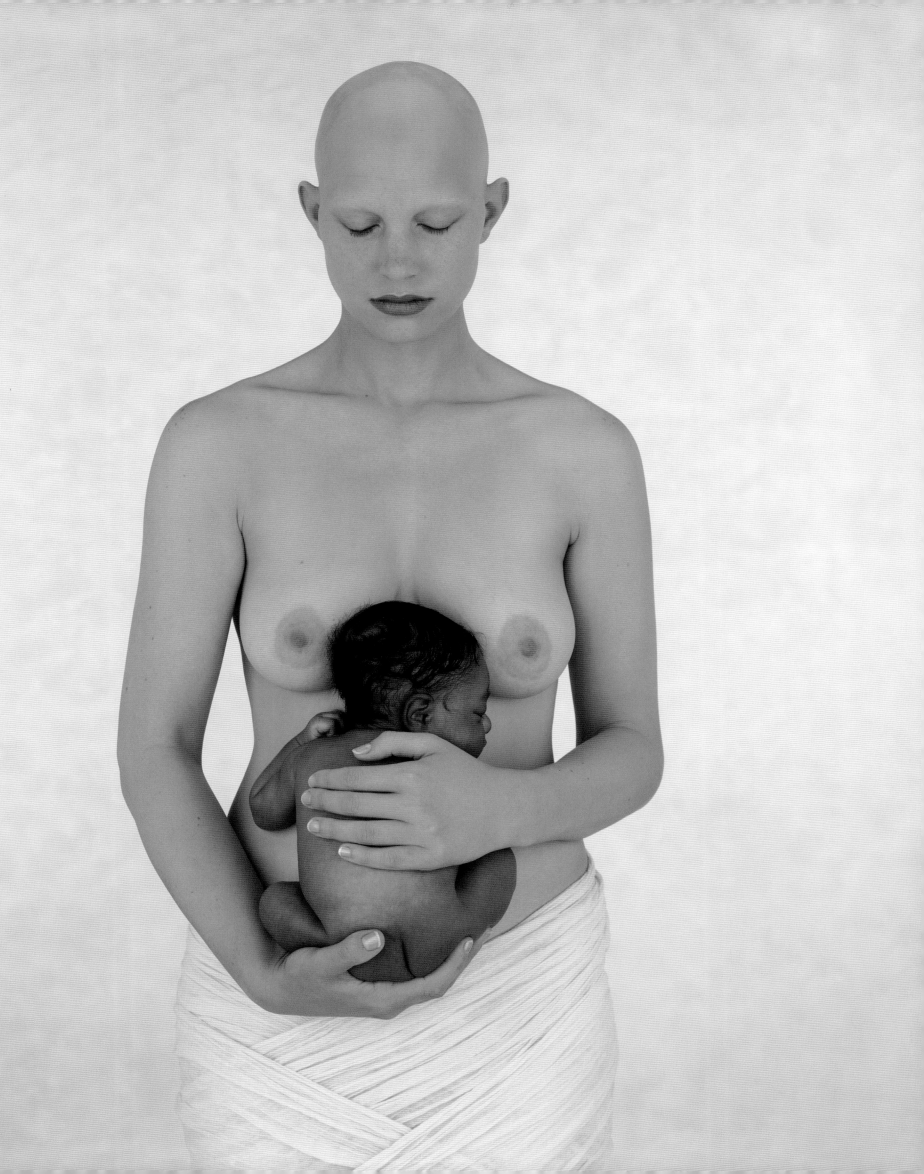

WONDERFUL

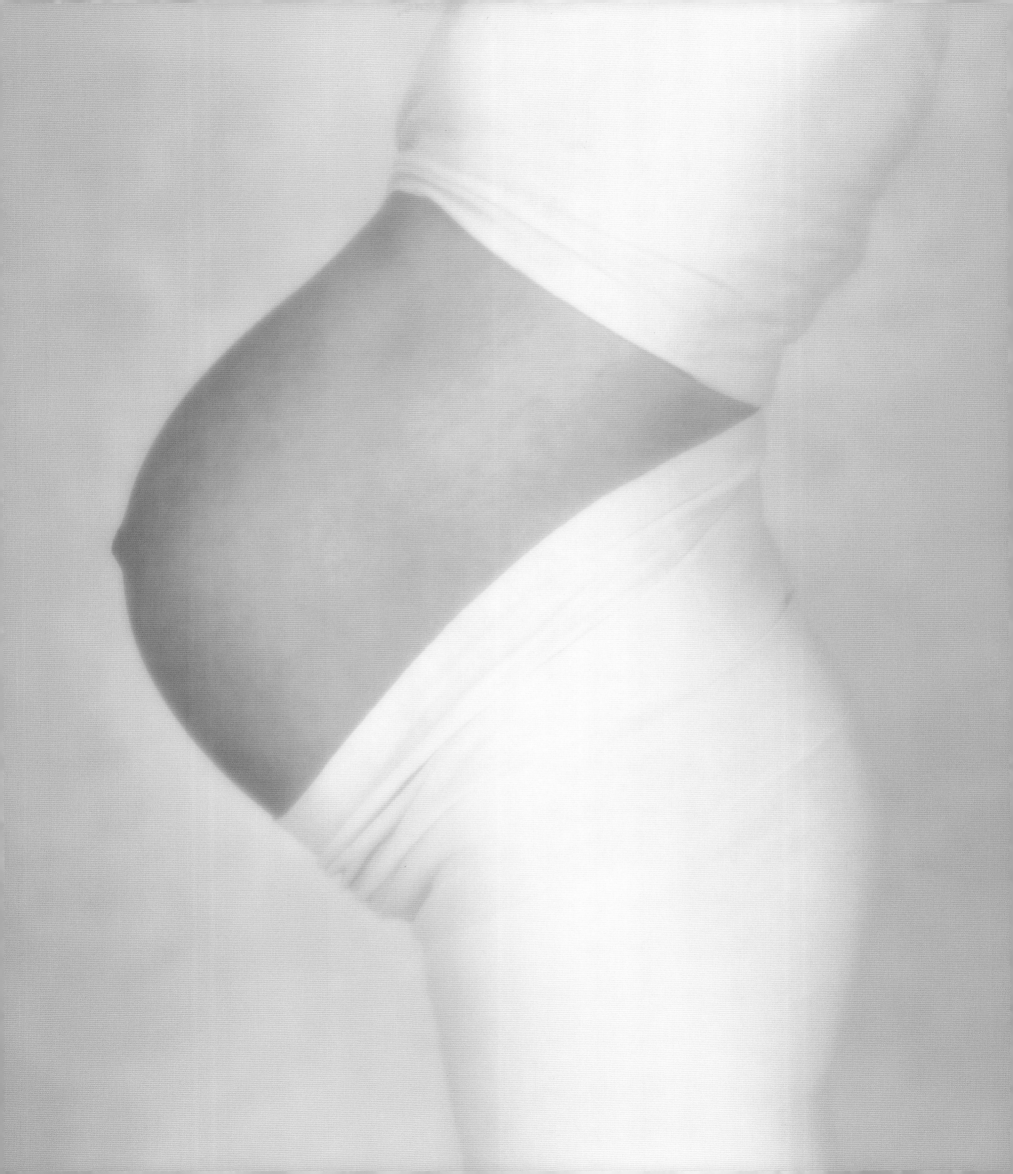

INCREDIBLE

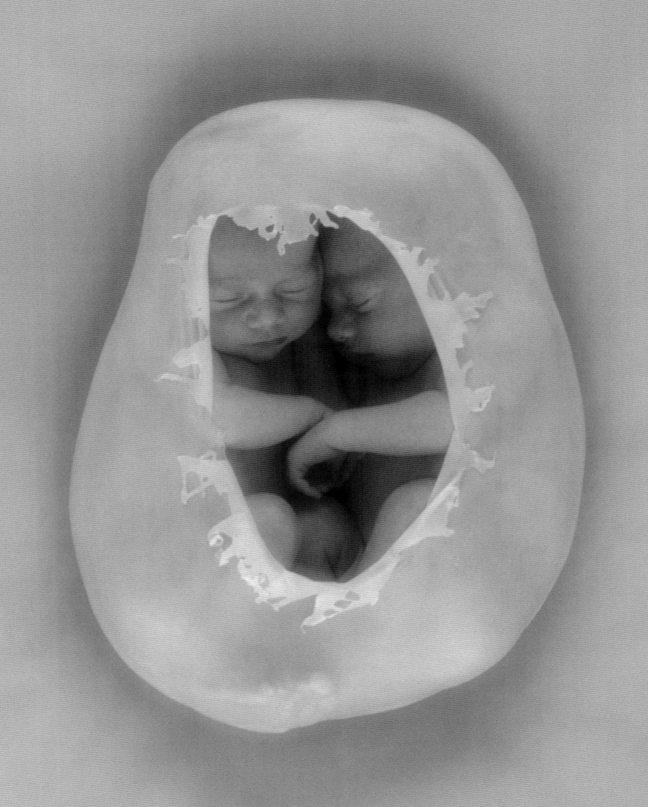

CAPTIVATING

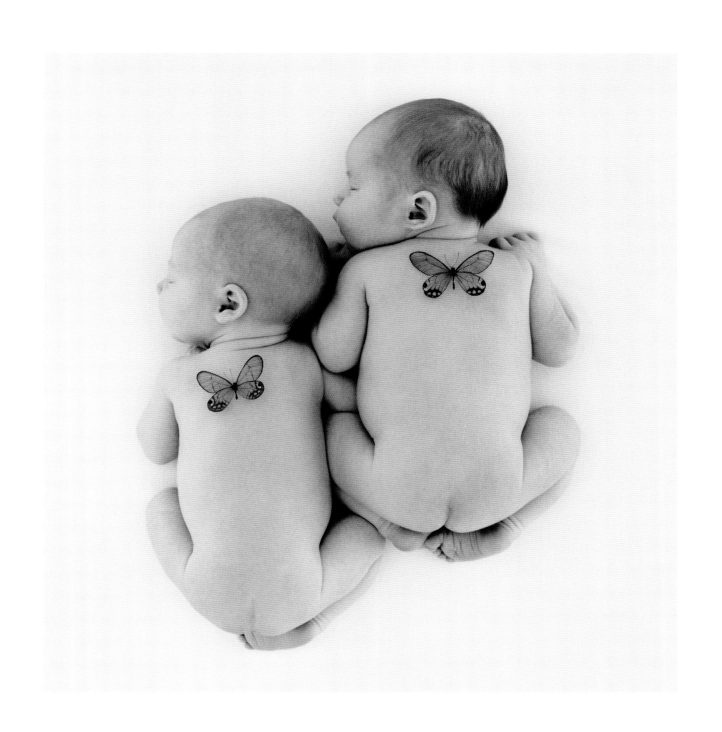

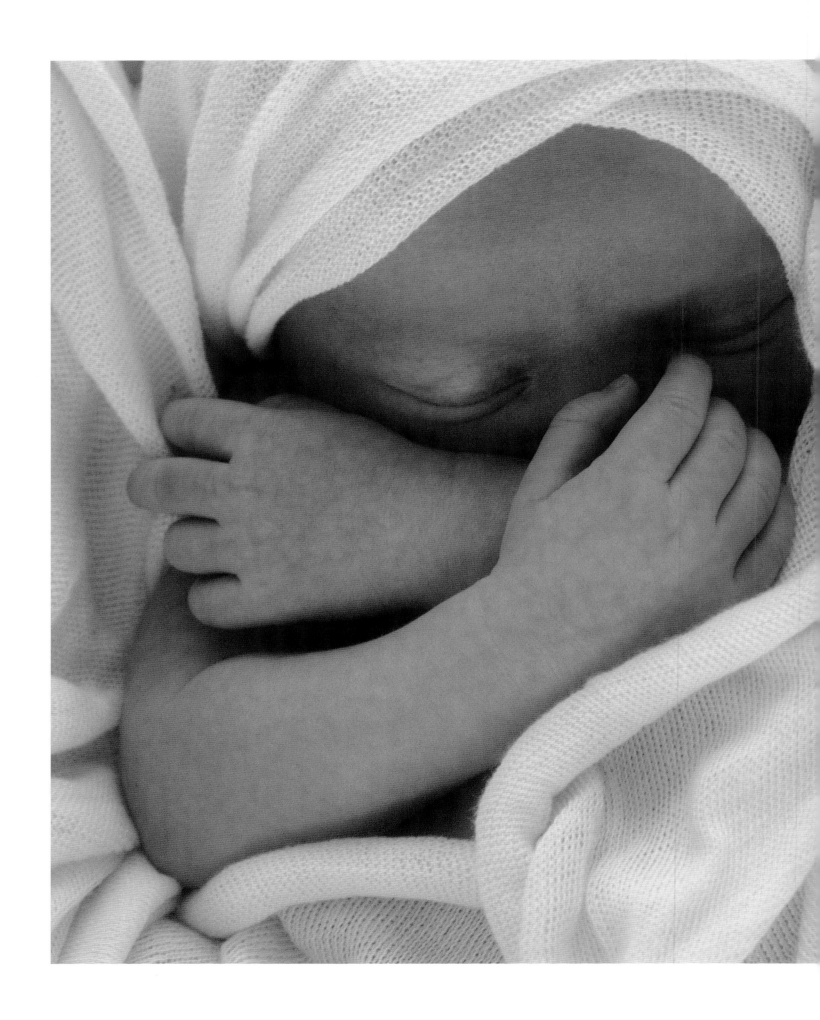

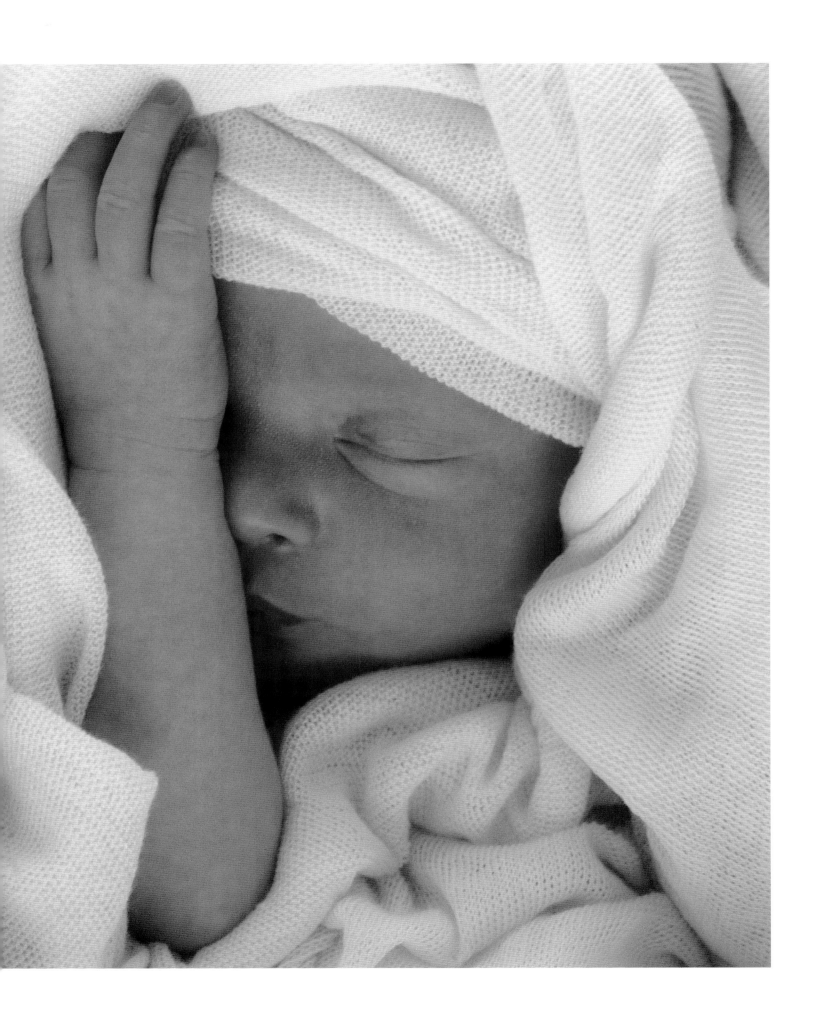

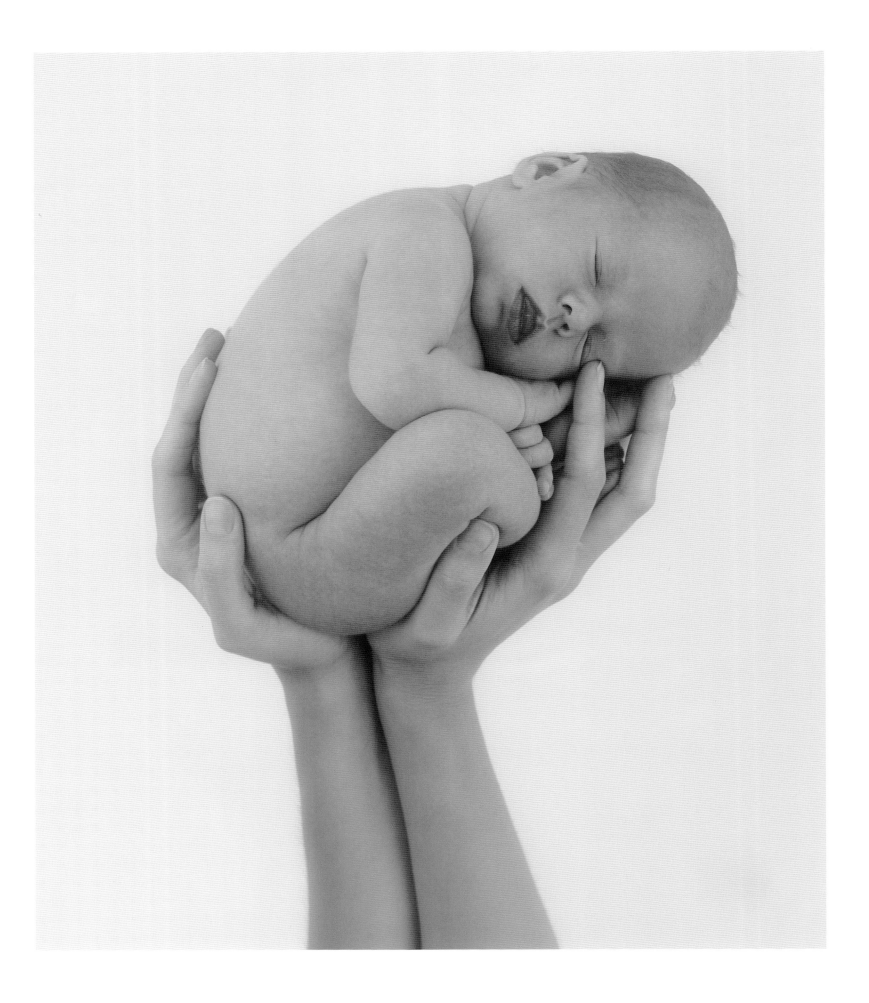

PROTECT

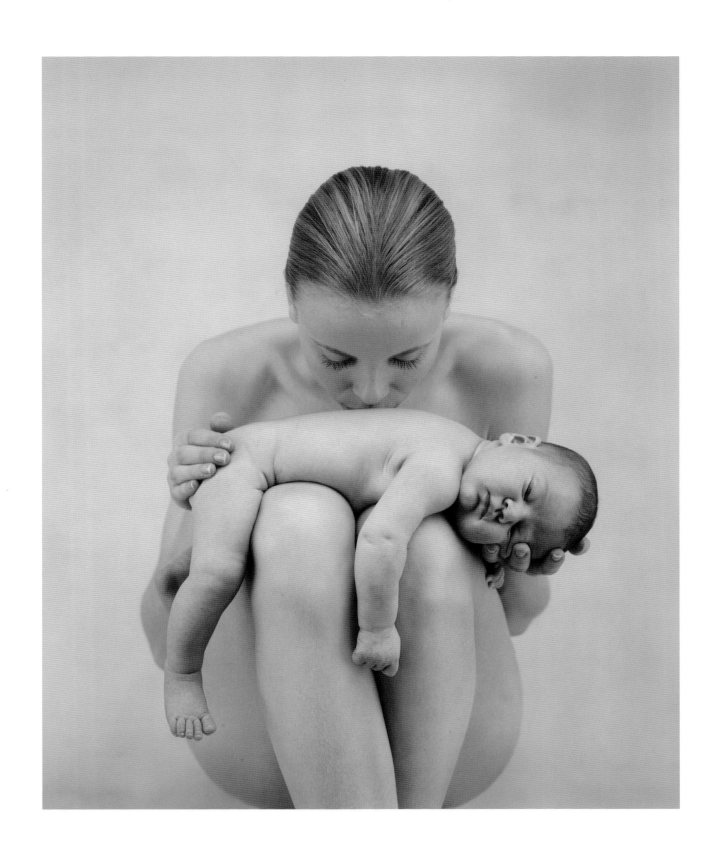

NURTURE

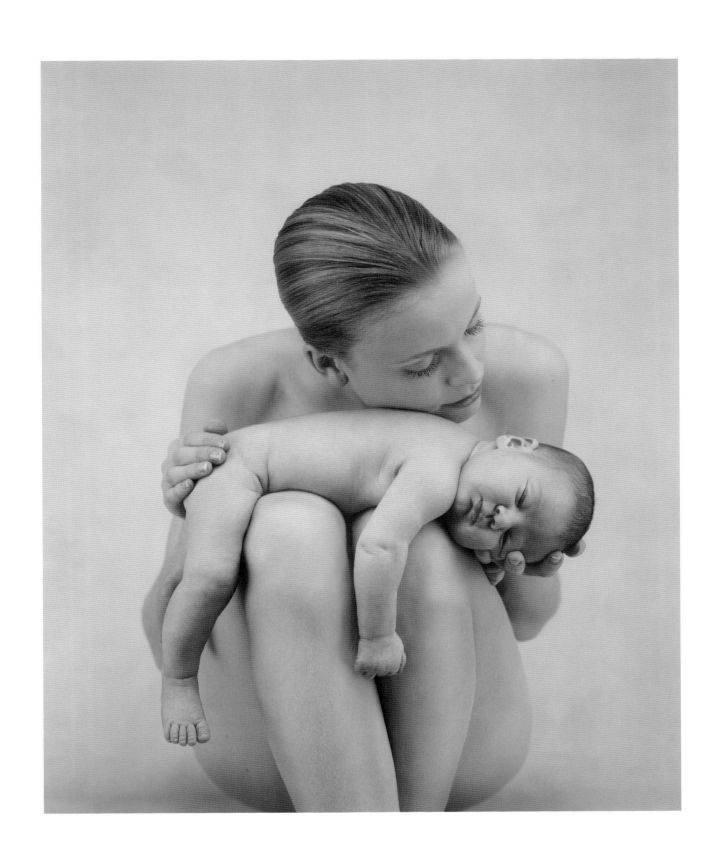

L O V E

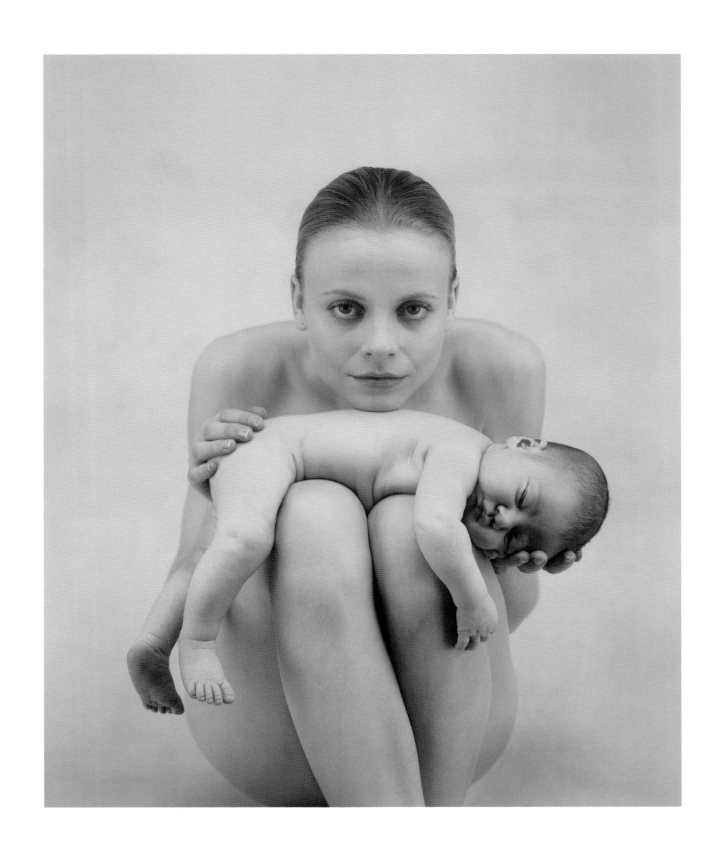

P U

R                    E

*The question I am most often asked is,*
*"Why do you photograph babies?"*

I am generally not one who enjoys talking about herself, because my inspiration is so private and important to me for many reasons. But essentially I feel that babies need a voice, and their importance in this world is so often undervalued.

Photography is my voice, and also my way to add weight to the needs and dignity of those children throughout the world who are suffering in a multitude of ways. I choose to present babies in their purest form, not just to show how lovely they are, but also to emphasize the fact that they are vulnerable, fragile and very precious human beings.

There are many dedicated people working for the prevention of child abuse and neglect, and

in a host of organizations around the world that care for children, who deserve far more credit than myself for their stand on children's rights. I applaud each and every one of them.

In this "new world" in which we all now find ourselves living, it has become even more important for us to reinforce our core values. The babies pictured in PURE to me represent *hope*. They are all brand new citizens of the world, with no notions of hatred, racial bias, political correctness or religious intolerance.

Yet children are not only our hope for the future. By their very existence, they will *be* our future. And yet we so often take them for granted, or underestimate their essential importance. We need to take care of them now, educate, nurture and love them now, teach them the values of harmony, love, understanding, tolerance and an appreciation of other cultures now. Because now is the time to lay the right foundations for their future.

In PURE, in order to further emphasize my personal point of view, I have also selected a range of words to accompany some of the images. These words, to me, help symbolize the essence of babies.

I owe a huge amount of gratitude to the parents of every baby in this book, who so willingly entrusted their tiny newborns to me. Thank you. I feel very honored.

I would also like to acknowledge the trust placed in me by the beautiful and courageous pregnant women featured in PURE, all of them in the final stages of their pregnancies. None of these women are professional models, nor had we ever met before. But all of them, without hesitation, were prepared at such a vulnerable time in their lives to share their unique beauty with the world.

I hope these images give women everywhere a confidence that at any stage of pregnancy they are all, in their own special way, absolutely beautiful. In a world that is deluged by a manufactured perception of beauty, it gives me a great deal of pleasure to be able to photograph what actually is "real" beauty.

In the four years I worked on PURE, every single person involved with the imagery and the production of the book has shared and appreciated my message, and embraced the concept wholeheartedly. I think that's a good sign for the future.

I feel humbled at having such a wonderful opportunity to be a voice for babies, after having been immersed in the lives of so many babies and parents for the past 15 years.

Although I photographed the images for PURE in a small number of locations around the world, the babies came from many different backgrounds and ethnic origins. Yet with all their diversity, they are all babies – all loved by their parents – all having the same inherent potential to become "a Shakespeare, a Michelangelo, a Beethoven."* Each and every one of them, at this stage in their lives, has the capacity for anything. Each is undeniably "a marvel."

My desire is that these images will further help to create a strong platform of hope and promise for humanity and the future.

We all do indeed speak a common language.

*Anne Geddes*

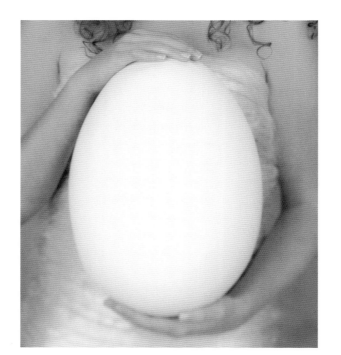

To my husband Kel, who has worked selflessly and tirelessly to bring this project to fruition.
It is with the greatest pleasure that I present the very first copy of PURE to you.

And to our daughters Stephanie and Kelly – you will always be my own most beautiful babies in the world...

## ACKNOWLEDGMENTS

### Studio Team
Dawn McGowan
Natalie Torrens
Holly Babuik

### Black & White Printing
Marie Shannon
Rebecca Swan

### Production
Relda Frogley

### Special Thanks
Terry McGrath
Gary Brown

### Co-publishing
Photogenique Publishers

### The rest of our great team from around the world
*(in alphabetical order)*

Dervla Bichard,  Nicki Brown,  Rebecca Douglas,  Megan Flashman,  Mark Fletcher,
Susan Holdsworth,  Betty Leiataua,  Rachel Little,  Kim Loasby,  Sue Massey,  Angela Mobberley,
Estelle Murray,  Alison Newton,  Trish O'Donnell,  Sarah Rees,  Brijen Shah,  Kelly Skelton,
Libby Twigg,  Sandra Vitali,  Natasha Webb,  Frances Young.

### Thank you for helping us to find so many beautiful babies
Midwives of Auckland
Multiple Birth Associations of Auckland
Black Infant Heath Projects – Los Angeles
The many generous New Yorkers who responded to our call for babies
during the time we were shooting there.

*Pablo Casals

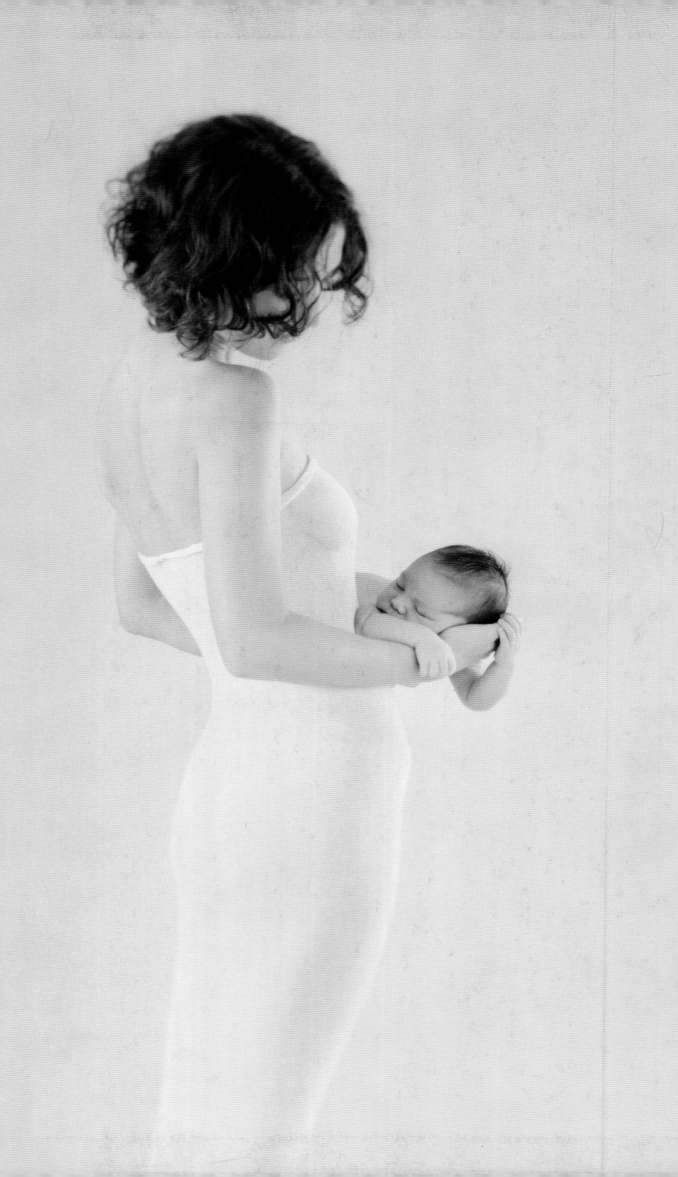